New Eco Homes

New Eco Homes

Manel Gutiérrez

HARPER
DESIGN

An Imprint of HarperCollinsPublishers

First published in 2015 by:
Harper Design
An Imprint of HarperCollins*Publishers*
195 Broadway
New York, NY 10007
Tel.: (212) 207-7000
Fax: (855) 746-6023
harperdesign@harpercollins.com
www.hc.com

Distributed throughout the world by:
HarperCollins*Publishers*
195 Broadway
New York, NY 10007

Editorial coordinator: Claudia Martínez Alonso
Art director: Mireia Casanovas Soley
Editor and texts: Manel Gutiérrez (@mgutico)
Layout: Cristina Simó Perales

ISBN 978-0-06-239518-4

Library of Congress Control Number: 2015941477

Printed in China
First printing, 2015

Contents

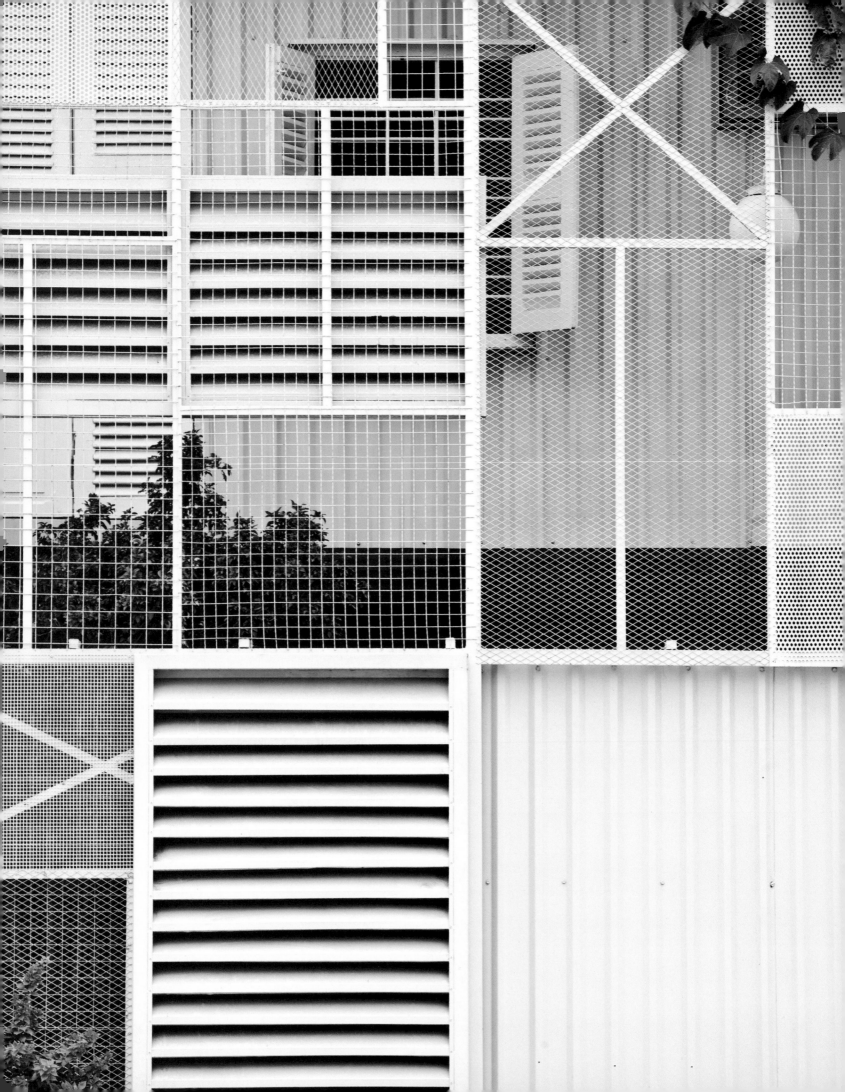

Introduction

Sustainable design integrates consideration of resource and energy efficiency, healthy buildings and materials, ecologically and socially sensitive land-use, and an aesthetic sensitivity that inspires, affirms, and ennobles... (as defined by the International Union of Architects [UIA] and the American Institute of Architects [AIA]).

World leaders met in September 2000 at the United Nations Headquarters and approved the Millennium Mission Statement, which established a series of objectives called the Millennium Development Goals. Among the eight goals approved at that meeting, the seventh refers to the environment and the necessary updates that are needed to guarantee sustainability.

Without a doubt, most environmental issues included in the UN goals regarded the palpable effects of climate change and concern about exhausting natural resources, but also featured other important global problems such as extreme poverty and gender equality.

Taking these issues into account, architecture, design, and construction have not remained at the margin of sustainability and respect for the environment. Building design, construction, and maintenance implies consuming large quantities of energy, water, and other resources, which in turn generates significant quantities of waste. The construction process affects the environment and surrounding ecosystem. Once buildings are constructed, the occupants and administrators face a series of challenges in their attempt to maintain a healthy, efficient, and productive environment.

For example, US buildings represented 38.9 percent of total energy consumption in 2005. In 2008, they contributed 38.8 percent of the total carbon dioxide emitted to the atmosphere, including 20.8 percent from the residential sector and 18 percent from the commercial sector.

To this point, different state institutions, like the US Environmental Protection Agency (EPA), approach these environmental challenges in both new and existing buildings by promoting the efficient use of energy and resources, waste reduction, practices for preventing contamination, interior environmental standards, and other environmental initiatives.

In order to meet these challenges, innovative and varied building strategies have been developed that can be grouped based on the place they are mainly employed:

Strategies related to the building location: attempt to minimize environmental impact, integrate the building into the landscape, and increase the alternative transportation options.

Strategies centered on energy: conserve energy and use renewable energies that guarantee the efficient use of natural resources and reduced public utility costs.

Strategies that ensure a state of well-being inside the home: use natural light and ventilation to reduce energy consumption and improve lighting and interior environment.

Water-management strategies: employ a system of maximum efficiency, reduce public utility costs, and manage rainwater and gray waters.

Use of materials: reduce materials, recycle, compost, and use green construction materials.

Finally, technology should be used as an ally in sustainable and efficient construction. For instance, automated home thermostats can greatly contribute to developing future sustainable strategies in building design, construction and maintenance.

All of these strategies are already regulated through a series of construction standards. Certification systems like Leadership in Energy and Environmental Design (LEED) in the United States, the Deutsche Gesellschaft für Nachhaltiges Bauen (DGNB) in Germany, among others, are equipped with tools that can evaluate buildings that promote sustainability and good environmental practices. These strategies and their regulations in standards and certifications contribute to the achievement of environmentally friendly homes that are alive and "breathe."

Despite all of these standards, we must not forget the essence of design: design is not a slave to the conditions imposed by the strategies of sustainability and energy efficiency. Design avoids being straitjacketed, and always finds sufficient freedom to allow itself to not forget about transmitting into the architecture beauty and emotion. In no way, does sustainable design forget about *"an aesthetic sensitivity that inspires, affirms, and ennobles..."* This has never been more apparent than in contemporary construction.

The symbols on each project's fact sheet refer to the following:

| Terrain | Water | Energy | Materials | Interior | Innovation |

HOUSE ON THE MORELLA RIVER

Andrea Oliva Architetto | Studio Cittaarchitettura

Location **Castelnovo di Sotto, Italy**
Surface area **22,604 square feet**
Photographs **© Kai-Uwe**

 Suspended by the ground to protect the aquifer

 Rainwater collection and use

 Photovoltaic solar energy
Passive solar
Green roof

 Natural daylight
Double insulated glazing separated by argon
Mechanised system to recycle the air

The typological value of this home is defined by its relationship with the highway, just two hundred feet away, and its design that enables it to be an integral part of the environment.

Dominated by permanent grassland, the landscape establishes a strong connection between the architecture and the agricultural surroundings. This relationship is achieved through improved internal and external points of view and through the interaction between solid and empty shapes (porches and windows). The design take into account the relationship between architecture and landscape.

Given all these variables, the main structure of the house is based on two elements: the large porch that surrounds the building and the inner body of the house. The porch acts as the element that defines the boundaries between home and countryside, while "independent objects," such as the stairs and ramps, represent a natural extension of the highways and roads. Meanwhile, the facades, enveloped by the surrounding porch, are characterized by the relationship between the filled and empty spaces that define the way in which the house relates to its surrounding landscape.

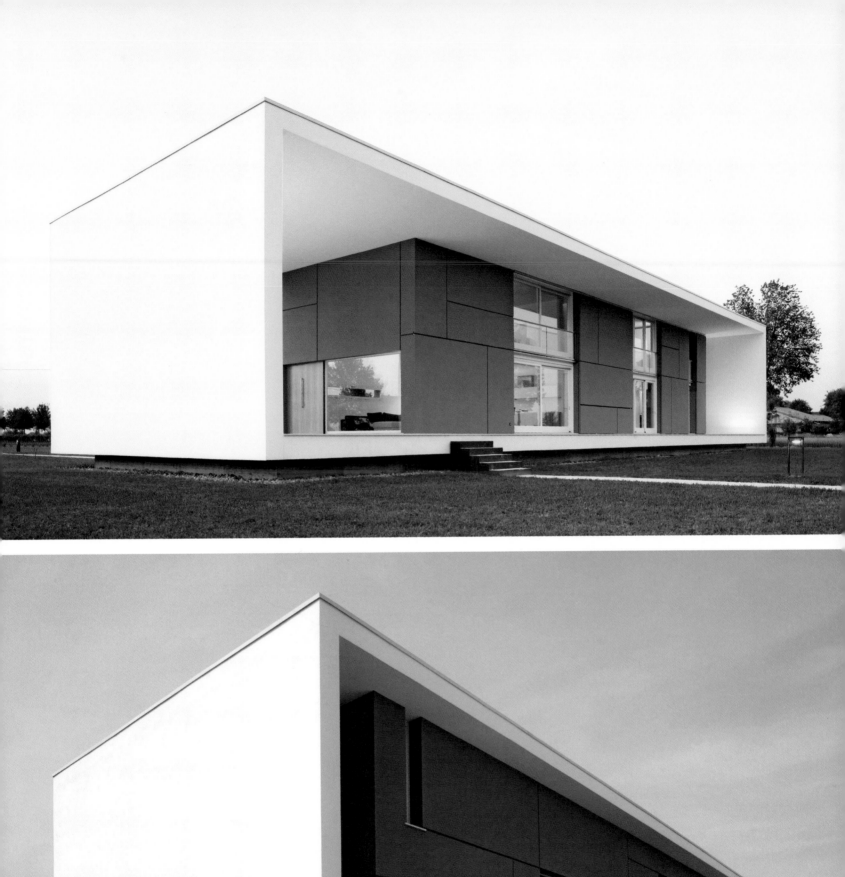

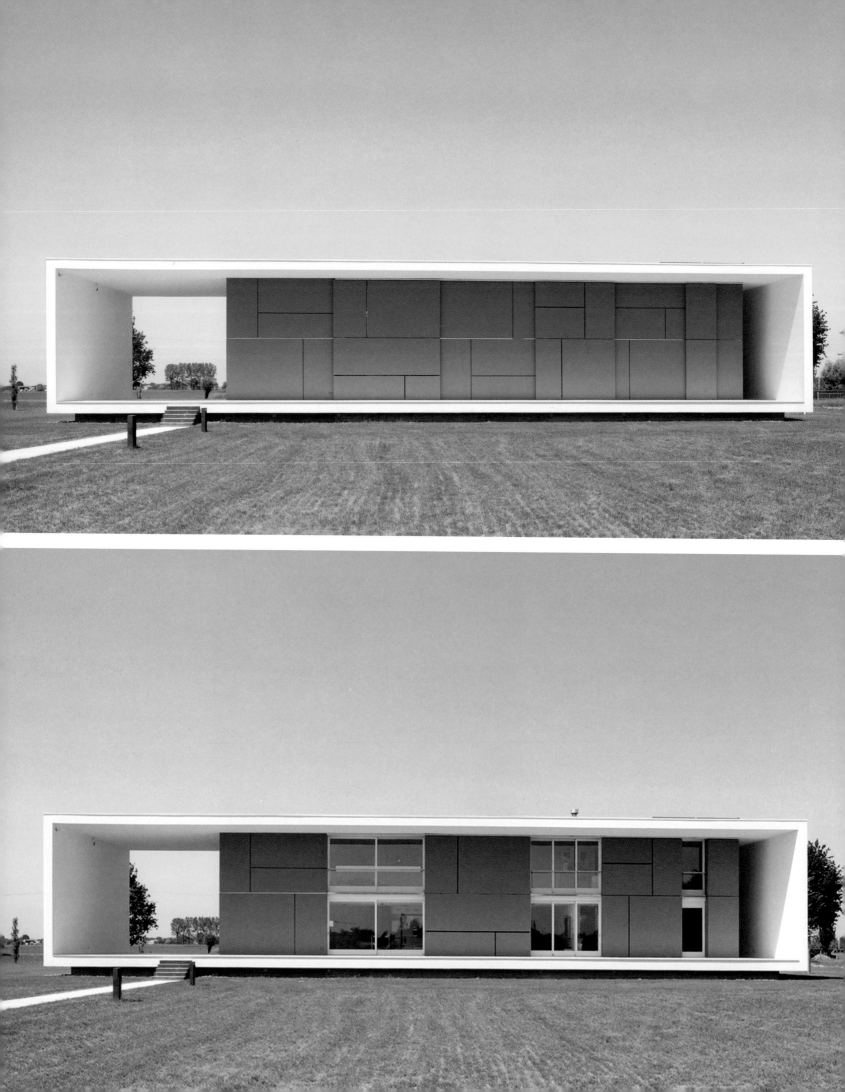

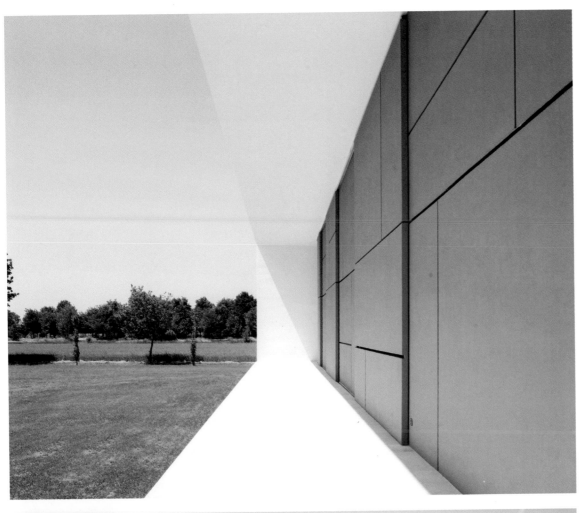

■ The home's foundation is aboveground in order to protect it from water runoff—like a throwback to the historical settlements of Terramare.

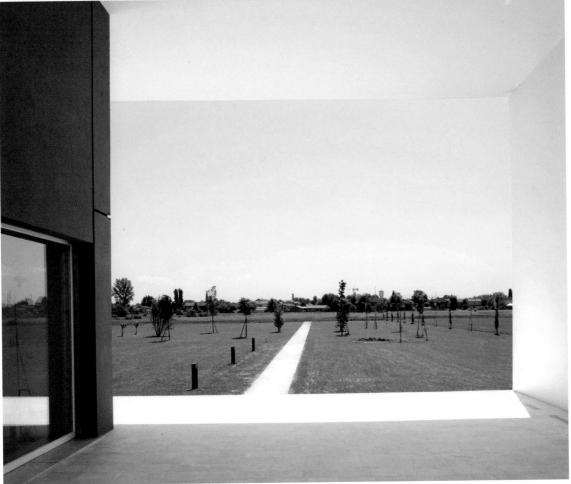

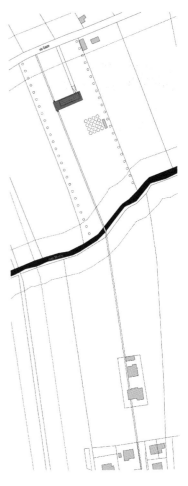

Site plan

South elevation

East elevation

North elevation

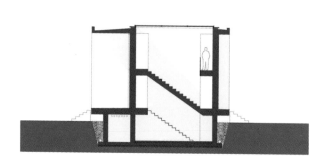

Section A-A

Section B-B

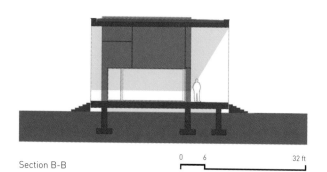

Sketch of axonometric exploded view

0 6 32 ft

1. Green roof
2. Climate reliever
3. Inertial wall
4. Sun screens
5. South large openings
6. Massive wall
7. Ventilated foundation

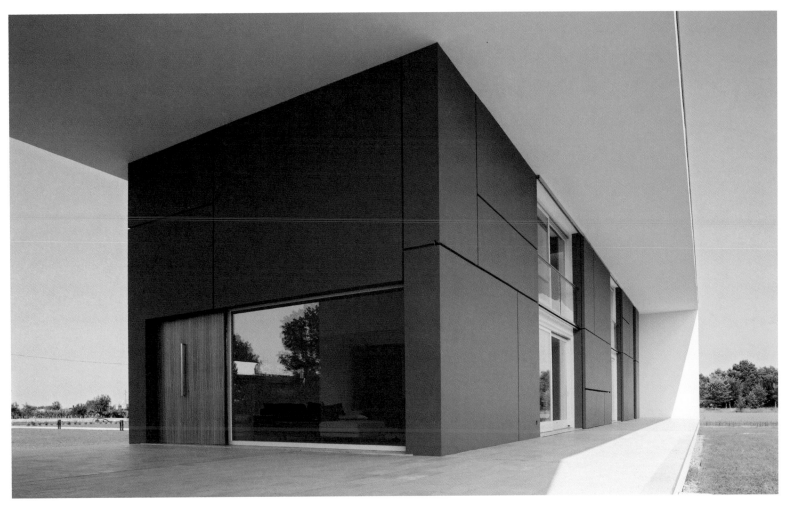

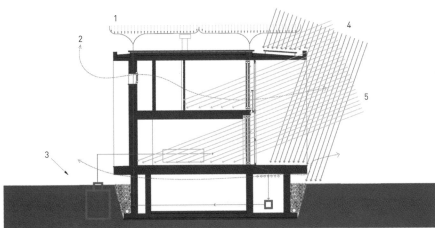

1. Rainwater
2. Natural ventilation
3. Rainwater tank
4. Summer sun 70°
5. Winter sun 20°

Bioclimatic systems diagram

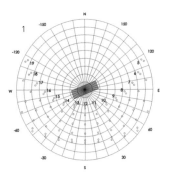

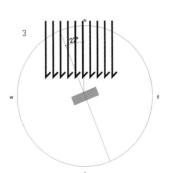

1. Solar chart
2. Orientation
3. Direction of
 prevailing winds

Solar and winds orientation diagram

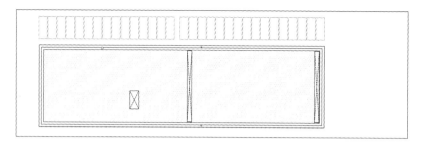

Roof

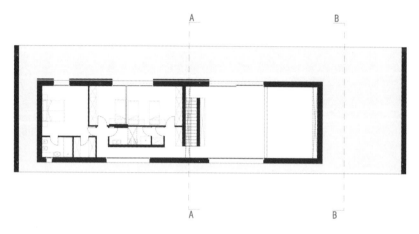

First floor

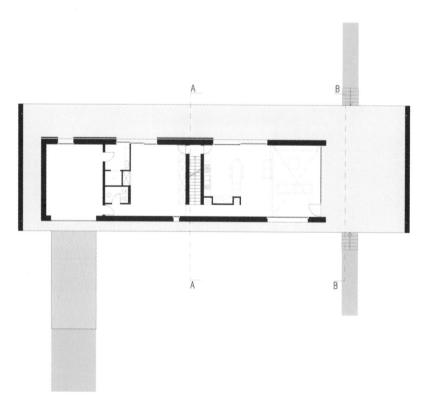

Ground floor

Basement floor

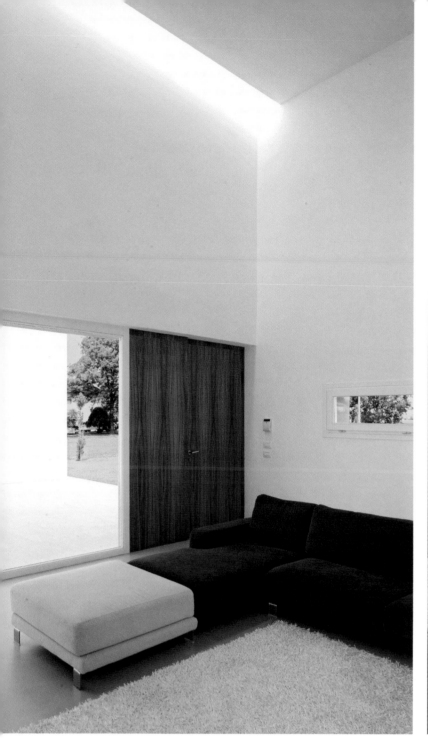

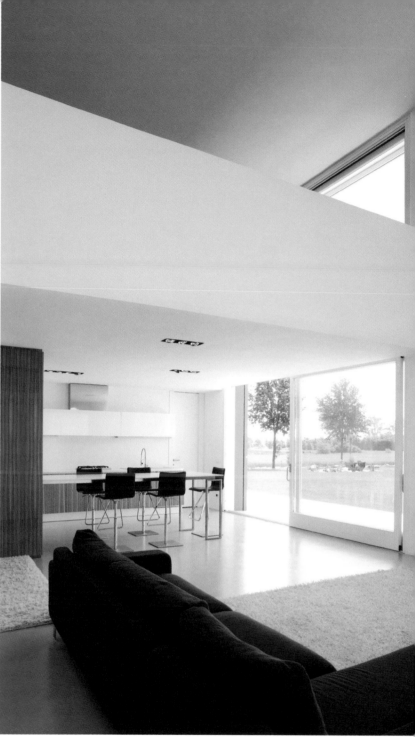

The large laminated wood doors and windows have an argon gas chamber, and the interior is protected in summer by the deep entryway and insulated sliding walls.

BALANCING BARN

MVRDV

Location **Thorington, England**
Surface area **2,260 square feet**
Photographs © Edmund Sumner © Chris Wright

Landscape integration

Geothermal energy

High insulation

Located in a beautiful setting, near a small lake, this house blends in to the natural environment through its architecture and its engineering. Its design, in the form of a traditional barn with reflective metal sheeting, references the local construction style. Contemporary architecture permeates all areas and spaces, even the most traditional.

Despite appearing to be a small house for two people, when visitors approach they appreciate the full length of the house and its overhang. At more than one hundred feet long and with an overhang of fifty feet the house is submerged completely in nature thanks to its lineal structure. Visitors are treated to nature from the ground floor to the final room in the overhang, which is the height of the trees and boasts windows on three sides as well as in the floor and ceiling. Moreover, the metallic cladding will never cease to reflect the continuous passage of the seasons.

The beautiful balance achieved by the attractive overhang is possible because of the rigidity of the building: the structure has a central concrete core, where the section that sits on the floor has been built with heavier materials making up the cantilevered section.

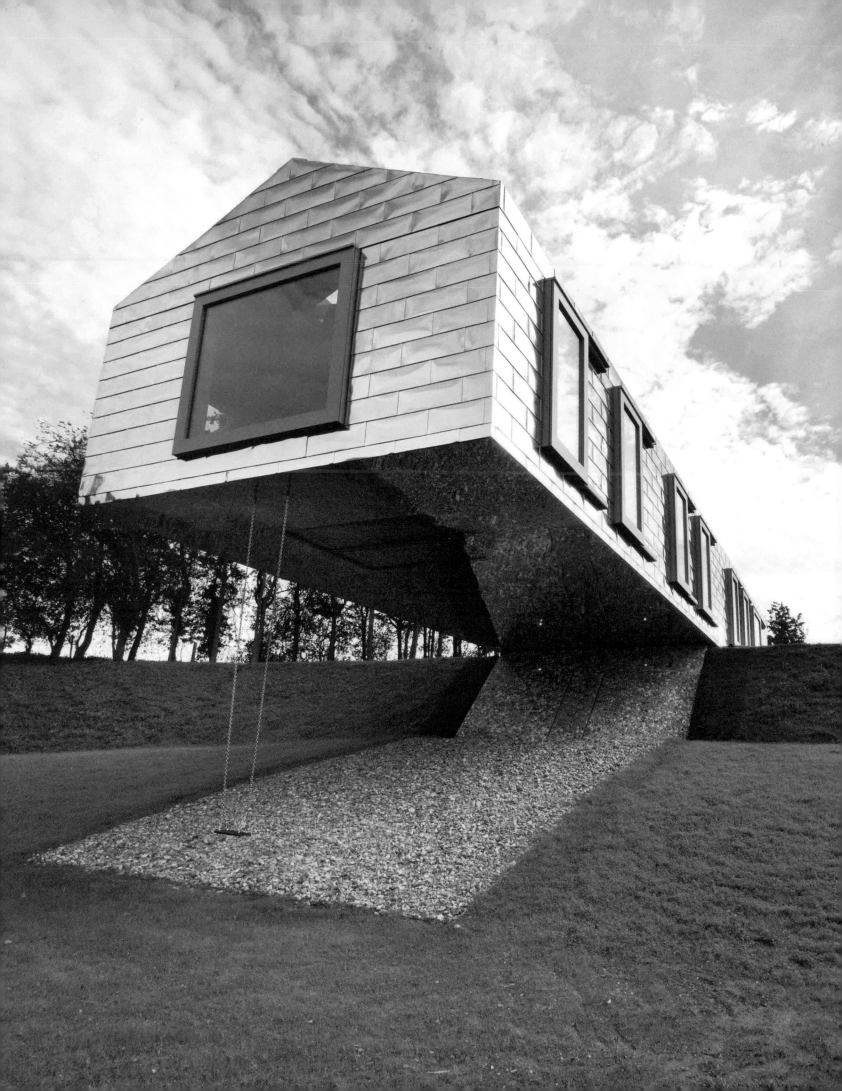

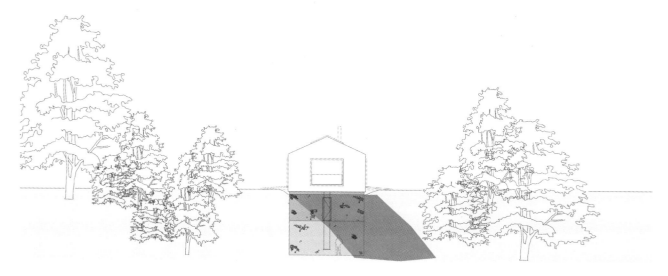

South elevation

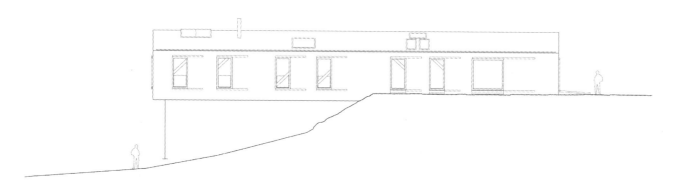

East elevation

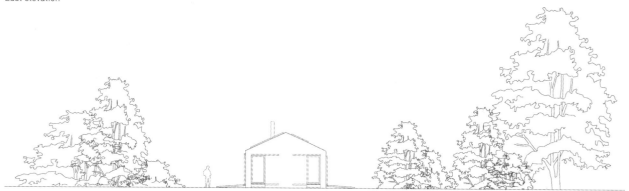

North elevation

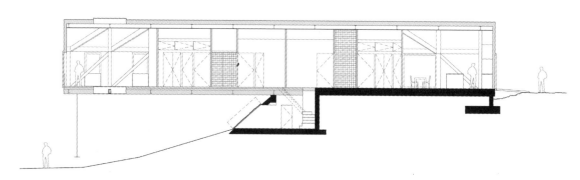

Longitudinal section

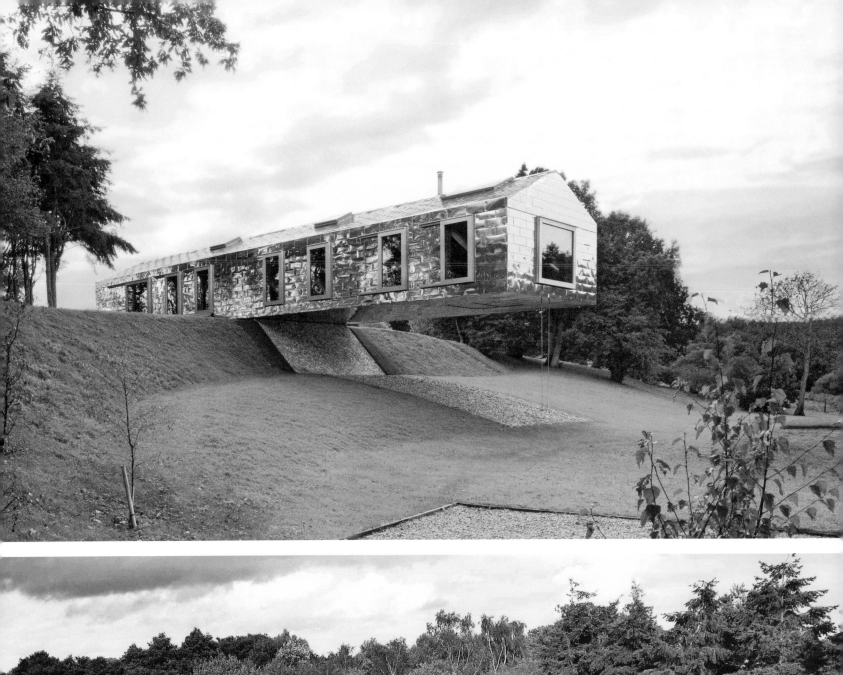

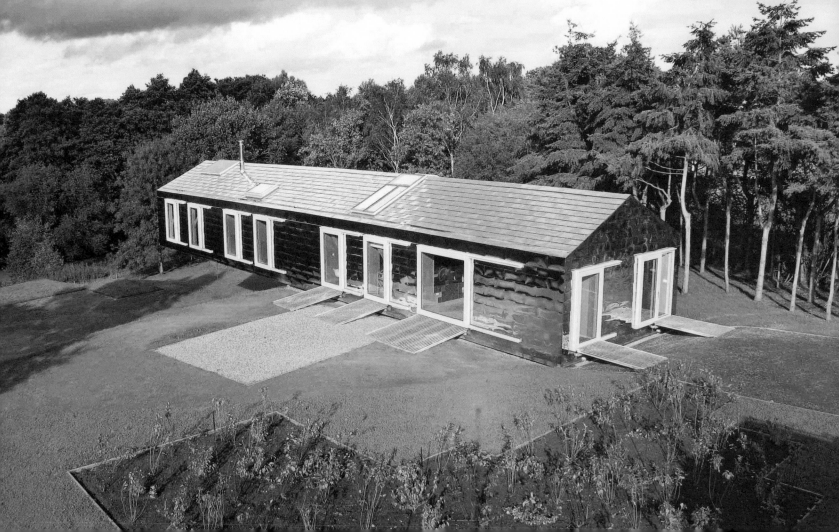

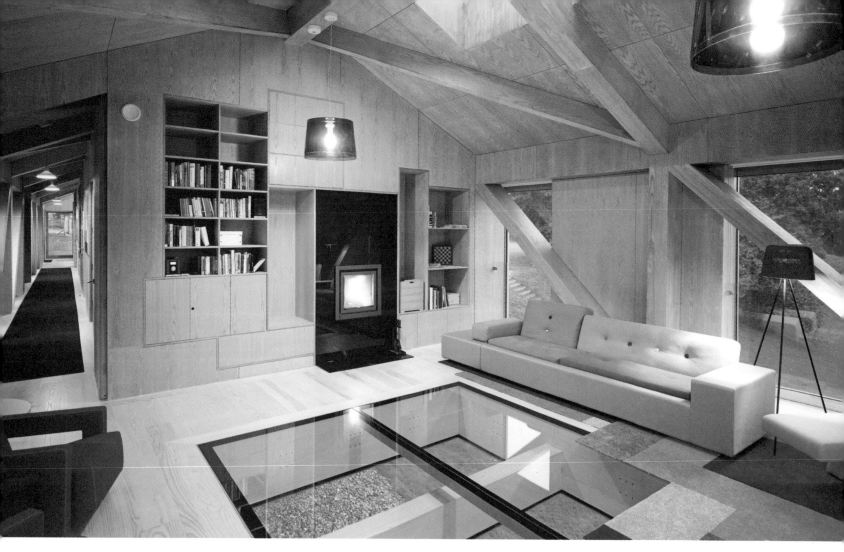

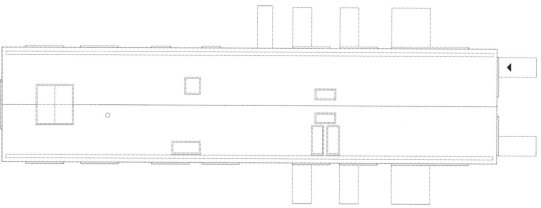

Roof

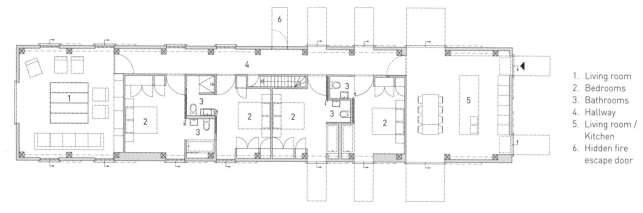

Ground floor

1. Living room
2. Bedrooms
3. Bathrooms
4. Hallway
5. Living room /
 Kitchen
6. Hidden fire
 escape door

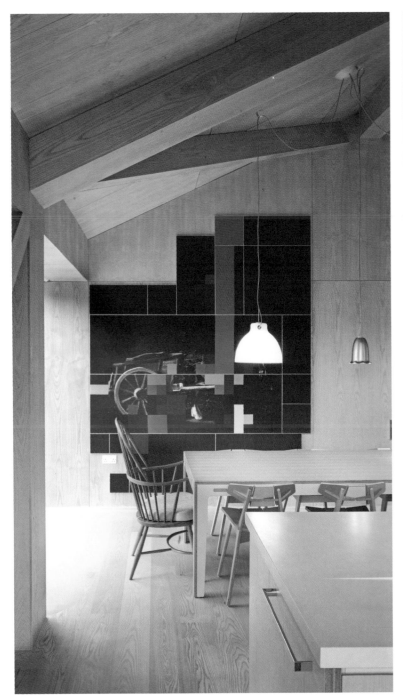

The sequence of four double bedrooms, each one with a shower and separate toilet room, is interrupted in the center of the home with a hidden staircase that accesses the lower garden.

A HOUSE FOR THE BEST YEARS

Matej Gašperič

Location **Velesovo, Slovenia**
Surface area **1,668 square feet**
Photographs © **Virginia Vrecl**

 Visual integration

 Wooden construction

 Rainwater collection and use

 Natural daylight

 Low energy consumption

 Domotics: KNX home control

This property was designed as the perfect home for an older couple with their own list of expectations and personal preferences. With their children now grown up, the parents are returning to life as a couple, and while the children will still return to the house, they will do so only for visits. The house also needed to be sustainable in the widest sense of the word, with low energy consumption.

The powerful combination of romantic pastures and contemporary architectural approaches is in tune with the rural environment and fits with the owners' passion for living life in the present. The wrought-iron peacock on the roof that dutifully marks the direction of the wind, together with other details, reinterprets knowledge and forgotten forms that are carefully adopted into modern materials, construction methods, and, of course, the new way of life.

The long, thin house, humbly follows the natural slope without being higher at any point. It maintains its proportionality as a fixed-height shape, giving it a unique look. Furthermore, the local architectural heritage, rich in both quality and quantity, was respected on all levels throughout the entire design process.

As the last building of the village, the house acts as a type of transition between the urbanized area and the surrounding meadows and countryside.

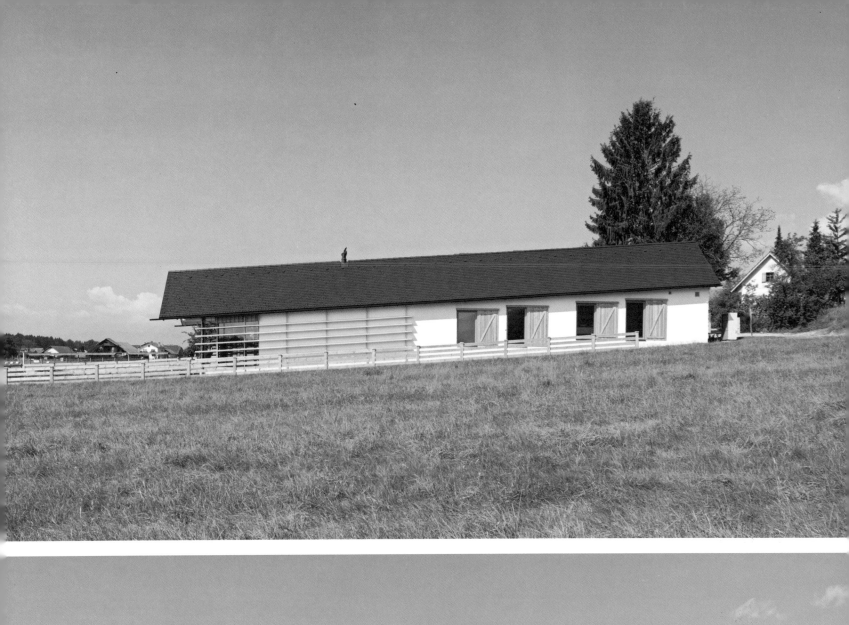

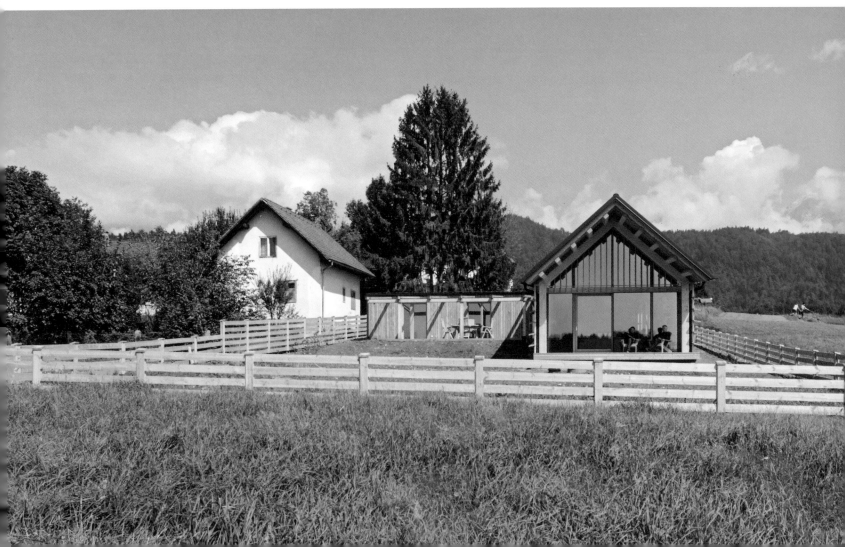

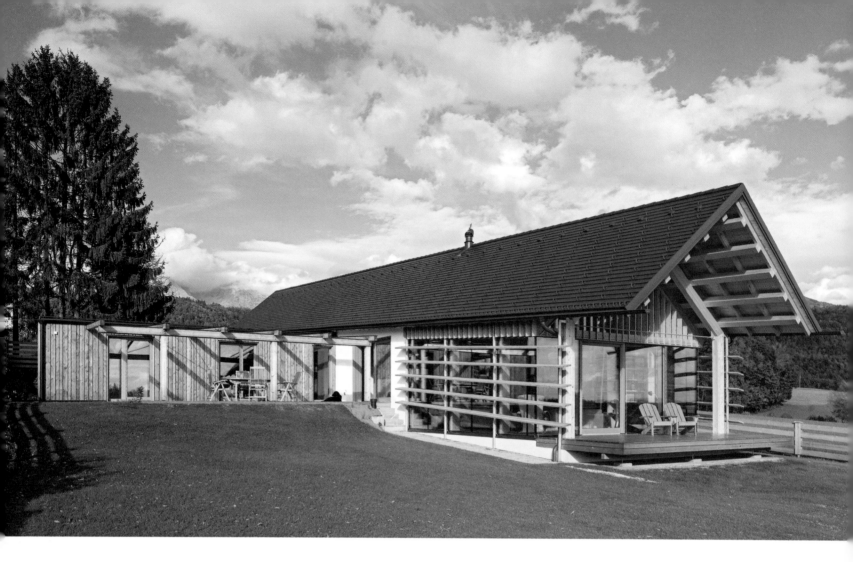

■ The porch entryway offers an unobstructed view. The open layout traps and conserves incoming sunlight from the south and directs it inside through the structure of adjacent spaces.

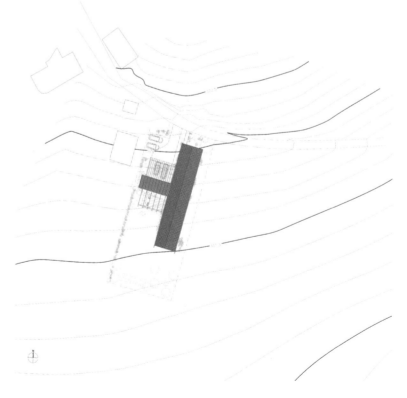

Site plan

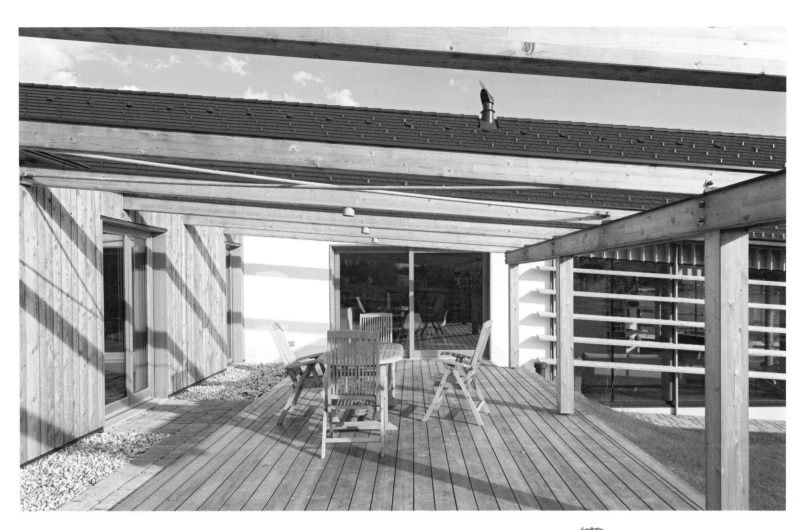

East elevation

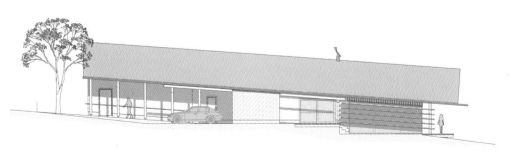

West elevation

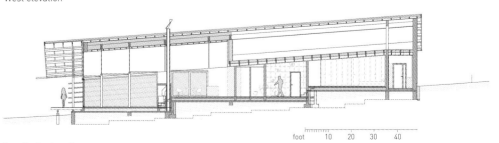

foot 10 20 30 40

Longitudinal section

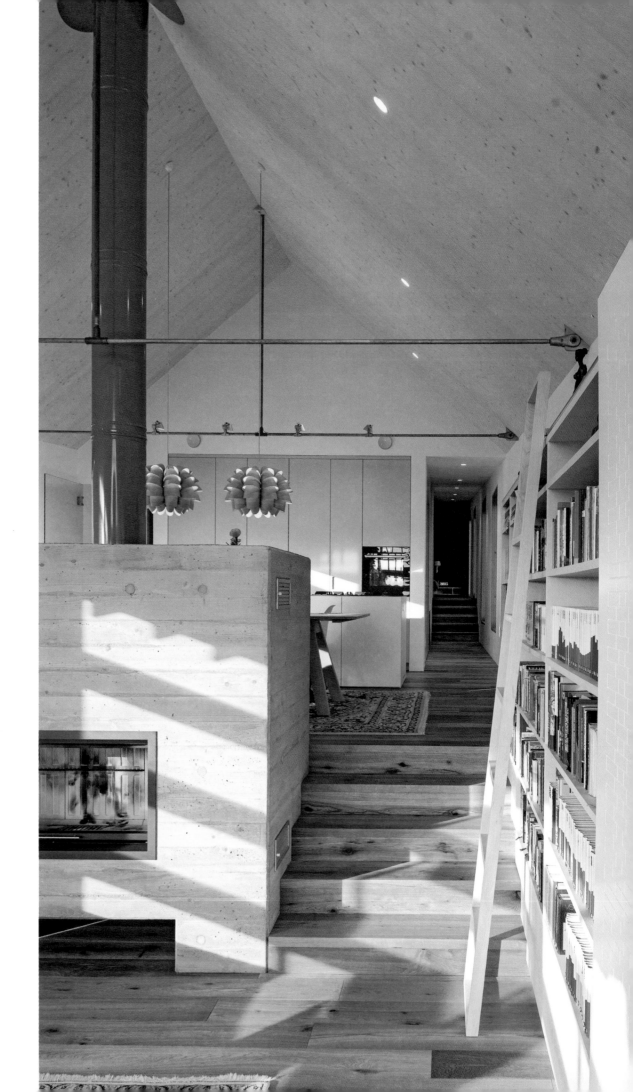

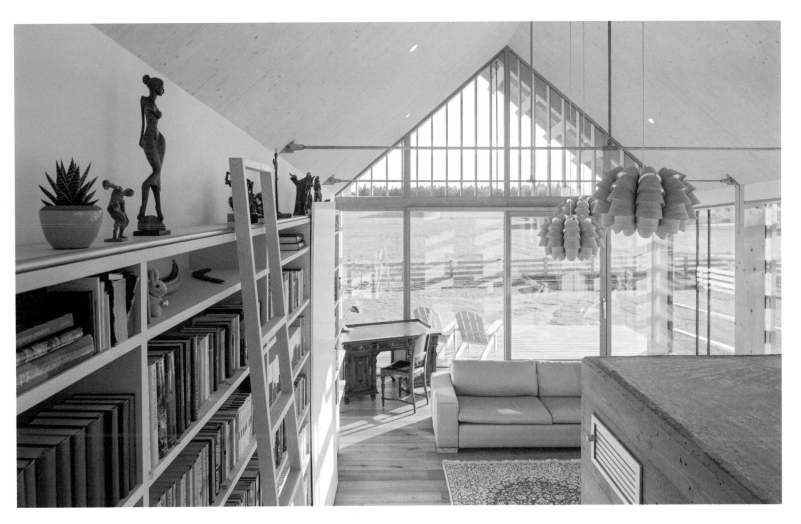

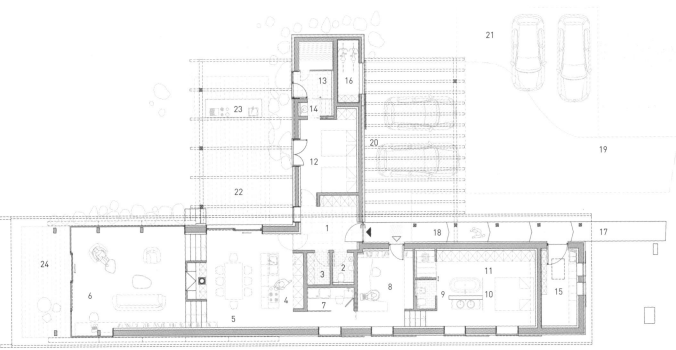

Floor plan

1. Entrance
2. Toilet
3. Storage room
4. Kitchen
5. Dining room
6. Living room
7. Utility room
8. Studio
9. Bathroom
10. Master bedroom
11. Wardrobe
12. Guest room
13. Sauna
14. Shower
15. Heating and ventilation
16. Bike storage
17. Walkway
18. Corridor
19. Driveway
20. Parking
21. Guest parking
22. Summer terrace
23. Outdoor kitchen
24. Morning terrace

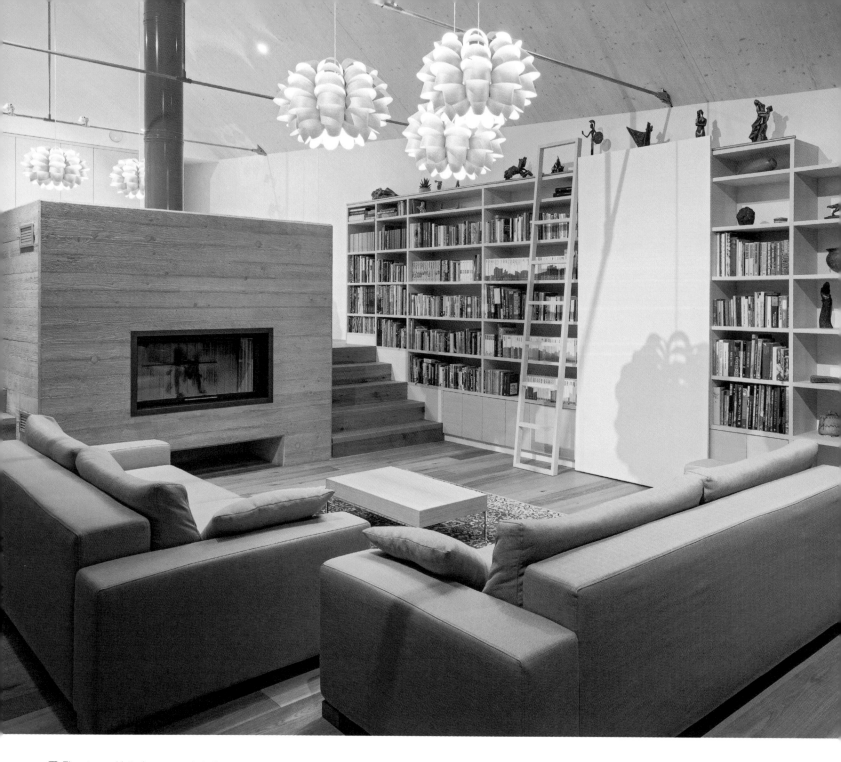

■ The stepped interior responds to the steep incline of the terrain on which the house sits. The multilevel floor plan helps separate the different functions, while maintaining an open feel.

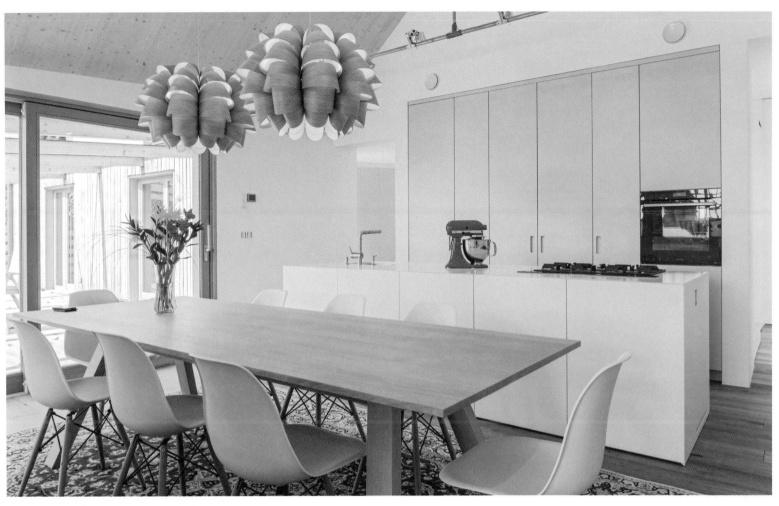

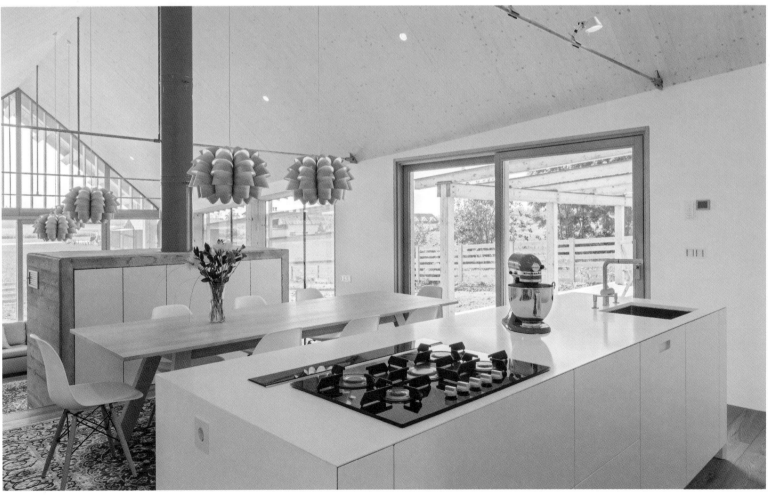

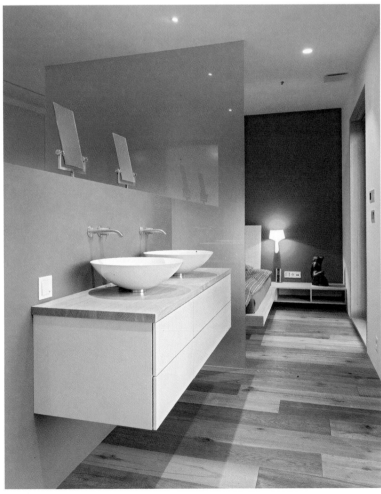

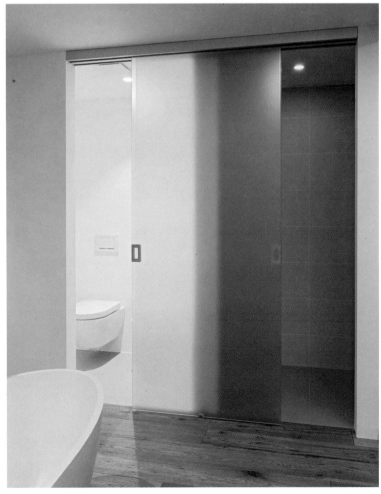

COBOGÓ HOUSE

Studio mk27 - Marcio Kogan + Carolina Castroviejo

Location **São Paolo, Brazil**
Surface area **10,764 square feet**
Photographs **© Nelson Kon**

 Low water consumption
Pool maintenance without
chemical products

 Photovoltaic solar energy

 Recycled and ecological materials

 Natural daylight

The abundant tropical sunlight strikes the white of the upper floor of the house, entering through holes in the recesses and covering the entire floor of the interior space. Thus, the confluence of shadows and sunlight creates the illusion of a delicate visual lace. The effect is further enhanced throughout, allowing light to create its own shapes. During the course of the day, as the months elapse, the recesses assume different forms with the changing nature of the sunlight; not even at night does this effect cease to be transformed: in a continuous process of metamorphosis, light alone is able to transform the very shape of the house.

The soft volumetric geometry of the recesses is a complex construction, with endless curves. The modular element is a work of art designed by Erwin Hauer, who has been creating sculptures for architectural spaces since 1950. His minimalist elements, in dialogue with architecture, are a nod to the Brazilian architecture of Oscar Niemeyer. In addition, the concrete shapes are adapted from the *cobogós* that give the house its name. Created in Recife, Brazil, these are a delicate reference to colonial architecture.

Finally, the use of environmentally friendly architecture and a respect for the local climate give this home a very comfortable interior.

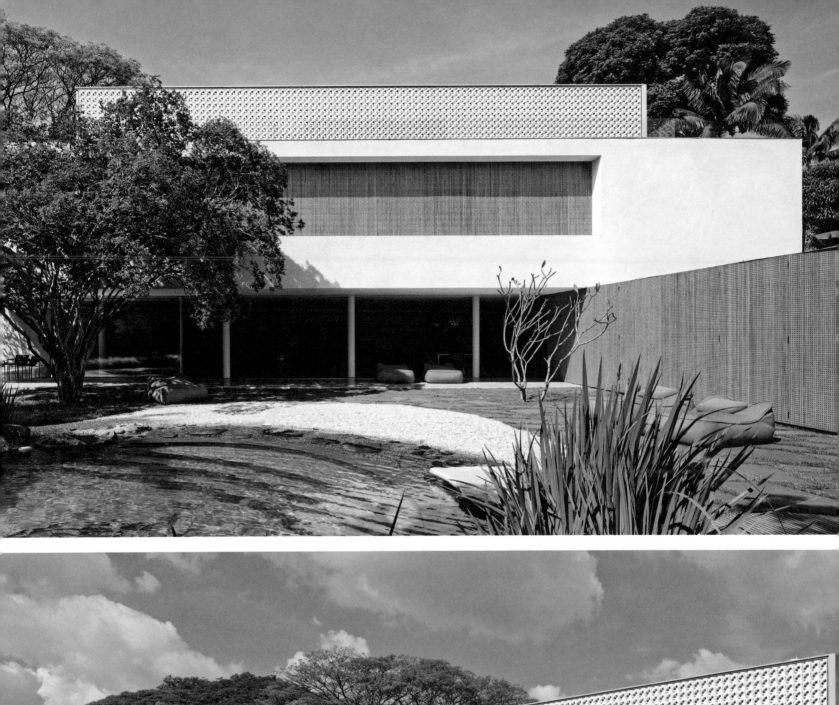
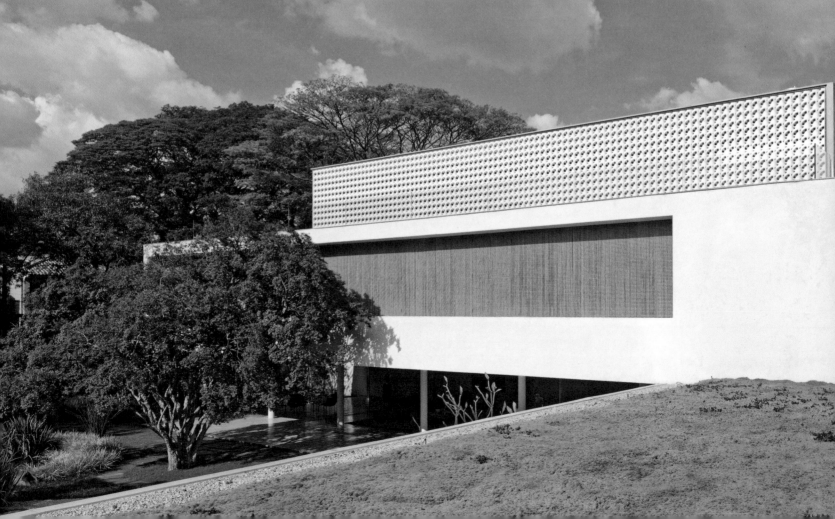

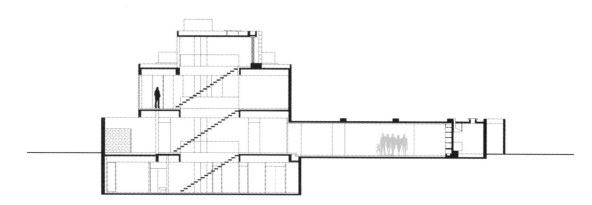

Site plan

House volumes diagram

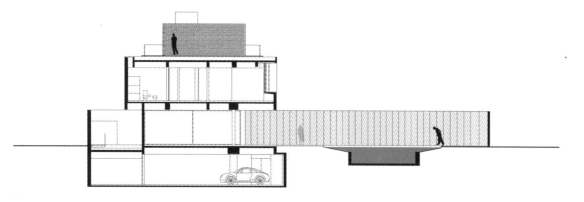

Section 1

Section 2

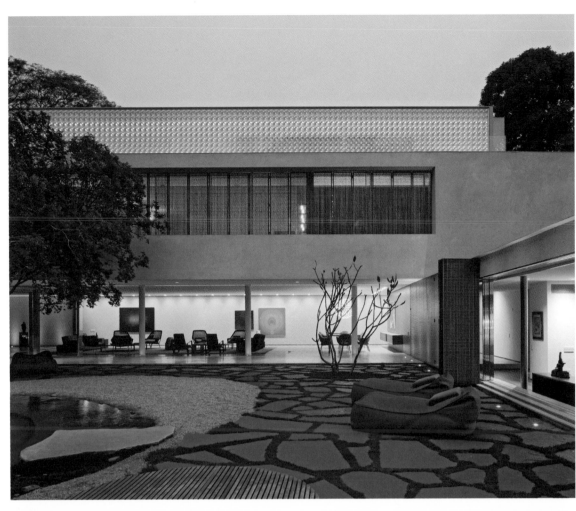

The use of *mashrabiya* latticework provides soothing ventilation and shadows. The panels can be completely opened from floor to ceiling, thereby diluting the transition between the interior and exterior.

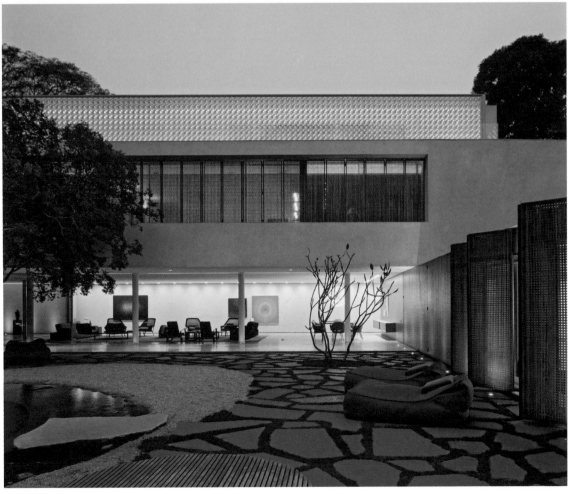

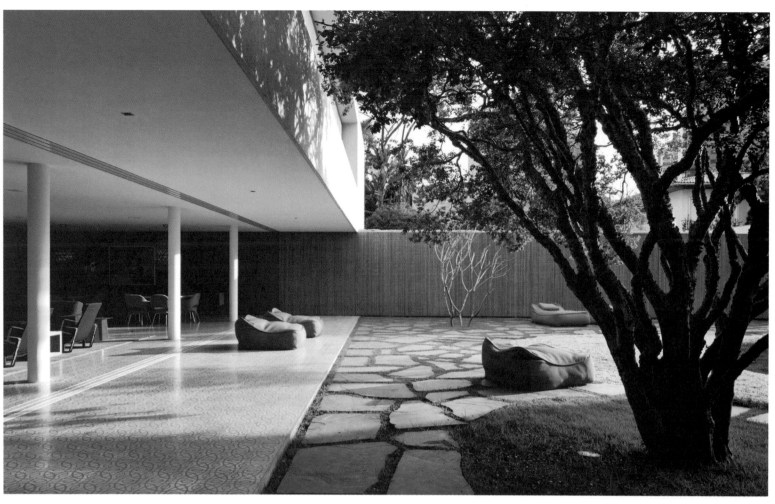

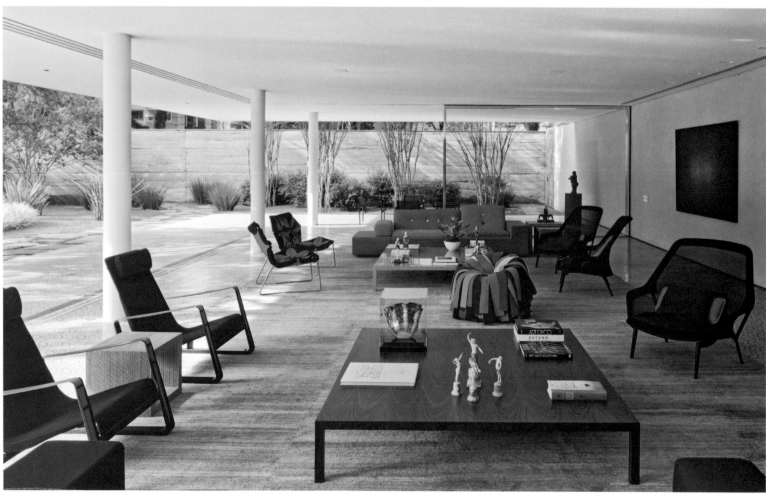

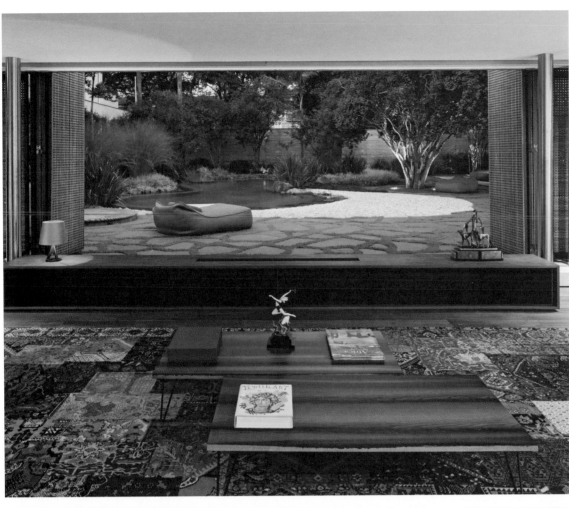

The living room connects to the garden and a small artificial pond. Fish and plants maintain the biological balance without needing to use environmentally hazardous chemical products.

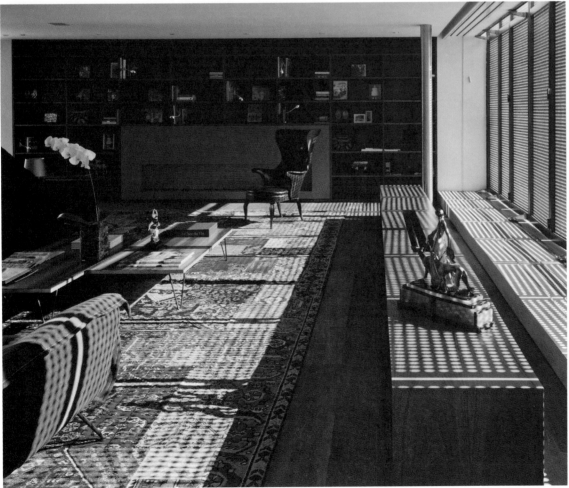

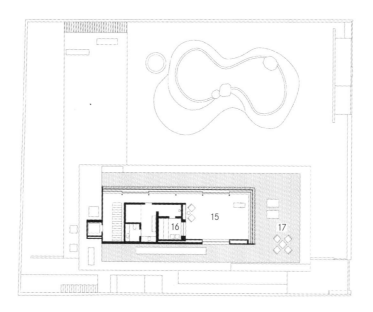

Second floor

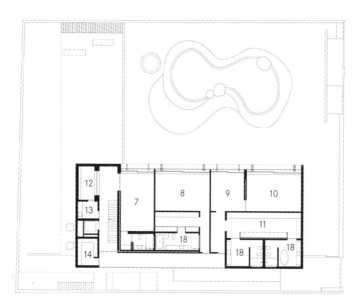

First floor

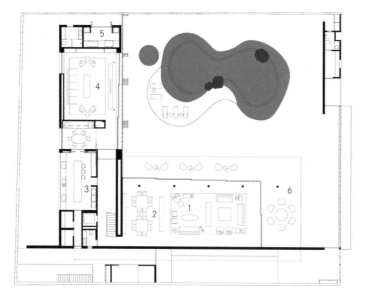

1. Living room
2. Dining room
3. Kitchen
4. TV room
5. Barbecue area
6. Terrace
7. Guest room
8. Bedroom
9. Study / TV room
10. Master bedroom
11. Closet
12. Wine cellar
13. Pantry
14. Wardrobe
15. Gym
16. Sauna
17. Deck
18. Bathroom

Ground floor

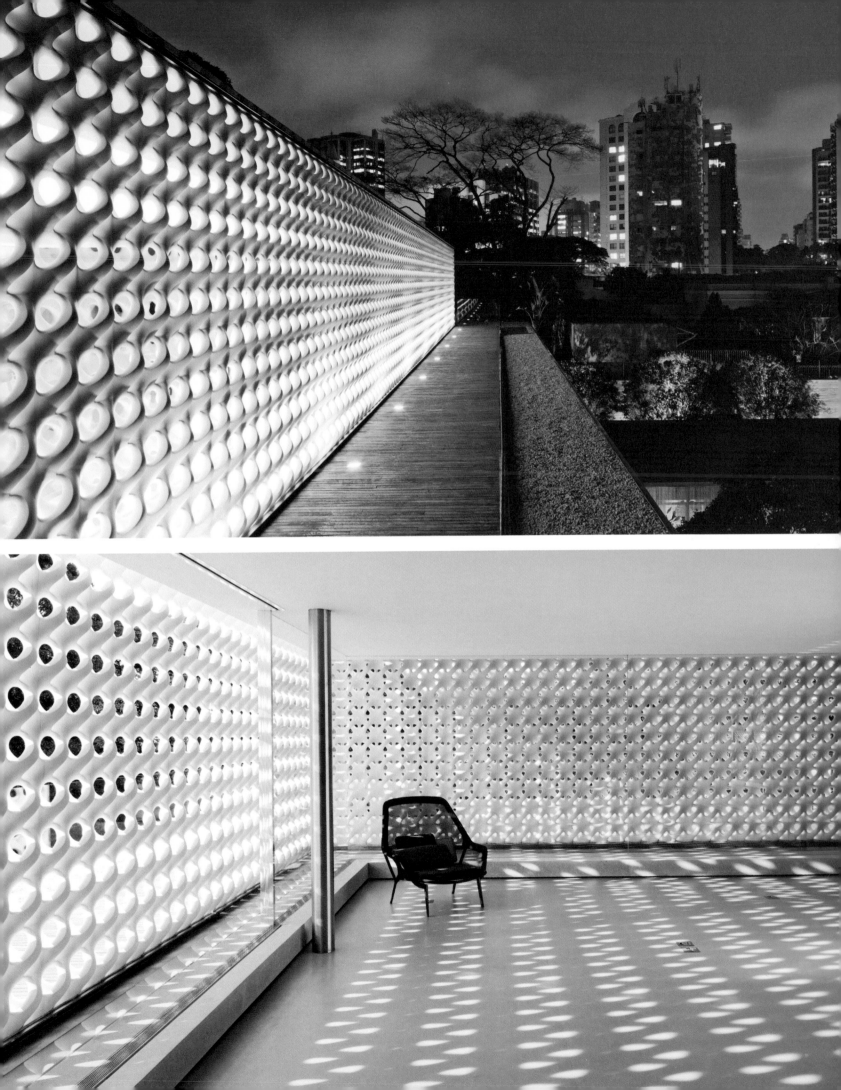

SOFT HOUSE

Kennedy & Violich Architecture, Ltd.

Location **Hamburg, Germany**
Surface area **9,902 square feet**
Photographs **© Kennedy & Violich Architecture © Michael Moser**

 Landscape integration
Good transportation and walkability

 Photovoltaic solar energy:
orientable panels
CO_2 low consumption

 Local material: wood
Recyclable materials
Sustainable wood

 Natural daylighting
Natural ventilation

 Domotics: Soft House smart building
management system (BMS)
Smart curtains

Completed in June 2013, this is a set of four housing units designed for life and work. The project's construction gains its character from a traditional structure made of solid local wood, which can be fully recycled at the end of the building's life span. The architectural shell is simple, solid, and durable. The organization of the design shows how a domestic infrastructure can become a "soft" attractive, ecological, solid-wood construction.

The clean domestic energy, lighting, and elements that liberate the internal spaces are transformed into a type of mobile furniture, and are interactive, upgradable, and connected to the home's wireless network, an intelligent building management system. Thus designed for a flexible life, the wireless controls of the building articulate an infrastructure of sensitive textiles that establishes a new public identity for architecture.

This Kennedy & Violich Architecture project meets and exceeds the stringent German Passivhaus Institut environmental standards: it transforms the rigid typology that these environmental requirements impose, to create a free house with zero carbon footprint, which is adaptable and can be personalized to meet the changing needs of the owners and of the house itself.

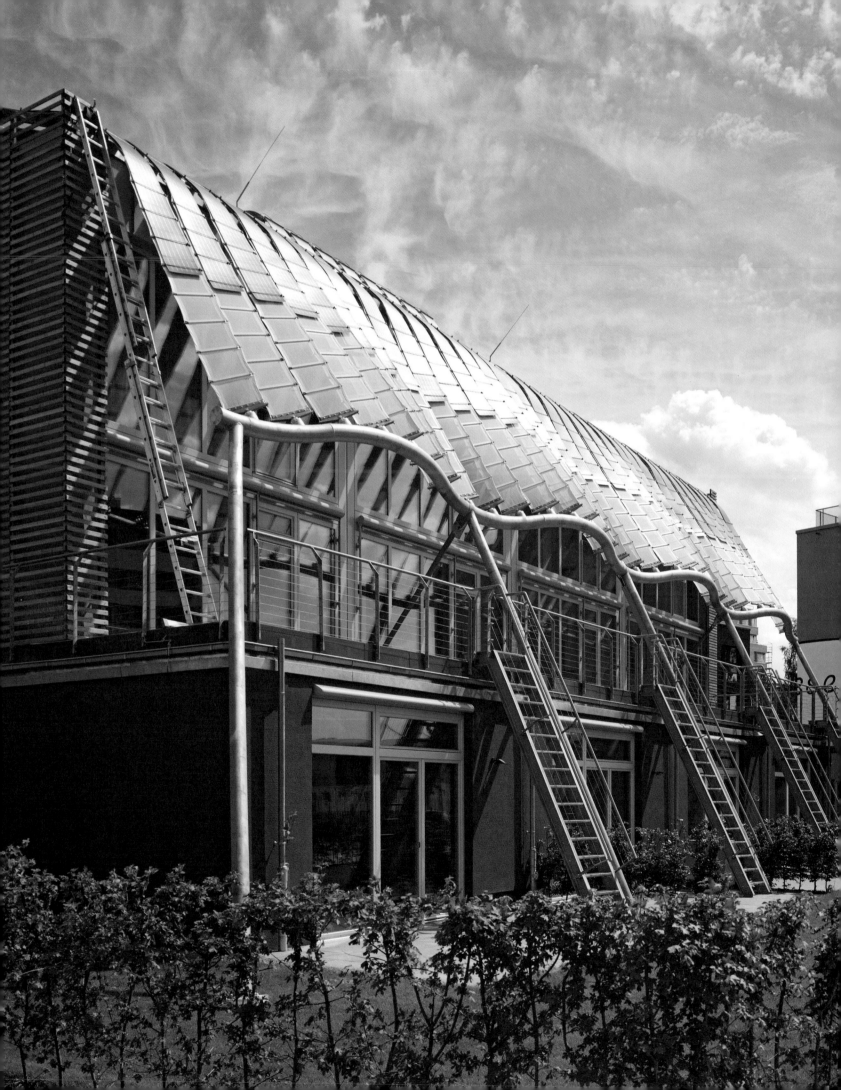

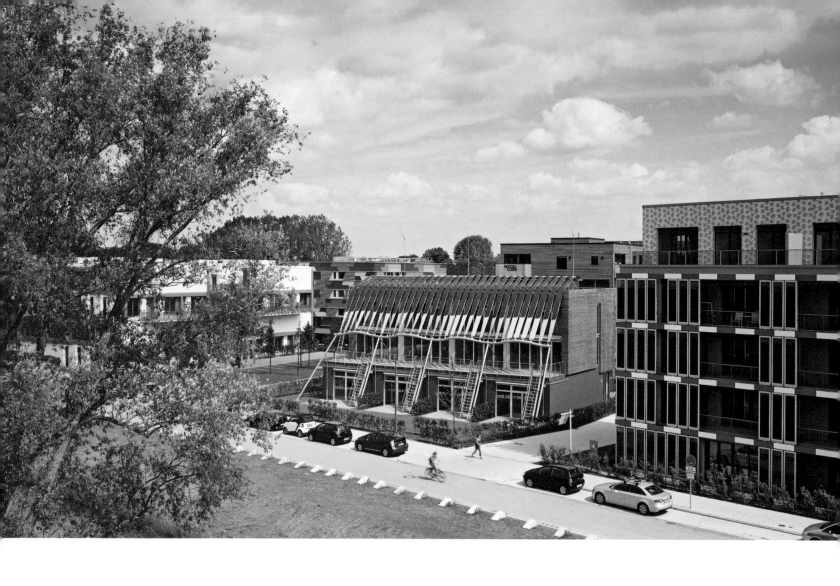

Site plans

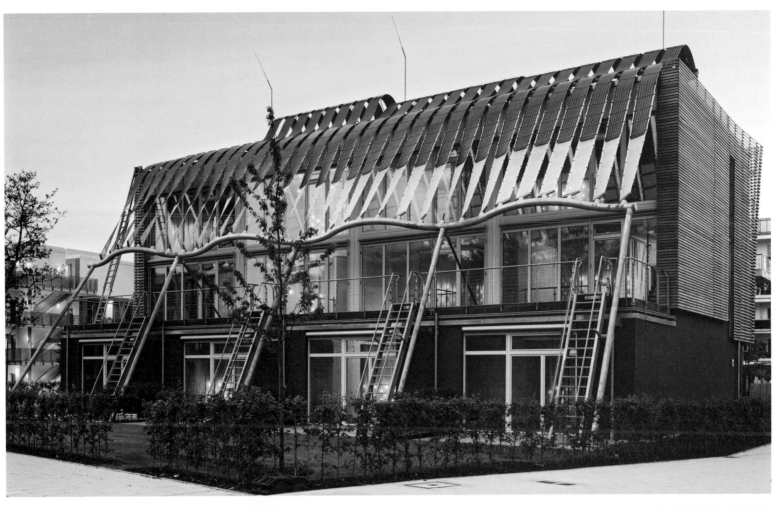

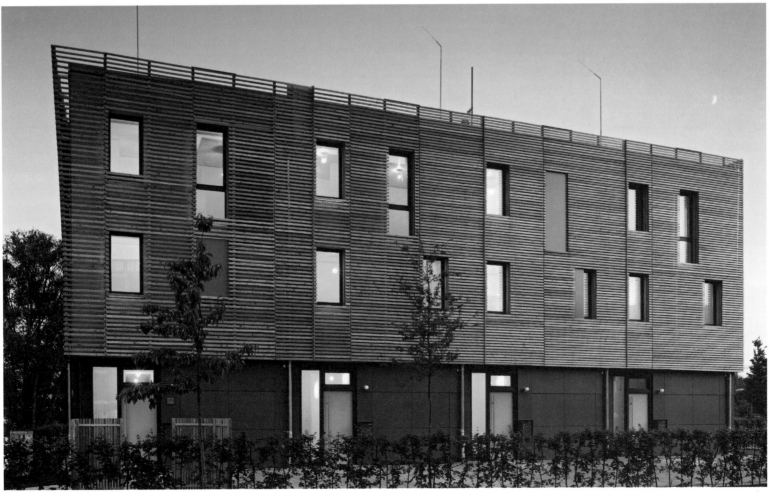

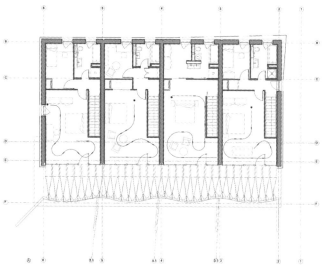

Upper floor

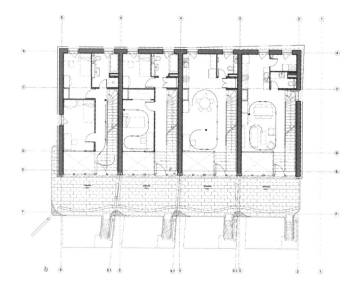

Middle floor

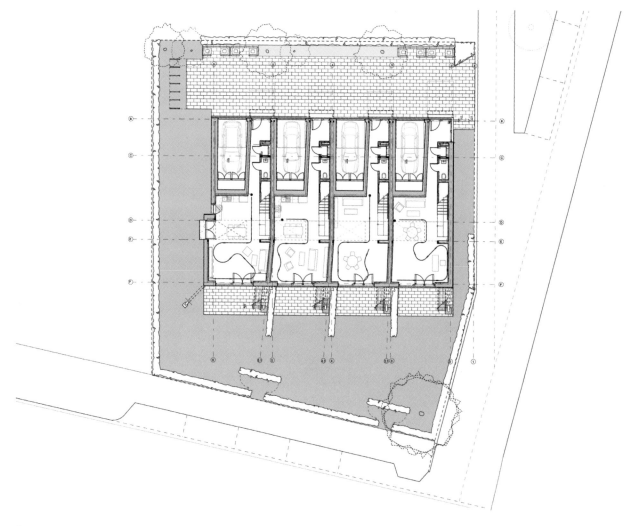

Ground floor

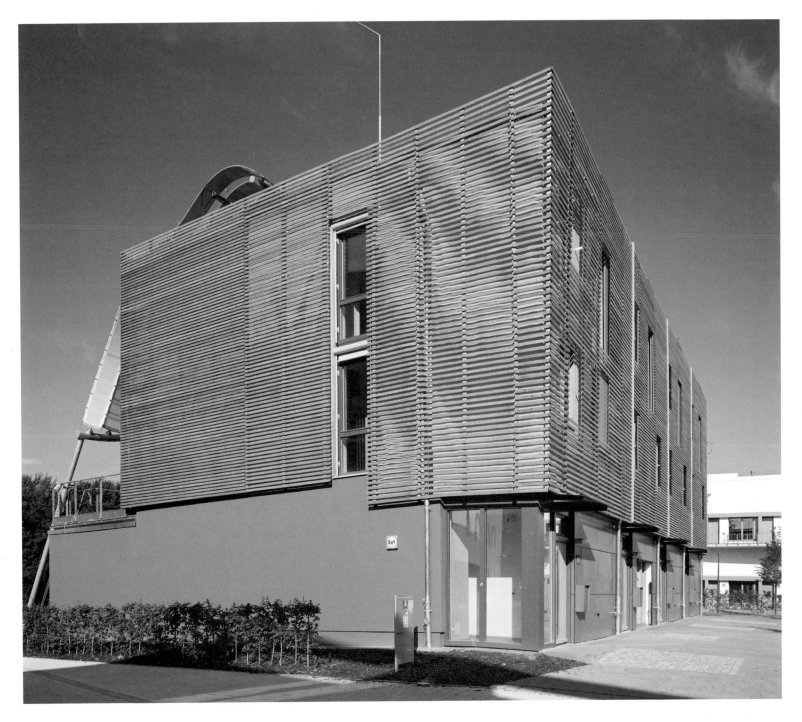

The solid wood floors and walls give the architectural structure permanence yet are totally recyclable upon the completion of the building's useful life.

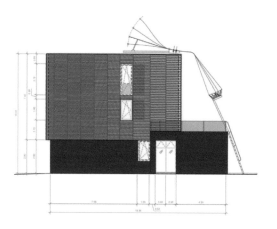

West elevation

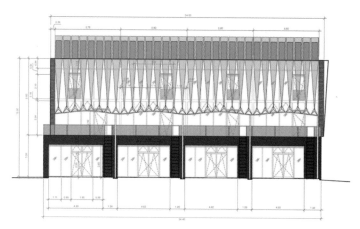

South elevation

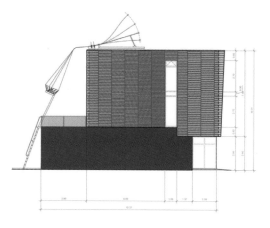

East elevation

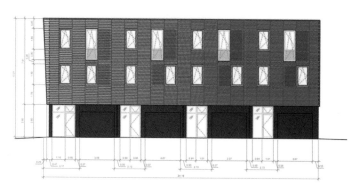

North elevation

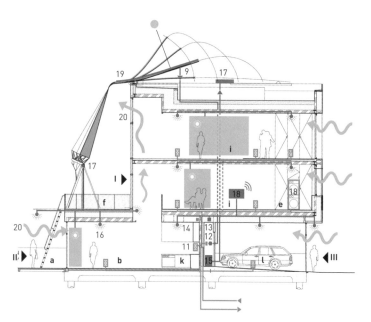

Sections

I. Terrace entry
II. Garden entry
III. Primary entry

a. Terrace and private garden
b. Living room
c. Winter garden
d. Mechanical room
e. Bathroom / Laundry

f. Upper terrace / Garden
g. Bridge
h. Stairwell with wire mesh
i. Bedroom
j. Skylight with reflectus
k. Kitchen
l. Garage

1. Geothermal pump
2. Hotwater tank
3. Radiant cooling and heating
4. Mechanical ventilation return
5. Mechanical ventilation supply
6. Views to park and canal

7. Winter position
8. Fall position
9. Summer position
10. Hurricane position
11. Electrical distribution panel (AC)
12. AC-DC converter
13. DC mechanical device
14. AC mechanical device
15. AC receptable

16. DC 30v. lighting
17. DC motors
18. DC system controller and wireless dimmer
19. Photovoltaic cell
20. Stacking effect for natural ventilation
21. Views to sky and dynamic membrane

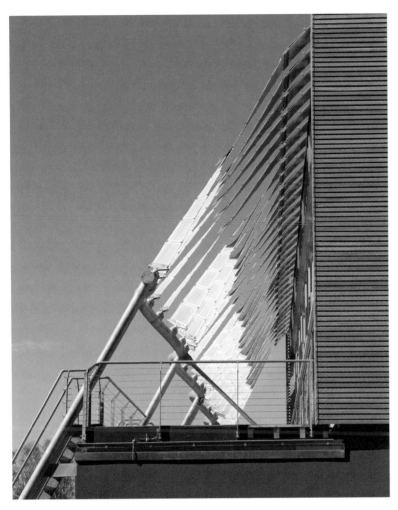

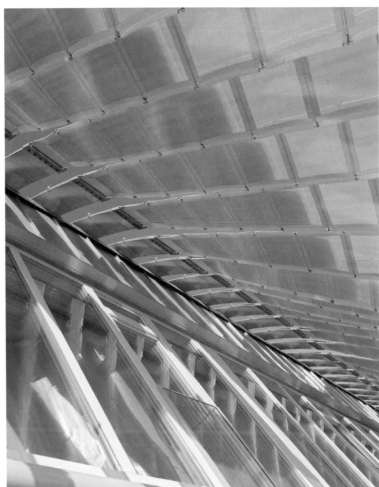

■ Like a sunflower, the facade moves to capture the maximum amount of solar energy. The flexible and innovative photovoltaic structure surrounding one side of the building adapts every day to the sun's movement.

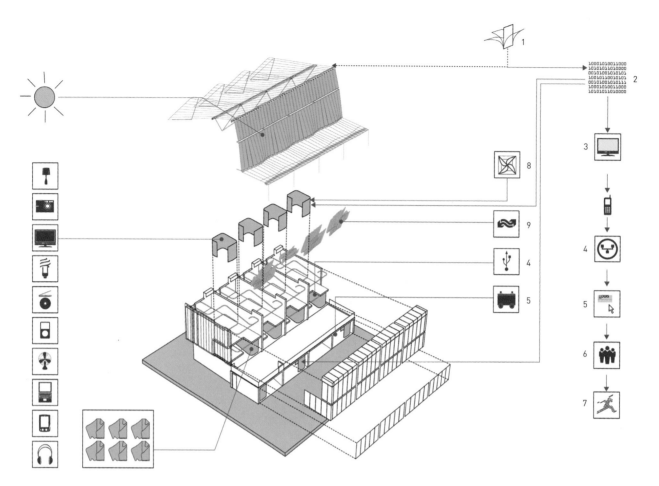

Smart building systems axon

1. Wind sensor
2. Data
3. SOFT HOUSE. Clean Energy System GNU / Linux / Mac OS / Windows / Java
4. Internet
5. Open source
6. Community: user group
7. Visual breeze
8. Fan
9. Soft ducts
10. USB

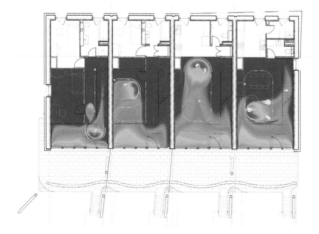

Interior thermal climate diagram

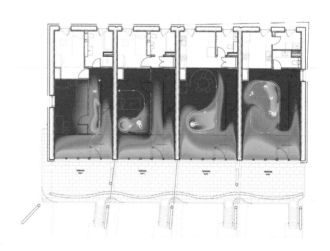

| 68 °F | 66.2 °F | 64.4 °F |

Radiant temperature

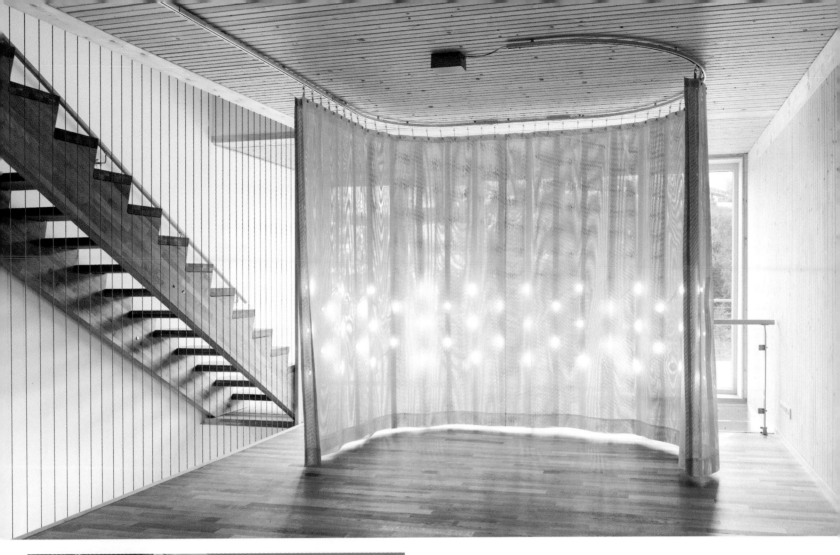

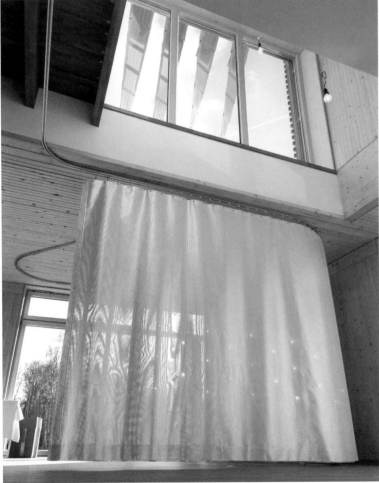

The design expands on the traditional functions of the curtain. By allowing movement, "rooms" are instantly created that can trap sunlight and use it to heat or cool the house.

AREOPAGUS RESIDENCE

Paravant Architects

Location **Atenas, Costa Rica**
Surface area **8,072 square feet**
Photographs © **Julian Trejos** © **Christian Kienapfel**

 Landscape integration

 Recycled materials

 Rainwater collection and use
Gray water recycling
Minimized water waste

 Passive cooling: cross ventilation
and pool as a cooling pond
Natural daylight

 Passive solar
Photovoltaic solar energy

Planned by Paravant Architects as a retirement home for a client, this residence blends harmoniously into the landscape of the mountains of Costa Rica.

This thoughtfully designed project has two distinct facades, which take into consideration both the orientation of the walls and openings and the existing specific conditions of the site. By using passive strategies, no mechanical air-conditioning system is necessary in the house and the total amount of energy required to maintain a comfortable temperature is greatly reduced in comparison to buildings of a similar size and configuration.

The street-facing facade is a large concrete wall that provides the privacy that is needed. The openings frame the views to the nearby mountains and, together with other strategically placed openings, provide natural cross-ventilation through-out the property.

The south-facing facade, with its ample glazed areas and deep eaves, is completely open to the breathtaking views over the valley of San José. The living room boasts a fifty-foot-long sliding glass panel that is totally retractable into the corner, drawing attention to the strong relationship that is established between the inside and the outside of the house.

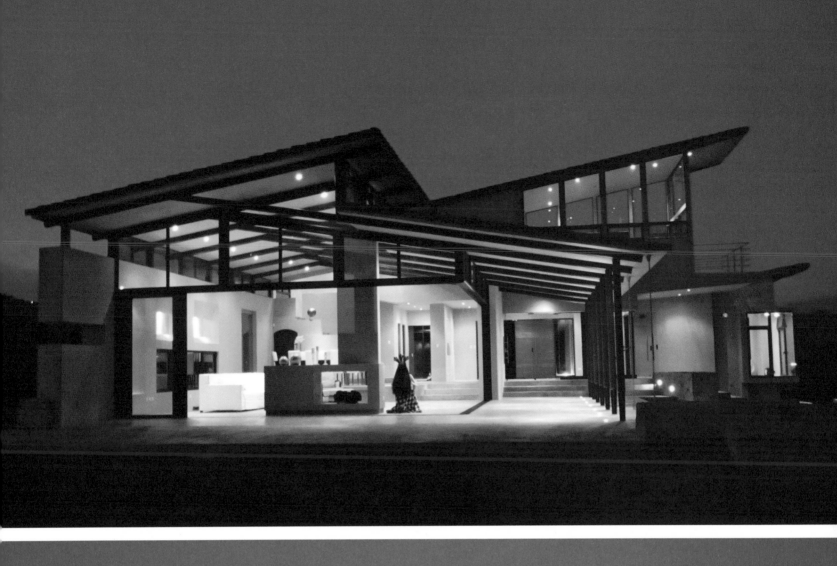

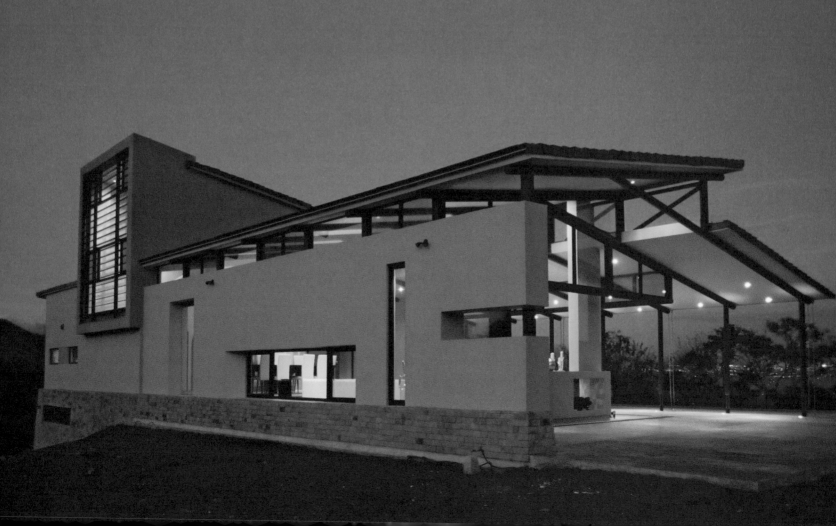

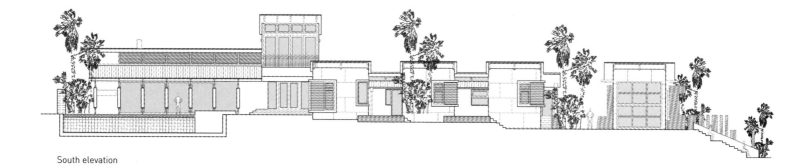

South elevation

East elevation

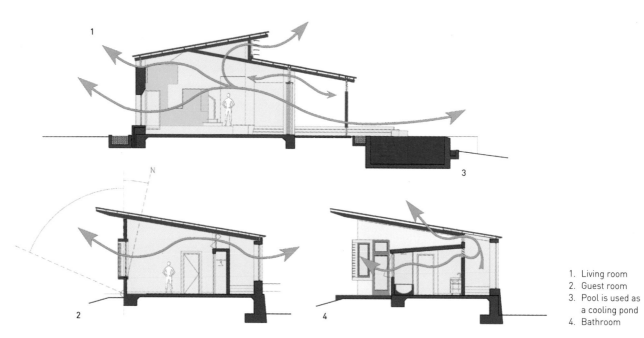

1

3

2

4

Cross-ventilation

1. Living room
2. Guest room
3. Pool is used as
 a cooling pond
4. Bathroom

■ Among other elements that make
the home sustainable, the solar
and photovoltaic systems installed
on the roof provide hot water
and electricity.

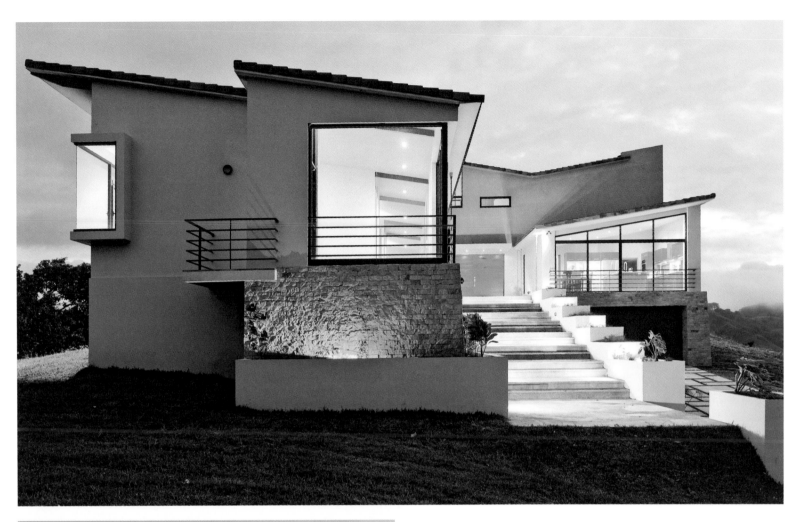

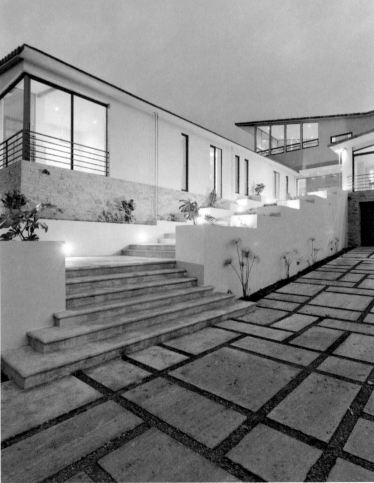

The pool, with its trailing edge, increases the perceived magnitude of space and acts like a cooling pond, by reducing the interior air temperature.

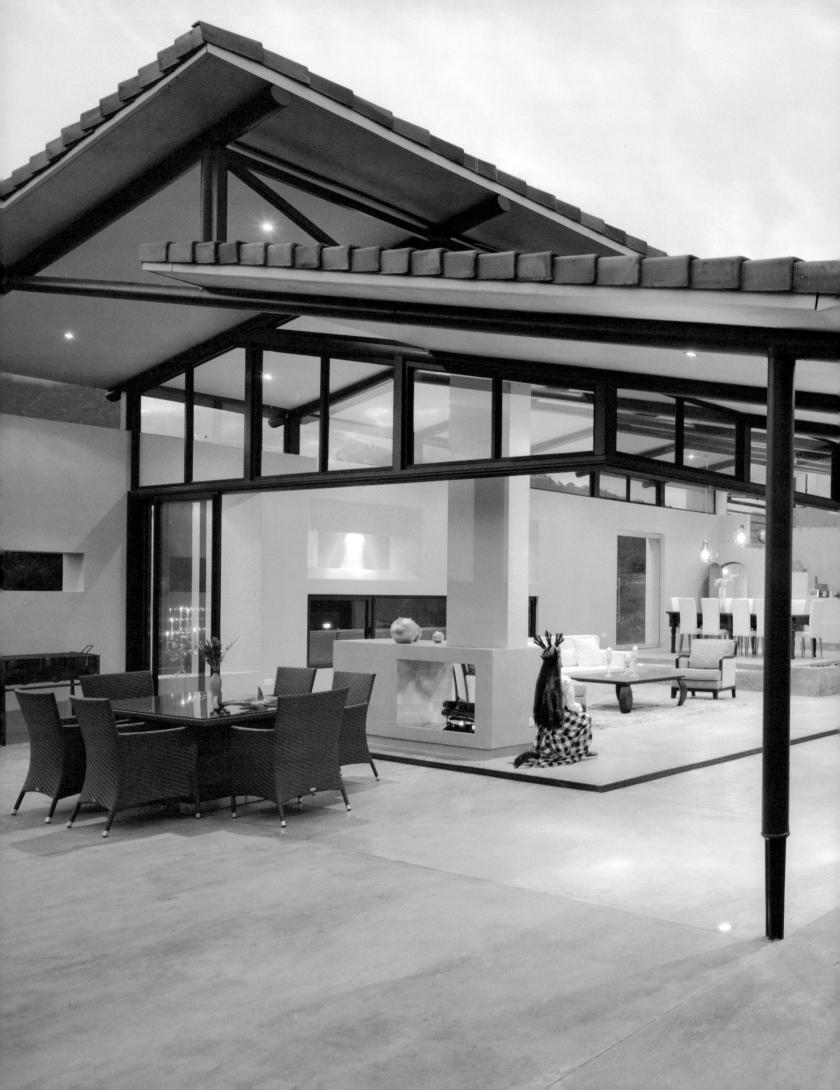

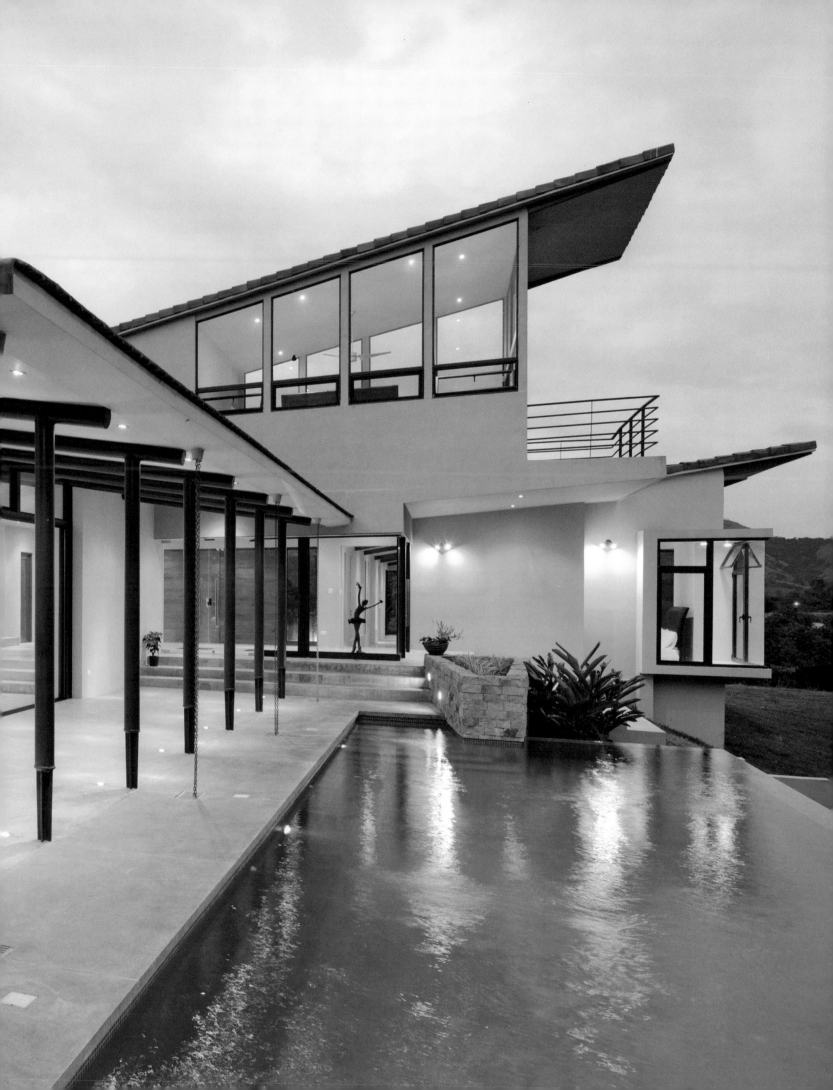

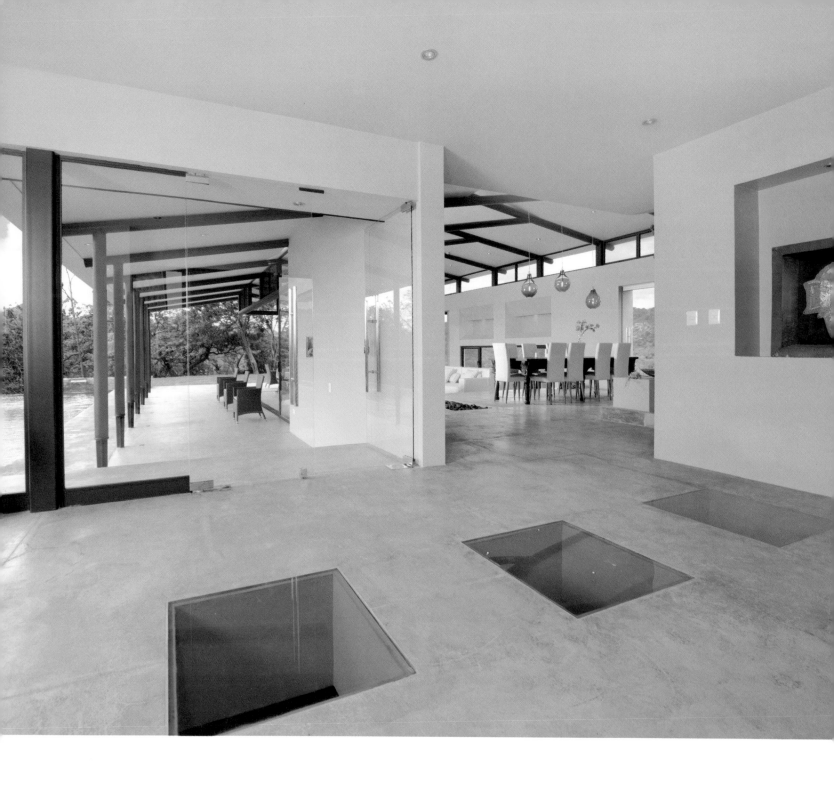

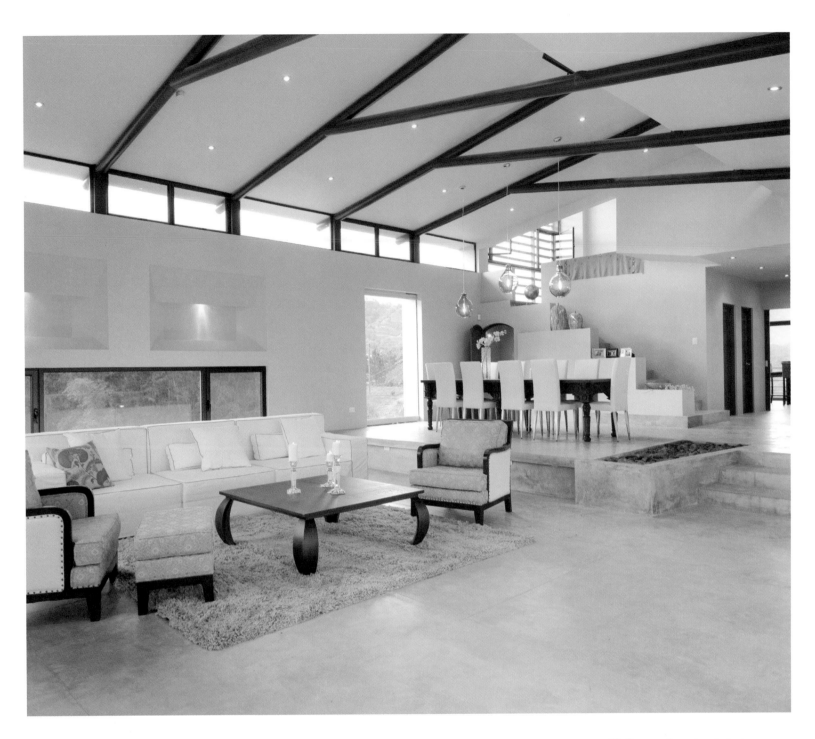

■ The use of passive strategies means the home does not need an artificial air-conditioning system, which drastically reduces the energy needed to sustain a comfortable environment.

First floor

Ground floor

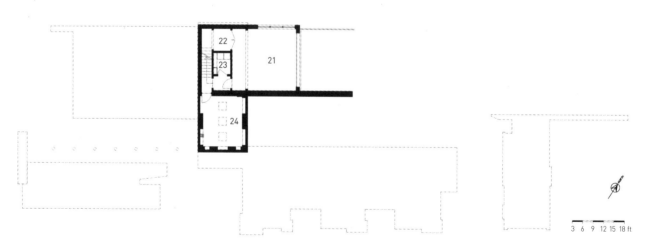

Basement

1. Master bedroom	10. Foyer with glass flooring	17. Bathrooms
2. Master bathroom	11. Powder room	18. Art studio
3. Master closet	12. Kitchen with pantry	19. Office
4. Mezzanine	13. Observation deck	20. Outdoor theater
5. Balcony	14. Porch	21. Parking
6. Living room	15. Gallery	22. Equipment room
7. Fireplace	16. Bedrooms	23. Laundry room
8. Endless pool		24. Wine cellar
9. Dining area		

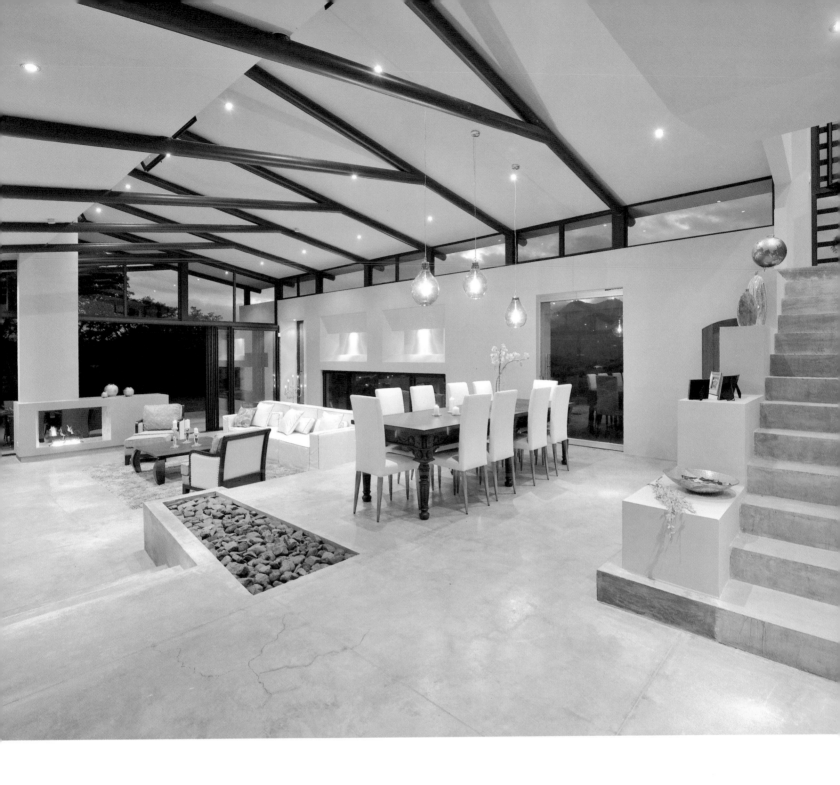

BIOCASA_82

Welldom

Location **Montebelluna, Italy**
Surface area **5,220 square feet**
Photographs **© Marco Zanta**

 Landscape integration
Garden with native plants

 Recyclable materials
Local materials

 Rainwater collection and use

 Free of radon gas
Free of electric, magnetic, and
 electromagnetic harmful fields
Maximum interior comfort
 (thermal, olfactory, visual,
 acoustic, and psychological)

 Photovoltaic solar energy
Geothermal energy for the production
 of heat, hot water, and cooling

"We dreamed of a house that was not just pretty and comfortable but was also consistent with our values and our social responsibility to our country and its future generations." Following the owners' wishes, Welldom has succeeded in creating the first private home in Europe to be awarded the LEED Platinum certificate of conformity, the highest LEED for houses.

From the beginning, the house was designed with the intention of fitting perfectly within the agricultural area, with one eye on sustainability and a respect for the history and nature of its environment. Thus, the design was forced to observe a number of rules, for example, sloping roofs and windows with typical farm shutters. The idea of sustainability arose spontaneously from the start at the request of the owners and gradually improved, pushing its development to places never before explored within this type of residential project.

Nevertheless, every detail has been also designed to enhance its inhabitants' quality of life; and although this is a "luxury" home, it is far removed from the concepts of wealth and consumerism. Its luxury is expressed through its respect for the environment without forgetting the important qualities that are fundamental in every home.

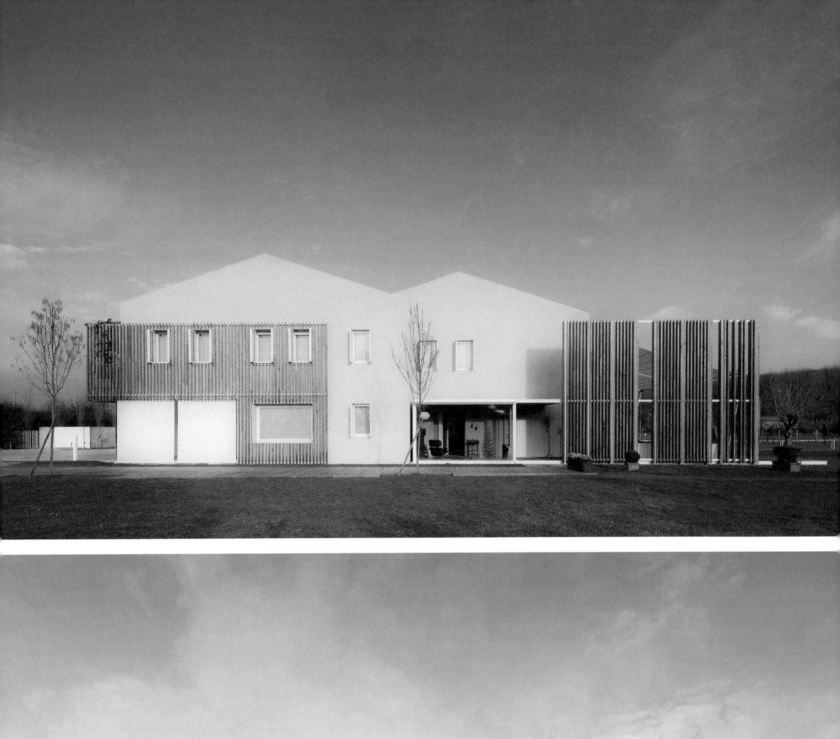

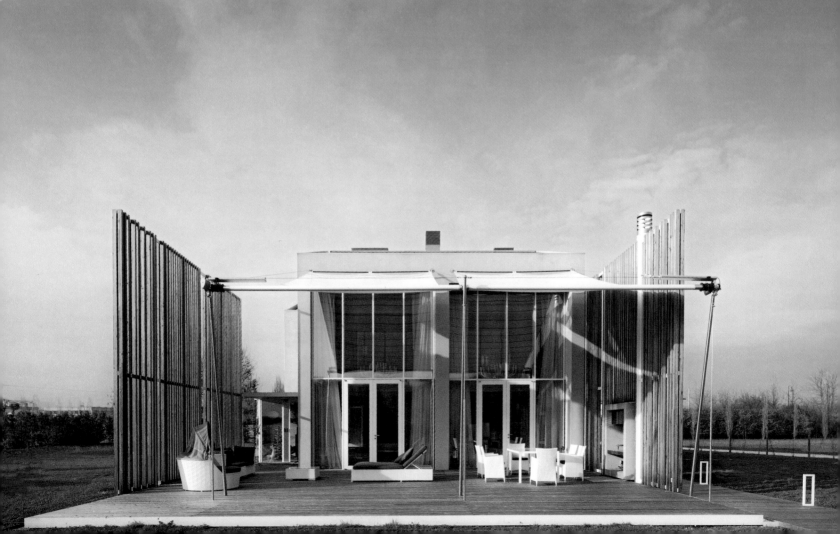

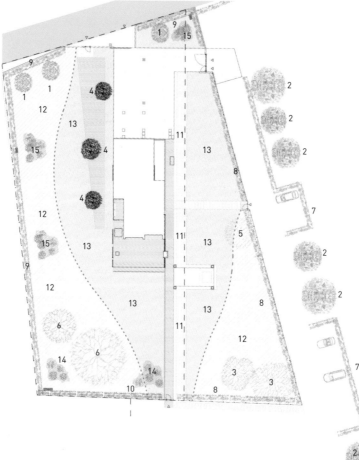

1. *Populus nigra*
2. *Prunus avium*
3. *Acer campestre*
4. *Calicanthus praecox*
5. *Fraxinus ornus*
6. Existing trees
7. Regulated hedge
8. Freeform hedge
9. Hornbeam hedge
10. Cherry laurel hedge
11. Flowerbed
12. Mowing lawn
13. Lawn
14. *Taxus baccata*
15. *Buxus sempervirens*

Newly planted species areas and site plan

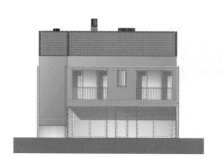

North elevation

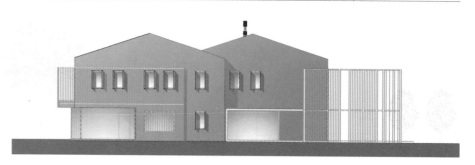

West elevation

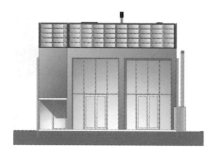

South elevation

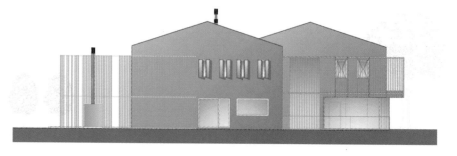

East elevation

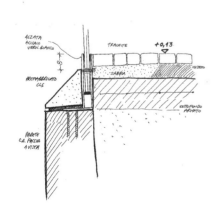

Section sketch of the forecourt

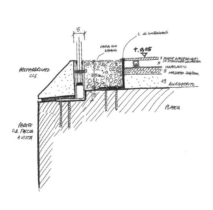

Section sketch of the wooden walkway

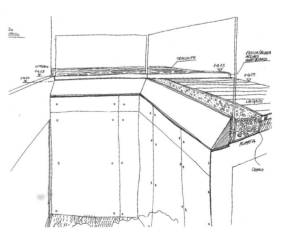

Perspective sketch

■ The interior maintains a uniform temperature and humidity all year, the acoustics prevent internal reverberations, and the lighting is totally natural.

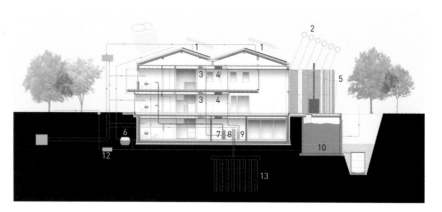

Summer section

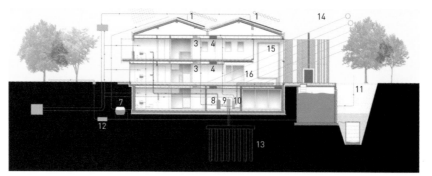

Winter section

1. Photovoltaic modules
2. Summer solstice 67º
3. Radiant ceilings
4. Mechanical ventilation with heat recovery
5. Filtering system
6. Recovery and reuse of rainwater
7. Water heater
8. HP1
9. HP2
10. Accumulating tank
11. Irrigation system
12. Oil separator, de-oiler, and grease separator
13. Geothermal heat pump
14. Winter solstice 21º
15. Solar heat recovery with mechanical ventilation
16. Solar heat recovery with radiant floor

■ 100% of the home's energy is obtained through renewable sources: a photovoltaic system provides electricity and a geothermal system provides heat and hot water.

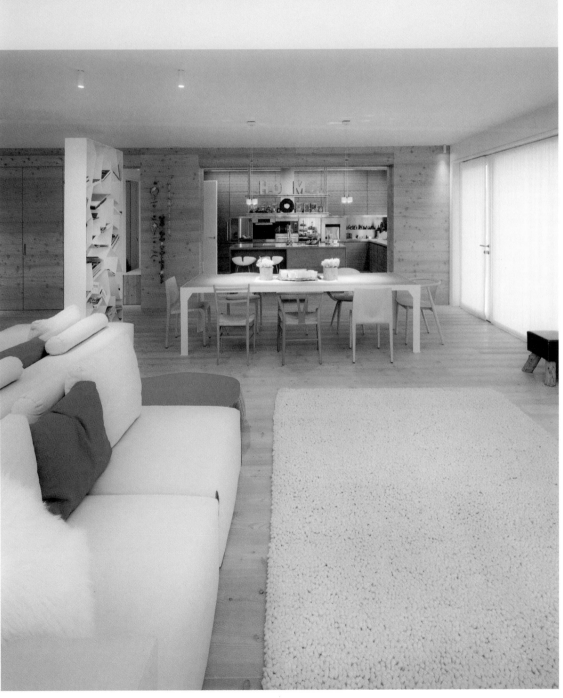

CASA 31_4
ROOM HOUSE

Caroline Di Costa Architect and iredale pedersen hook

Location **Perth, Australia**
Surface area **2,518 square feet**
Photographs **© Peter Bennetts**

Visual integration
Minimal removal of material
from the site

Low water consumption
and storage
Solar hot water system

Low-energy light fittings
Photovoltaic solar energy

Recycled materials

Cross-ventilation
Cooled with a manually operated
reticulation system

This house reinterprets the role of memory, tradition, and social and cultural value in a rich spatial experience that is both familiar and unfamiliar. Caroline Di Costa and iredale pedersen hook architects' work preserves and reinterprets the past. The house's design is a clear example of the importance of maintaining a 1935 Queen Anne-style house, while embracing the expectations of contemporary life and remaining faithful to its context on the street and the privacy of the neighboring houses: the house next door completes the sequence of the street in which "twins should never be separated."

All the living spaces contain elements of the past: the ceiling tiles, the use of the fireplace as a water reservoir, as well as the covers, doors, architraves, and furniture. At the same time, the front facade engages the street, maintaining the architectural style and tradition and reminding us of the value of the front garden as a social environment and meeting place.

If the front facade remains almost intact, as a silent figure or backdrop, the back is outgoing, complex, and challenging: a large mobile screen provides privacy, shade, and freshness. It manages to achieve a reinterpretation of the surrounding cityscape and the juxtaposition of old and new, historical and contemporary.

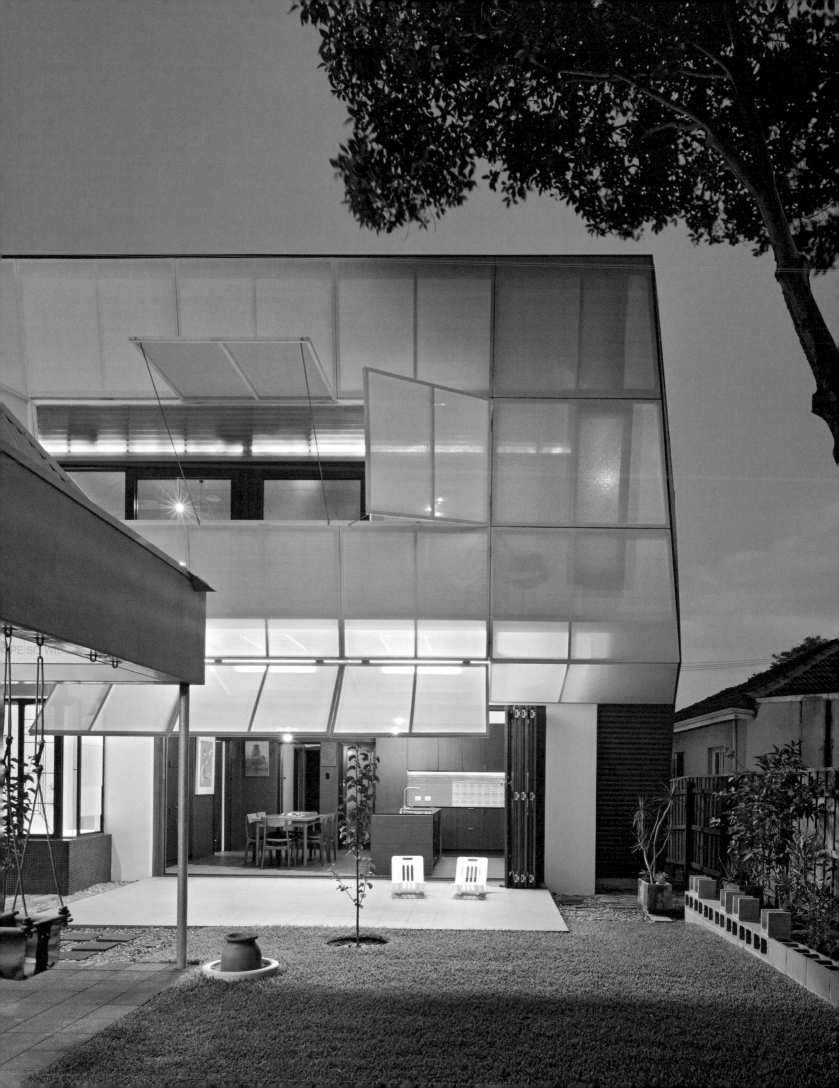

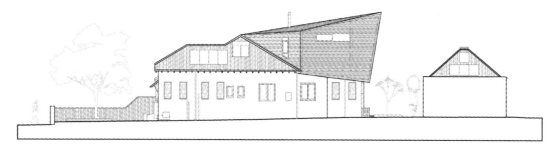

North elevation

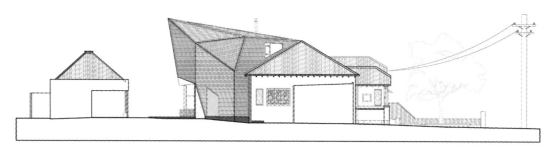

South elevation

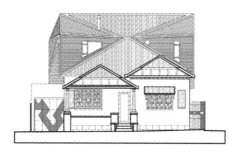

East elevation

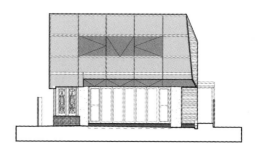

West elevation

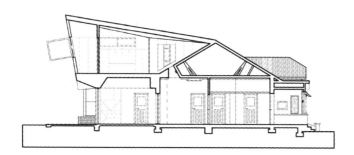

Longitudinal section

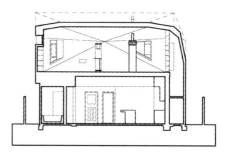

Cross section

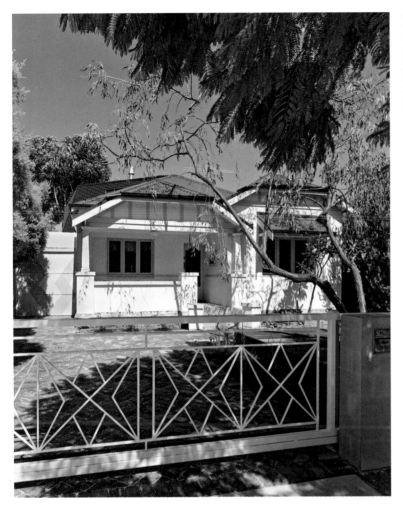

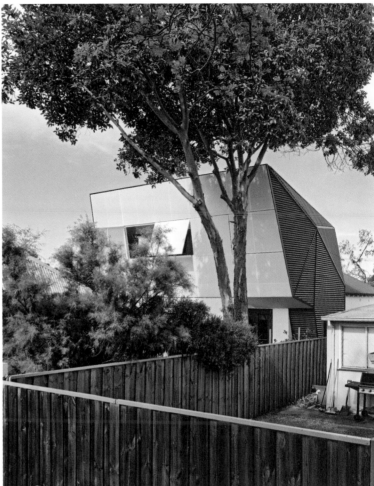

First floor

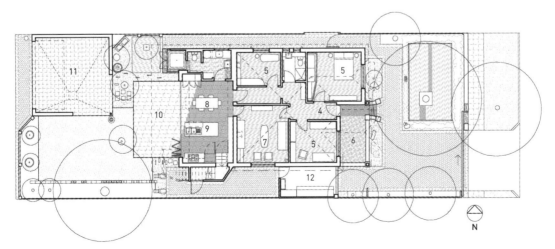

1. Study
2. Living room
3. Balcony
4. Entrance
5. Bedrooms
6. Veranda
7. Lounge
8. Dining room
9. Kitchen
10. Terrace
11. Multipurpose room
12. Workshop

Ground floor

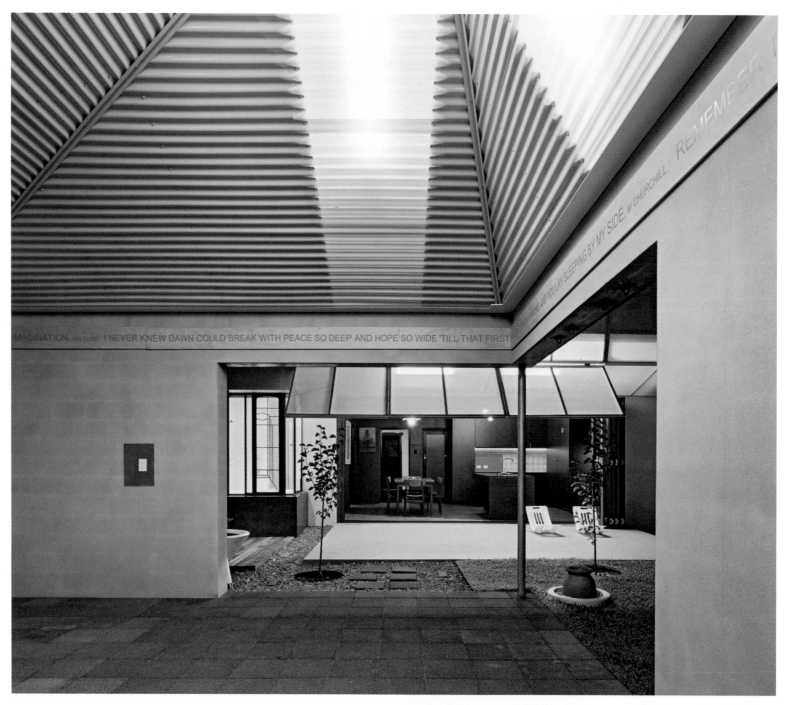

IMAGINATION. VOLTAIRE I NEVER KNEW DAWN COULD BREAK WITH PEACE SO DEEP AND HOPE SO WIDE 'TILL THAT FIRST

Kitchen sketch

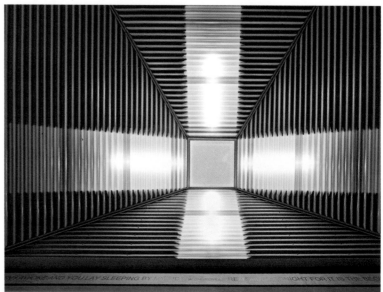

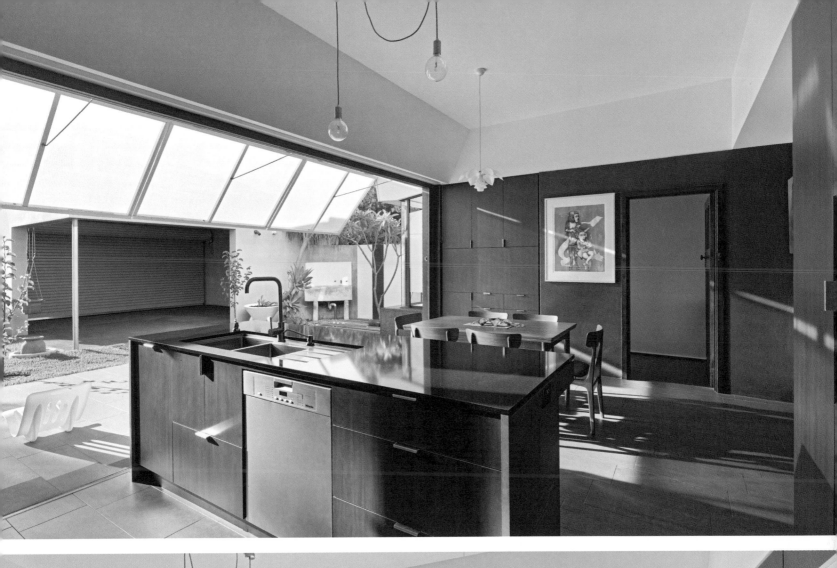
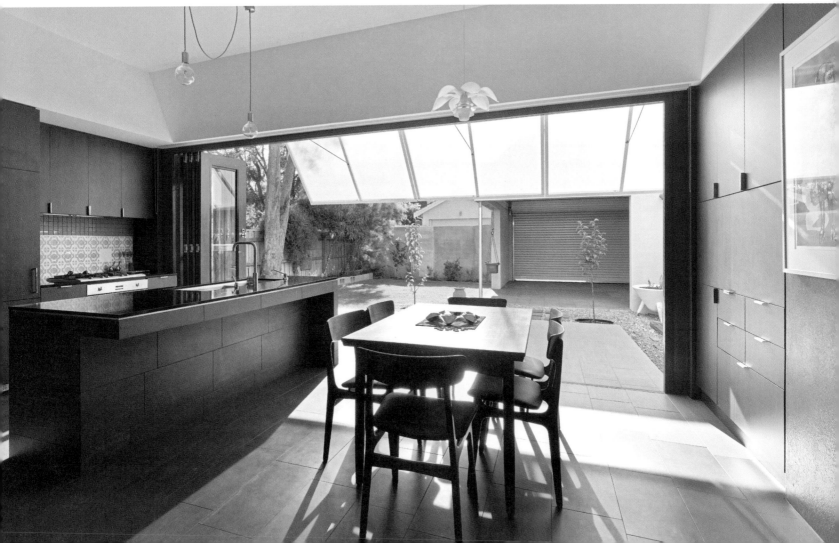

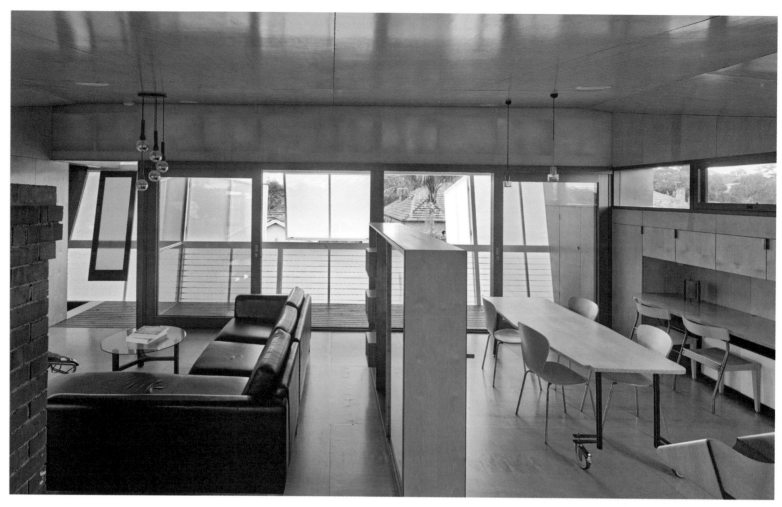

■ The low-tech air-conditioning system on the top floor, inspired by the Coolgardie Safe used in the nineteenth century, cools hot air through the principle of heat transfer that occurs during the evaporation of water.

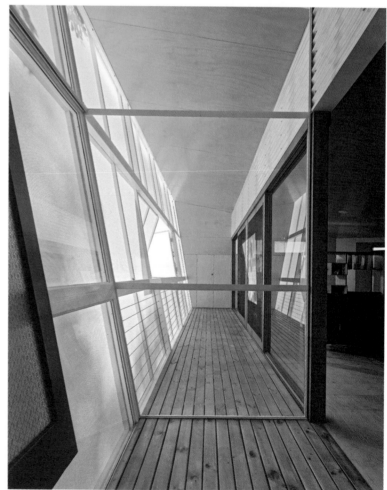

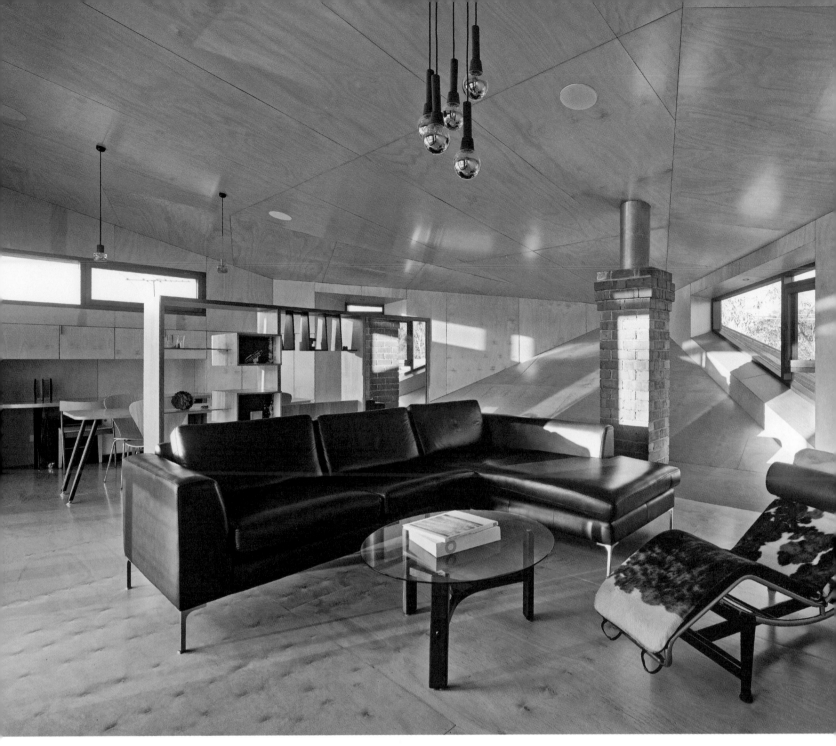

Stairs sketch

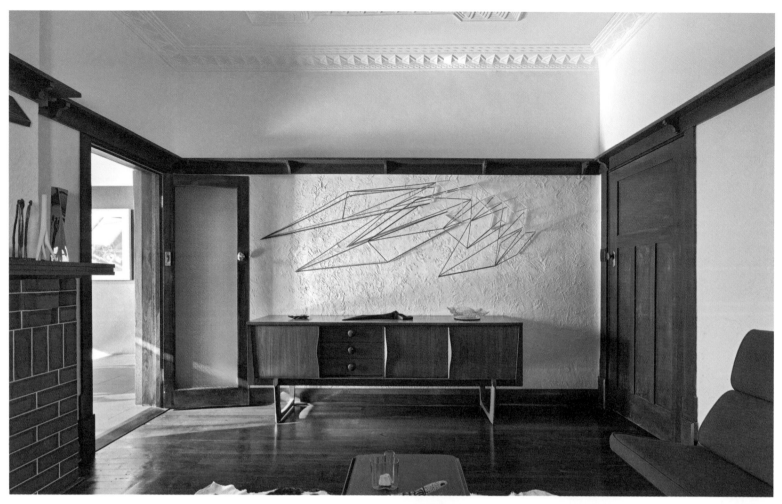

The interior explores the art of construction; the years of stratification; that which used to exist. It takes elements from the past, conserving some, highlighting others, and removing those that no longer fit.

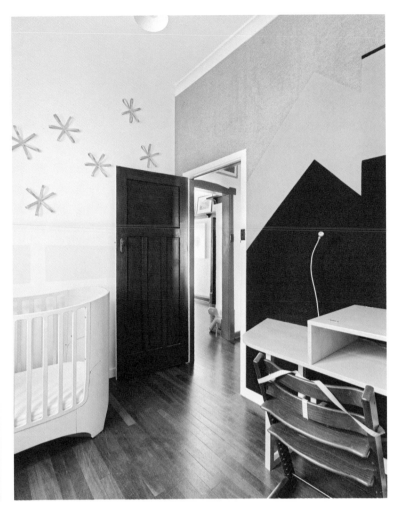

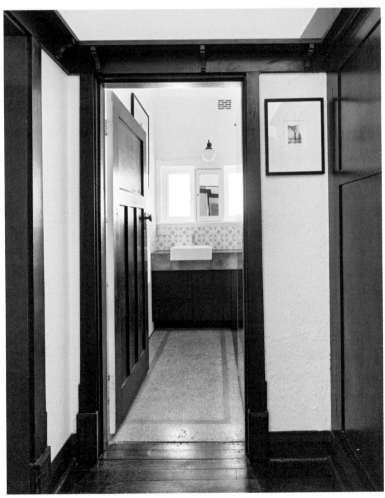

EASTERBROOK HOUSE

Dorrington Atcheson Architects

Location **Titirangi, New Zealand**
Surface area **1,291 square feet**
Photographs **© Emma-Jane Hetherington**

Passive solar

Natural daylight
Natural ventilation

Built as an escape from the city, this house is designed to provide a family with two children the opportunity to simplify their lives, while remaining aware of their surroundings and having a good time.

Situated in an isolated area with plenty of sun and views of the surrounding mountains, the hallmarks of this home are its identity with rustic outdoor living. This Titirangi property integrates a duo of compact buildings constructed from humble materials, allowing the environment to take its rightful place in the design. The main house—with its barn-shaped form and adult and child bedrooms located at opposite ends—and its mini-me cousin share a similar aesthetic and layout.

The family of four has moved into their new home and is enjoying a slower, gentler way of life. To achieve this, the color of their environment has played an integral part in the design process, an outward expression of their desire to live a more creative lifestyle. Thus, the choice of colors was central to the finish. Yellow and red accents complement the plywood walls and ceilings, and the concrete floors lend a playful and dynamic feel to the interior.

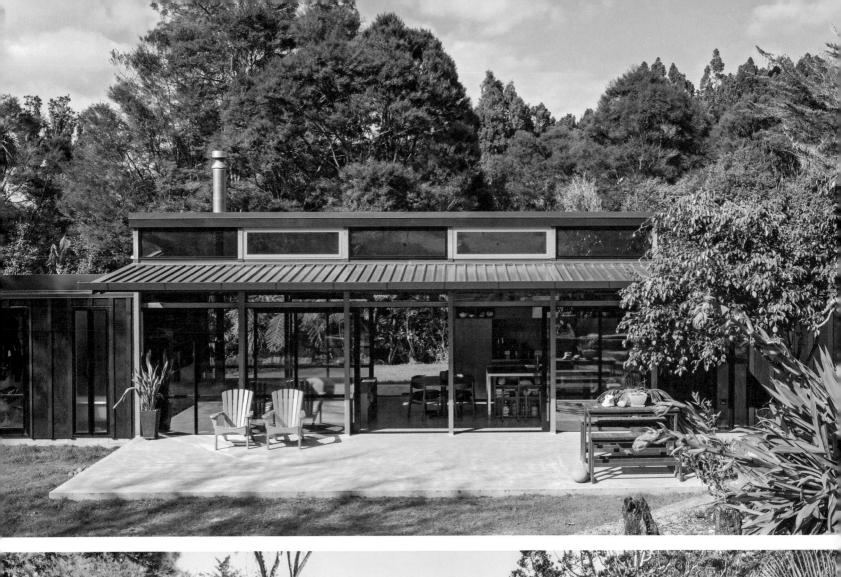

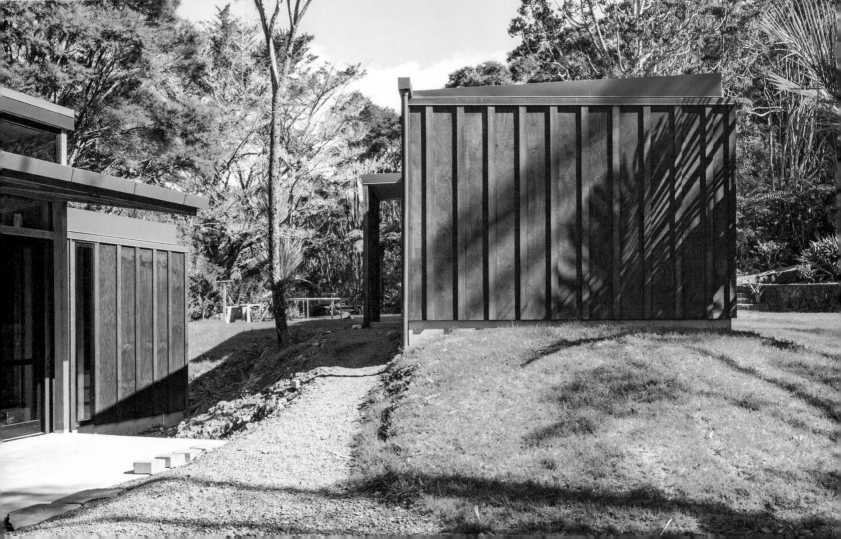

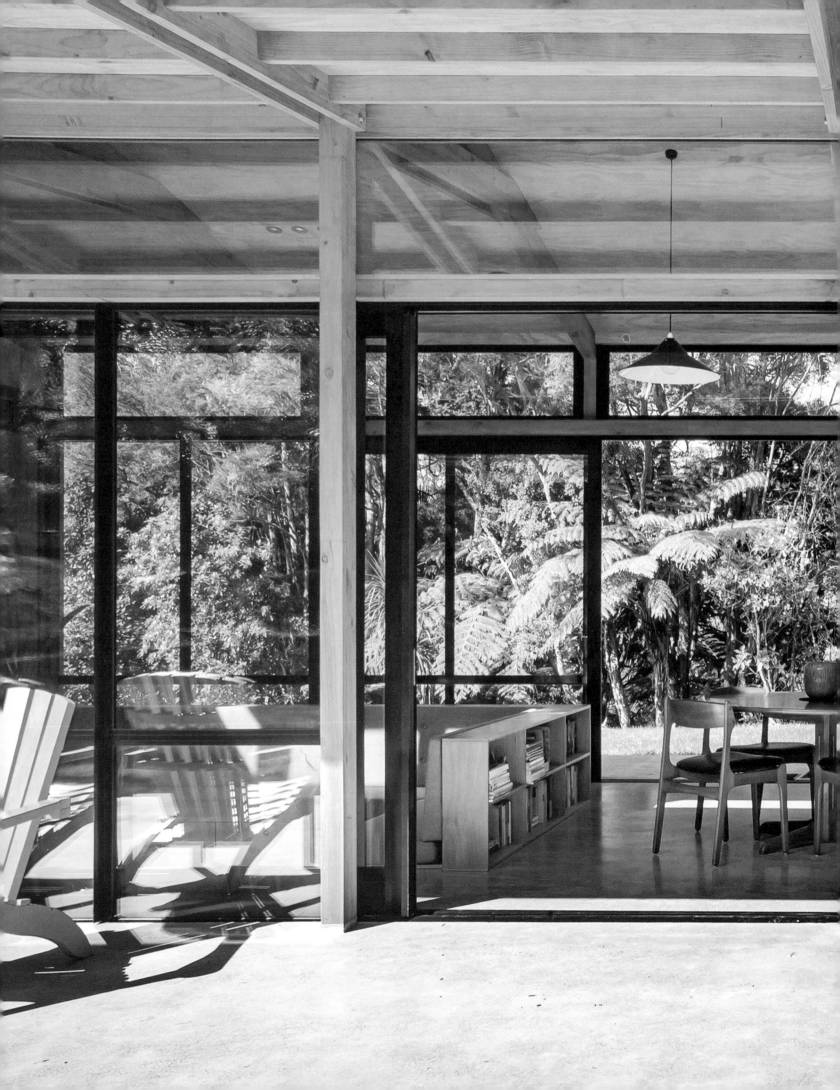

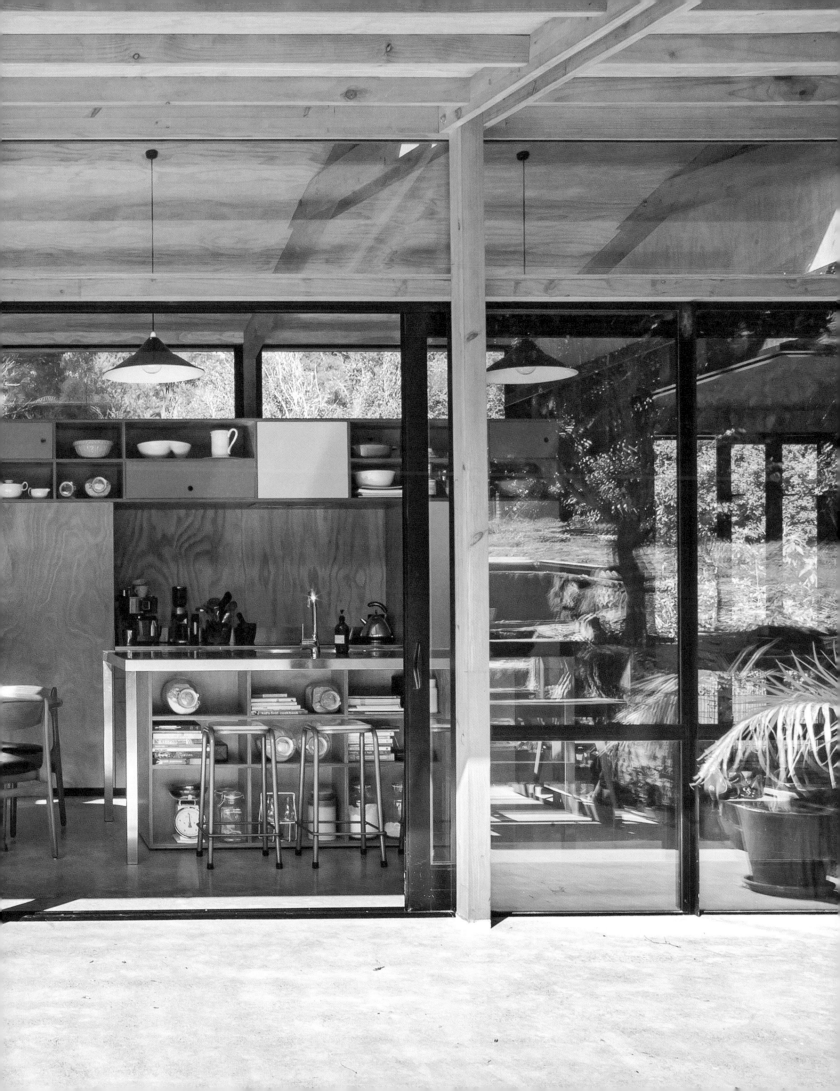

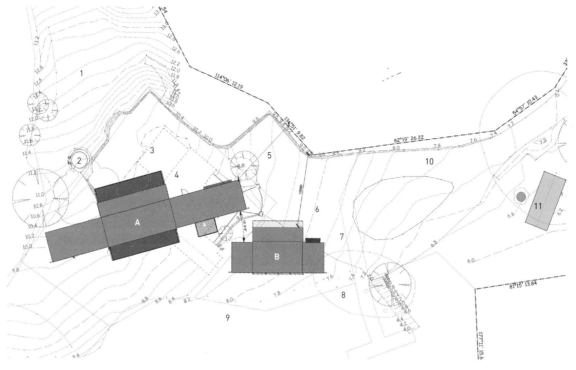

Site plan

A. Major Dwelling
B. Minor Dwelling

1. One-foot-high bund as per flood engineer's report
2. Existing spa pool to be retained
3. Area returned to grass
4. Demolished house outline
5. Car parking
6. Line of thirty-two-foot boundary setback
7. Minor dwelling car parking
8. Drip line of tree
9. Line of sixty-five-foot riparian zone setback
10. Gravel driveway, retained
11. Existing garage

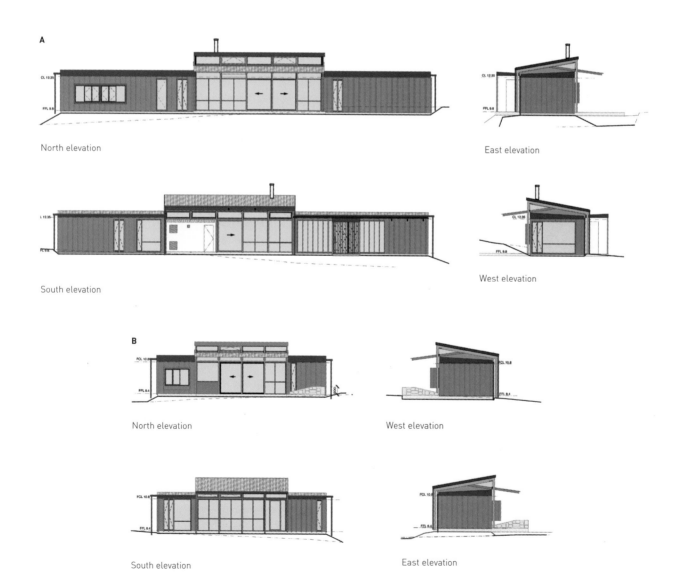

A

North elevation

East elevation

South elevation

West elevation

B

North elevation

West elevation

South elevation

East elevation

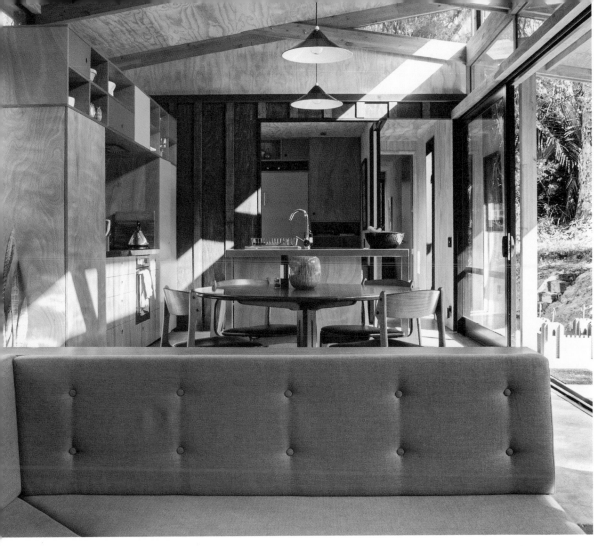

■ The rectangular home is only four-by-thirteen-feet wide; however, the high, simple ceiling and tall windows expand the feel of the room beyond its actual size.

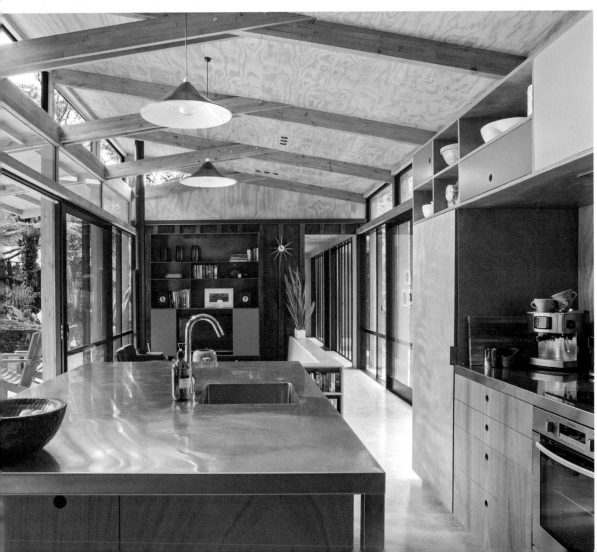

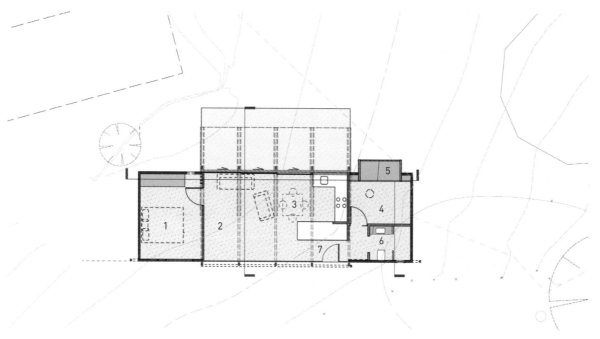

Minor ground floor

1. Bedroom
2. Living room
3. Dining room / Kitchen
4. Window seat
5. Study
6. Bathroom
7. Entrance

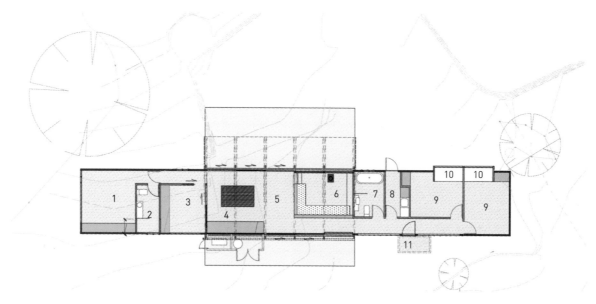

Major ground floor

1. Master bedroom
2. Master bathroom
3. Study
4. Kitchen
5. Dining room
6. Living room
7. Bathroom
8. Laundry room
9. Bedrooms
10. Window seats
11. Entrance

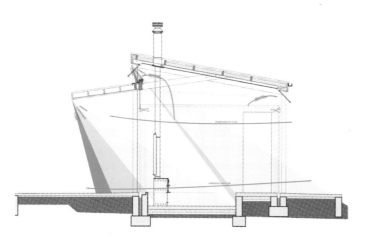

Summer sun diagram

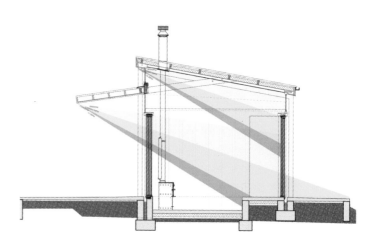

Winter sun diagram

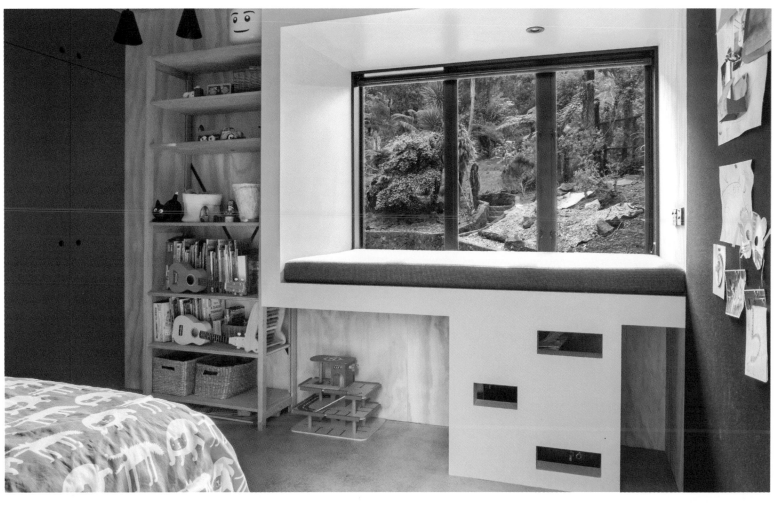

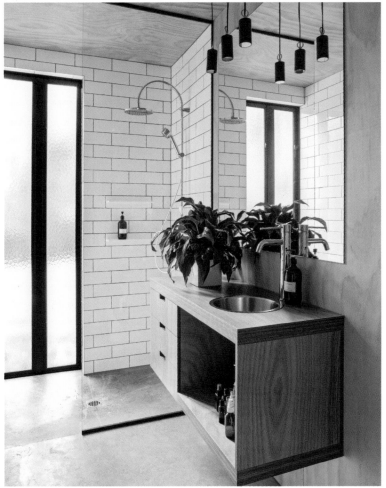

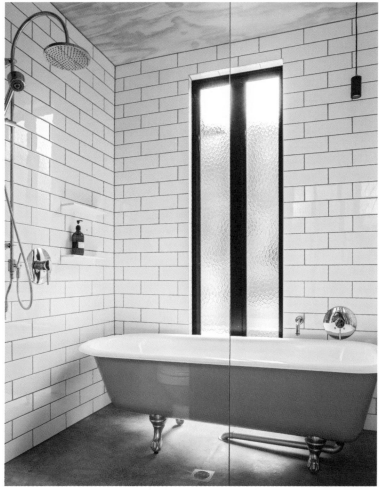

NANNUP HOLIDAY HOUSE

iredale pedersen hook

Location **Nannup, Australia**
Surface area **5,683 square feet**
Photographs **© Peter Bennetts**

 Landscape integration
Native plants preserved

 Gray water recycling
Rainwater collection and use
Minimized water waste

 Photovoltaic solar energy

 Material sourced from the site
Wooden construction
Recycled and ecological materials
Prefabricated materials

This vacation home forms part of the trail that wanders through the landscape between Perth and Nannup. The path establishes an intense dialogue with the landscape of thick forest, meandering river, and nearby hills. This spatial framework acts as a wrapper in which every experience is carefully choreographed to give maximum enrichment to the space in which the house is set.

Despite being a holiday home and therefore conceived as a short-stay residence, this iredale pedersen hook project offers a wide variety of experiences and relationships with the native landscape. From the careful control of the vertical oscillation, represented by the woods, and the horizontal oscillation, represented by the horizon, the house opens up and connects with the ground but also has a floating sensation that emerges from its projection on the ground. At this point, the windows play a vital role in the relationship between inside and out: the framed openings cut the horizontal views of the surrounding trees, to the forest, while the larger panels favor a wider panorama of the landscape, of the horizon.

Between the edge of the forest and a floodplain, in an area of fragility that exists between fire and flood, this building hangs over the landscape, barely disturbing it.

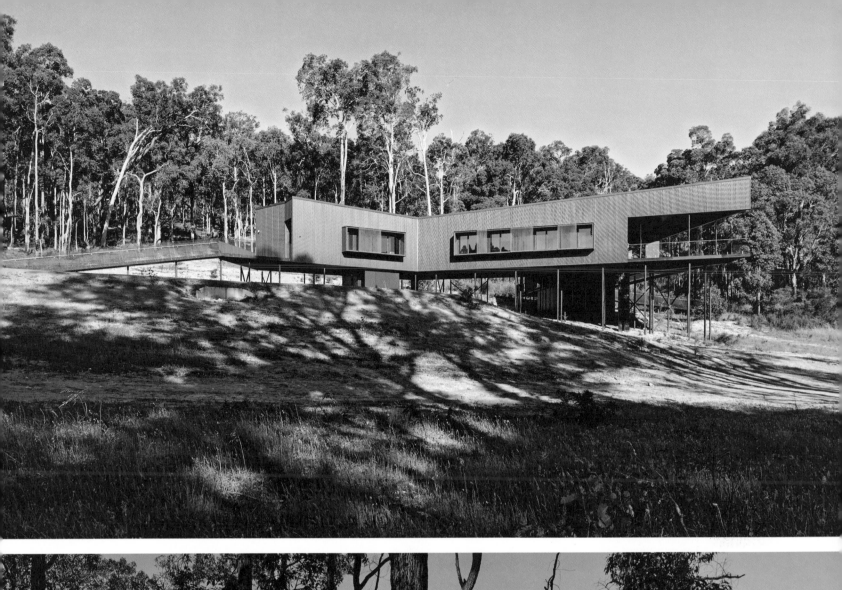

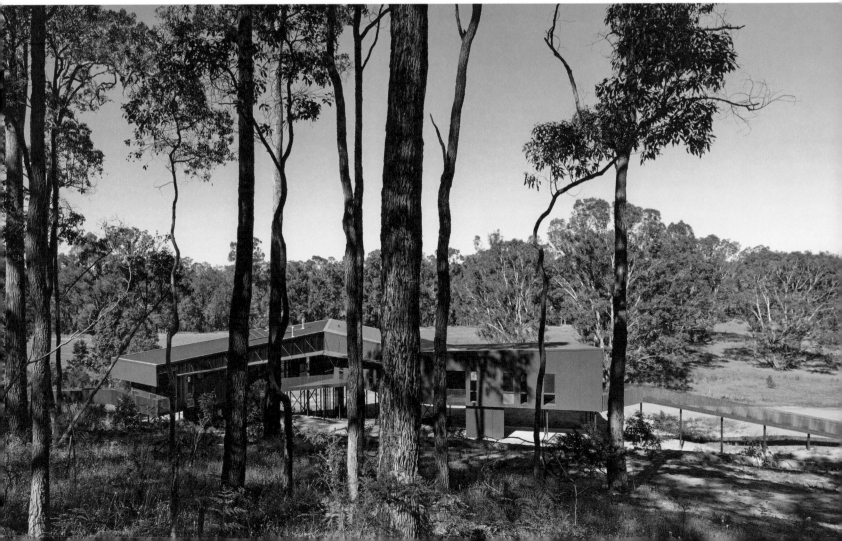

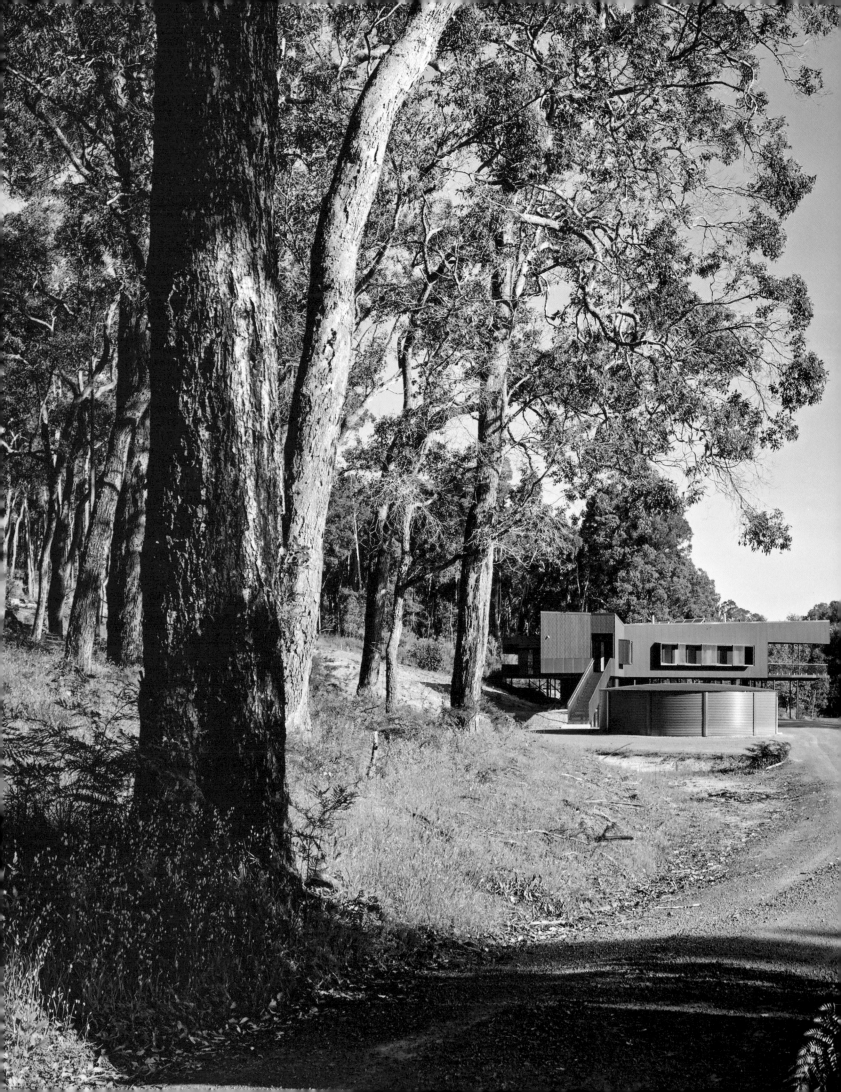

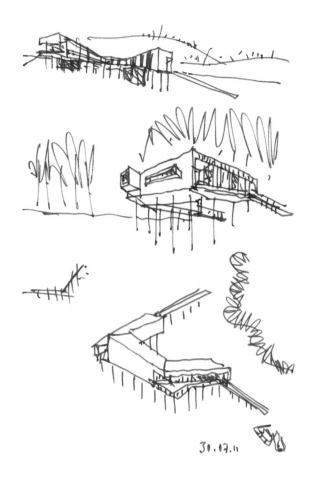

30.17.11

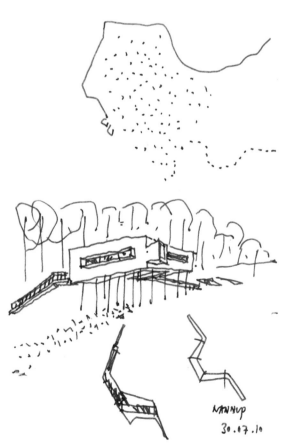

NANNUP
30.07.10

Sketches

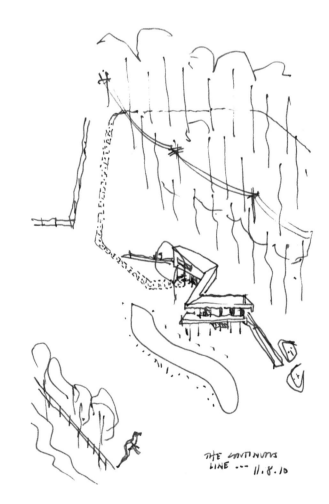

THE CONTINUS
LINE ... 11.8.10

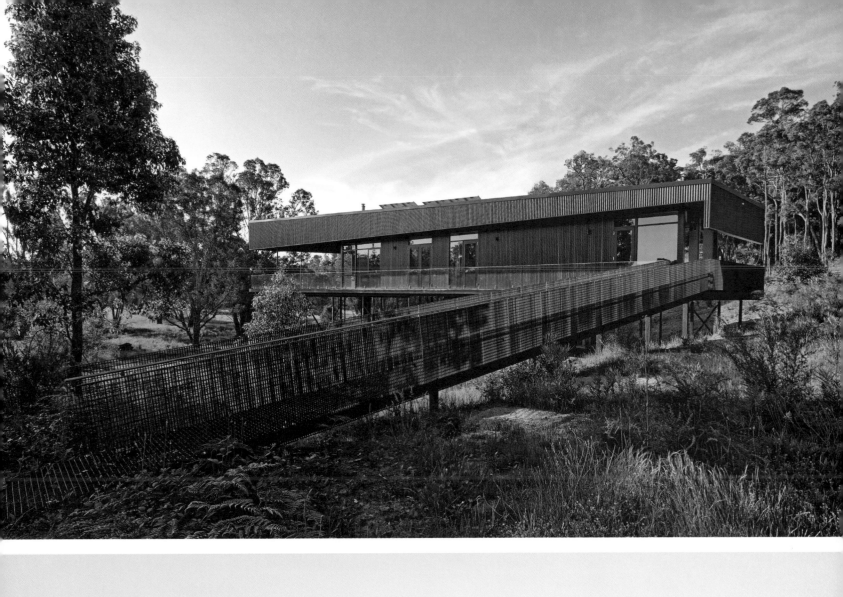

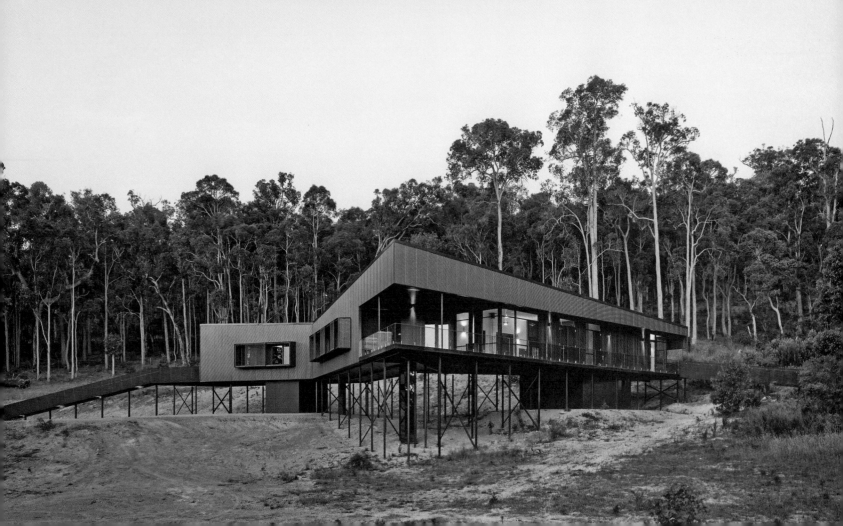

Site plan

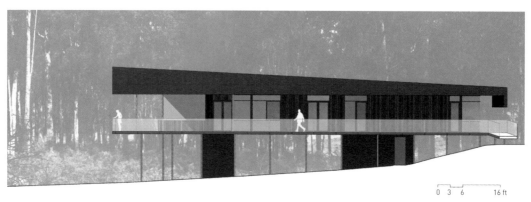

0 3 6 16 ft

South elevation

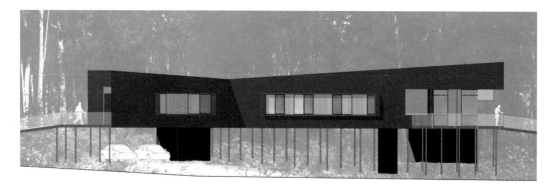

West elevation

■ The driveway is located along
the edge of the property. It must
be cleared of leaves and pine
needles and the like once a year
in order to serve as a fire division
wall, but otherwise requires
little maintenance.

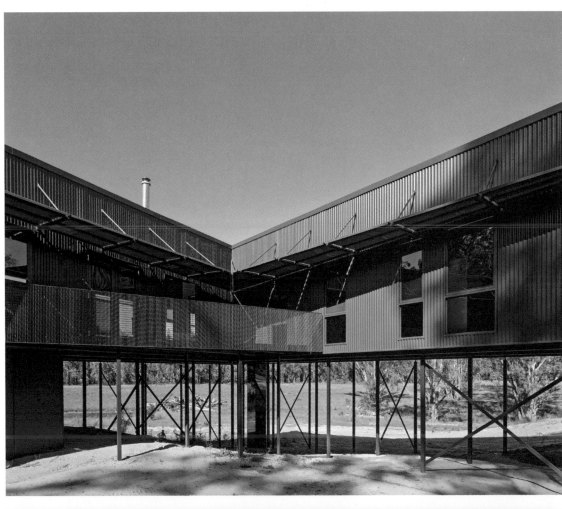

■ The house is situated and designed to minimize the need to trim trees and bushes. The area underneath the house is planted with indigenous species, as an attempt to reintroduce plants in danger of disappearing. A gray water recycling system is used to irrigate these plants.

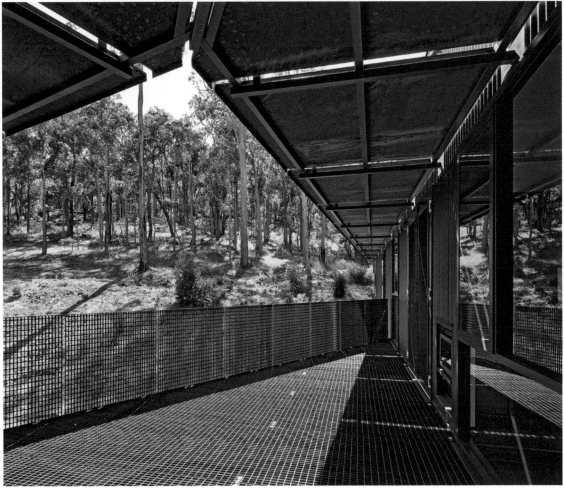

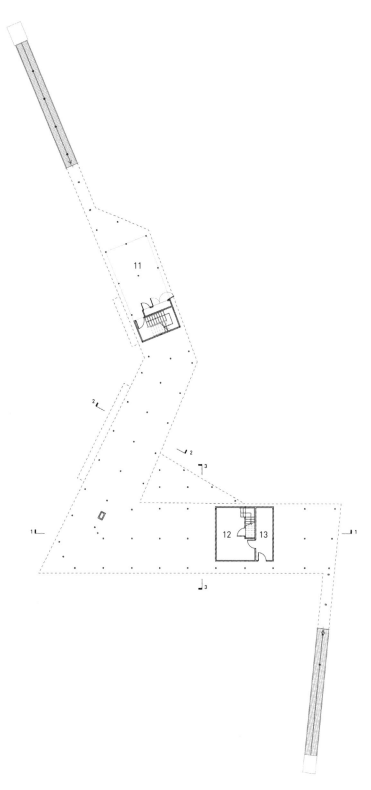

Ground floor

■ The building structure is made from
90 percent treated pine, and most
of the furniture is made from pine
plywood. Most of the structure is
prefabricated in order to minimize
construction waste.

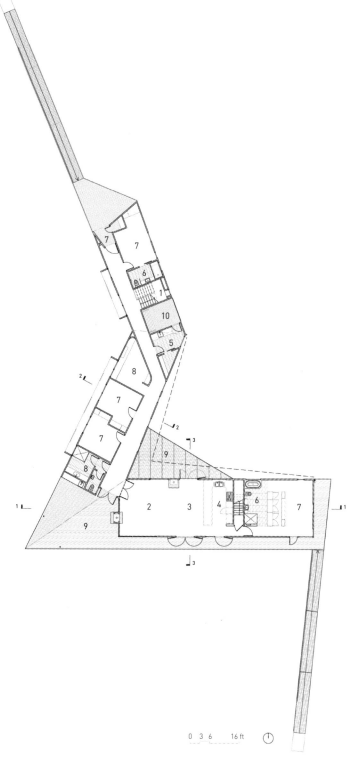

Upper floor

1. Entrance
2. Living room
3. Dining room
4. Kitchen
5. Laundry room
6. Bathrooms
7. Bedroom
8. Study / Office
9. Outdoor living space
10. Drying deck
11. Carport
12. Cellar / Free shelter
13. Wood storage

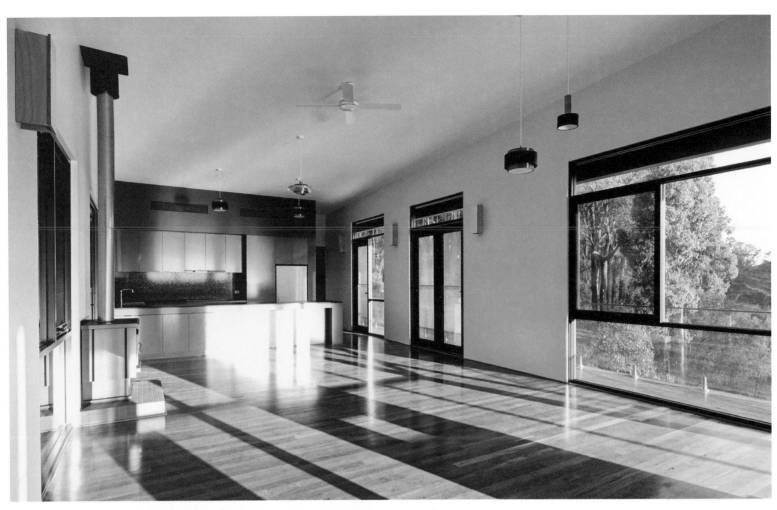

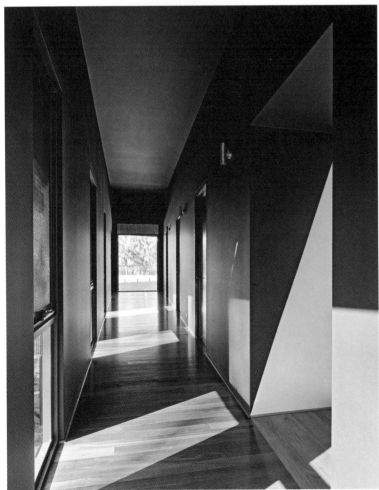

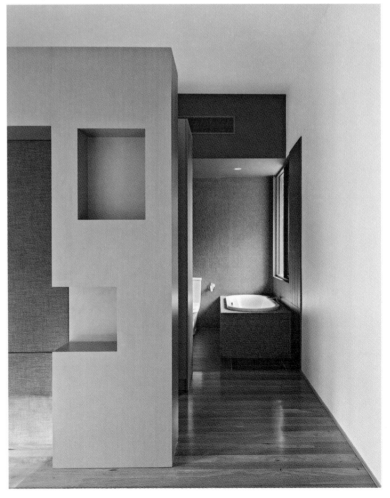

SANTA CRUZ STRAW BALE HOUSE

Arkin Tilt Architecs

Location **Santa Cruz, California, USA**
Surface area **2,500 square feet**
Photographs © **www.edwardcaldwellphoto.com**

 Low impact on the site

 Local materials
Recycled materials

 Passive solar
Photovoltaic solar energy
CO_2 low consumption

 Natural daylight
Natural ventilation
High insulated: straw-bale walls

The owners of this home are avid surfers and teachers of biology and environmental studies who wanted to push the limits of ecology in the design of their home. At the same time, they wanted a convenient and comfortable home for their family of six, plus a second unit suitable for their elderly parents or to rent out. The result is a beautiful 2,500-square-foot house over two floors that includes four bedrooms and an office, plus a small separate unit with a bedroom and its own entrance.

The house combines cutting-edge mechanical technology with natural construction techniques, passive solar strategies, and locally sourced materials, and is designed and built at net-zero-energy cost with a minimal carbon footprint. It is a compact house with separate spaces that serve various functions, characterized by the movements and changes that occur in light and shadows through the passing of the seasons.

Open and intimate, flexible and efficient, built to a tight budget, and cheerful in its silhouette and detail, this design by Arkin Tilt Architects delivers a narrative of the specificity of the place in which it is set, reflecting the consciousness and atmosphere of the urban Santa Cruz environment.

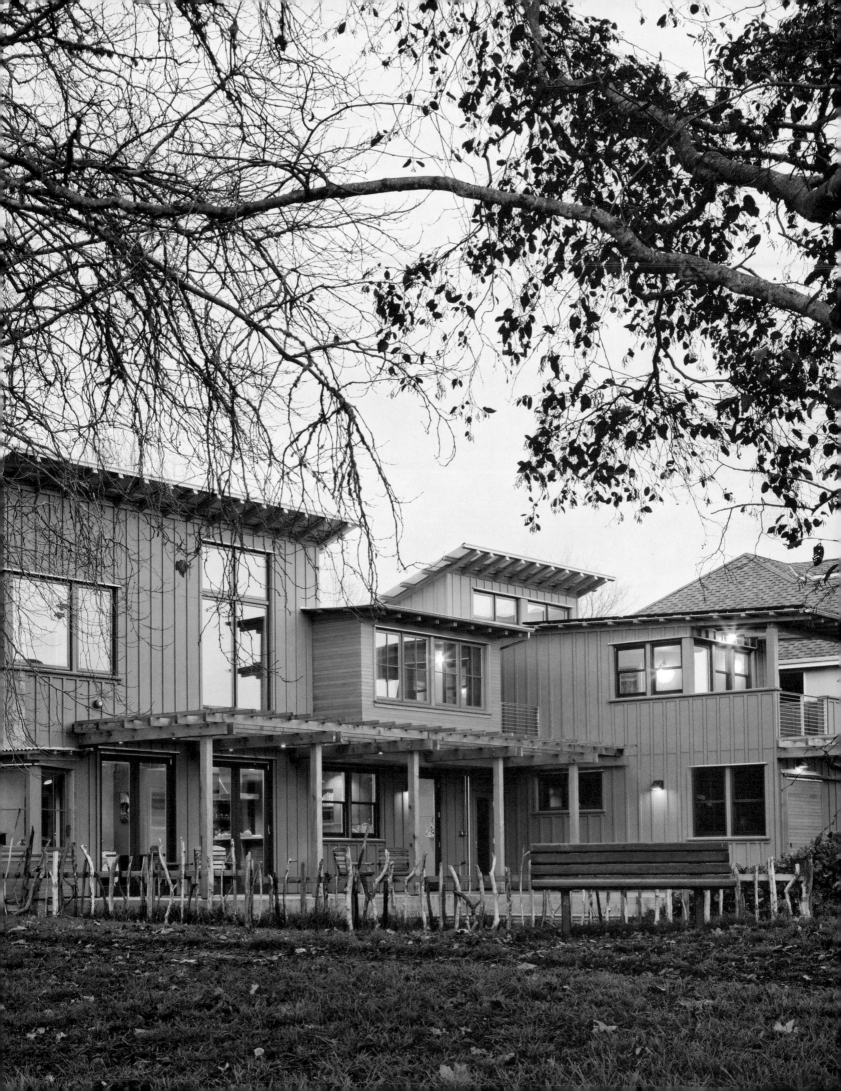

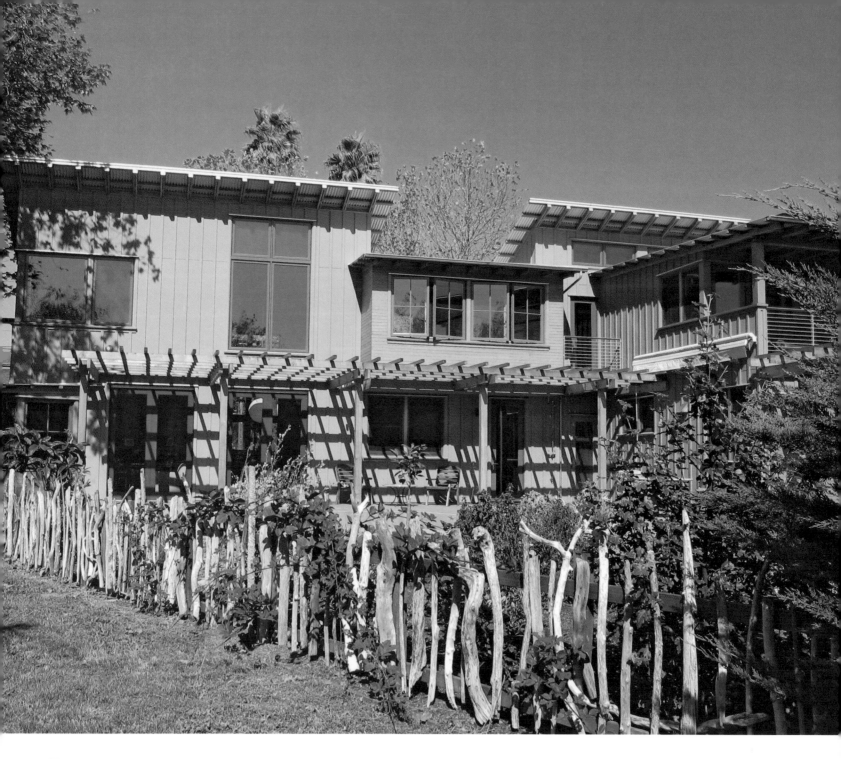

■ Inconveniences resulting from
construction are minimized by using
refurbished doors, windows, floating
wood floors, and a wood column next
to the entryway. These elements
combine to add charm and character
to the space.

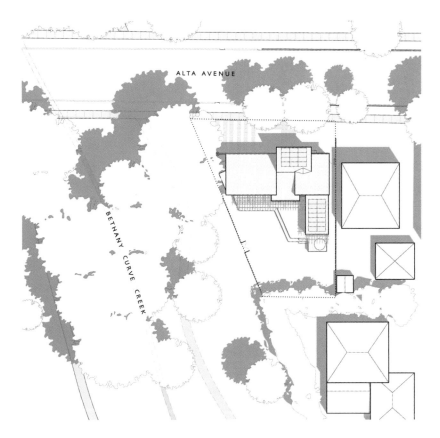

Site and roof plan

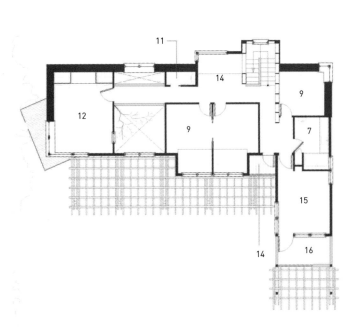

Upper floor

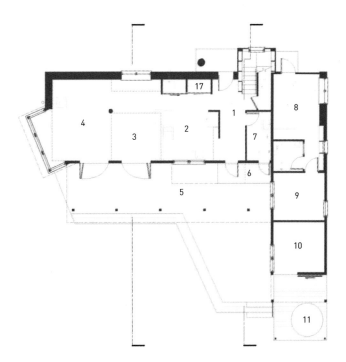

Main floor

1. Entrance / Foyer
2. Kitchen
3. Dining room
4. Living room
5. Terrace
6. Outdoor shower
7. Bathroom
8. Second unit living
9. Bedroom
10. Workroom / Mechanical room
11. Hot tub
12. Master bedroom
13. Powder room
14. Playspace
15. Office
16. Balcony
17. Storage room

■ The tall ceiling is accented with
a natural strawberry tree branch,
which the owners found on a
friend's property nearby.

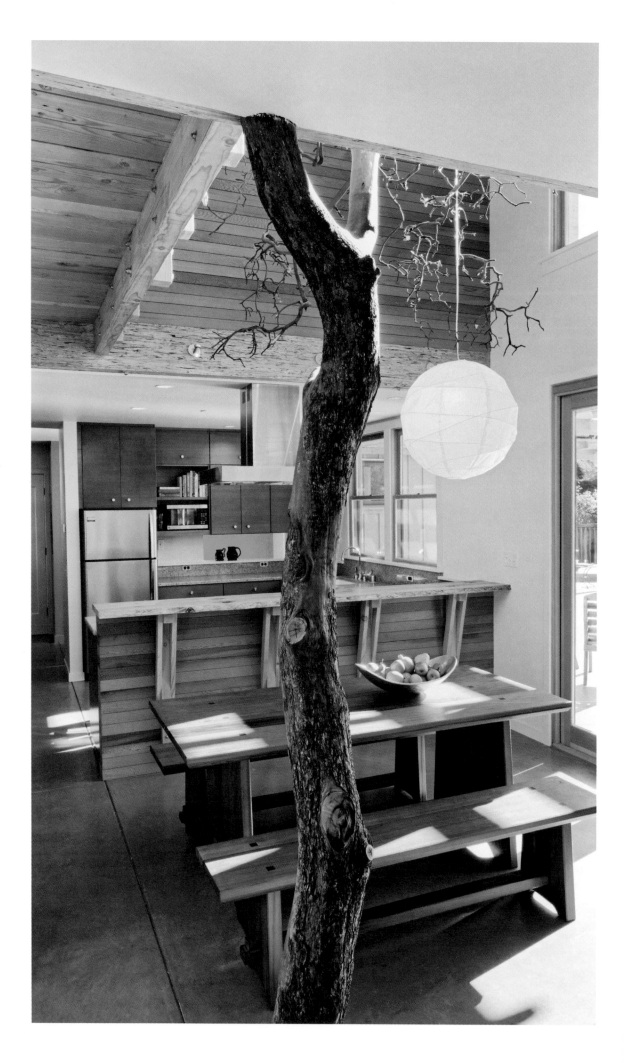

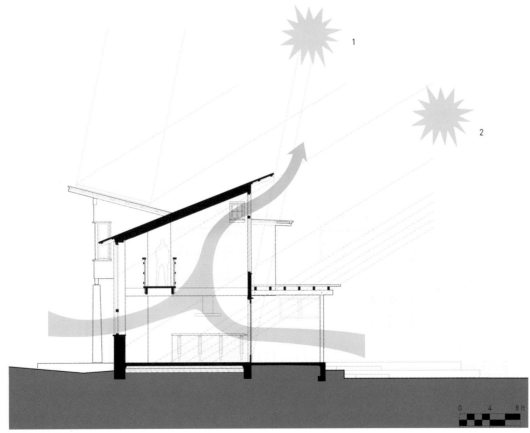

Diagram of passive solar and natural ventilation

1. Summer sun
2. Winter sun

THROUGH HOUSE

Dubbeldam Architecture + Design

Location **Toronto, Canada**
Surface area **1,450 square feet**
Photographs © **Bob Gundu**

Passive solar
Green roof

Natural daylight
Natural ventilation

This family residence was built 128 ago on a small plot in downtown Toronto. Its renovation is part of a broader strategy to revitalize the urban fabric of the area without the need to start again, creating comfortable environments for modern living with minimal impact on the area.

Dubbeldam Architecture + Design is responsible for meeting the owner's brief to create a bright and modern home that is connected with its outside surroundings while increasing the amount of interior living space. To achieve this, it rethinks the original space: elements from the surrounding area are incorporated, the ceiling heights are altered to define spaces instead of using walls, and by creating a powerful visual connection with the small backyard, the designers manage to expand the living space.

The house also achieves the owner's desire for an energy-efficient home. Light penetrates the center of the house via a large skylight, reducing the need for artificial lighting. The open staircase and mobile skylights provide natural ventilation. Finally, an extensive green roof reduces the environmental impact by cooling the roof and absorbing rainwater.

The result is an airy and spacious house with an intimate courtyard that creates a serene retreat within the hustle and bustle of city life.

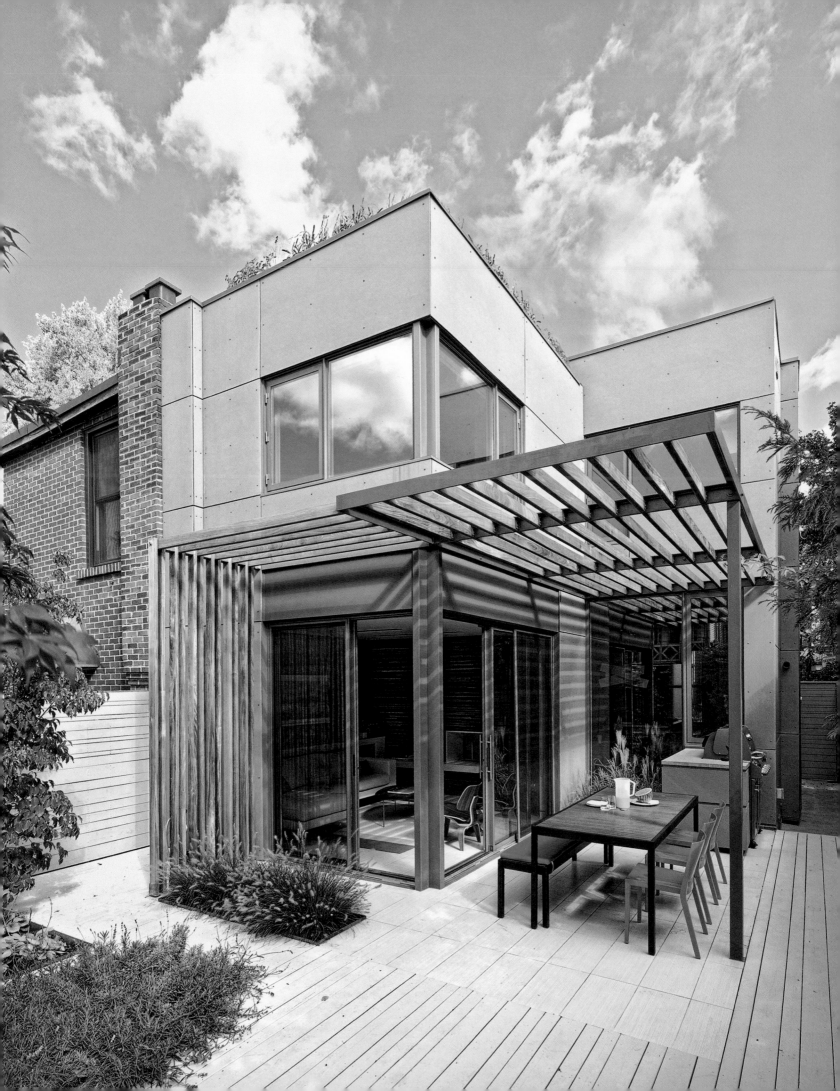

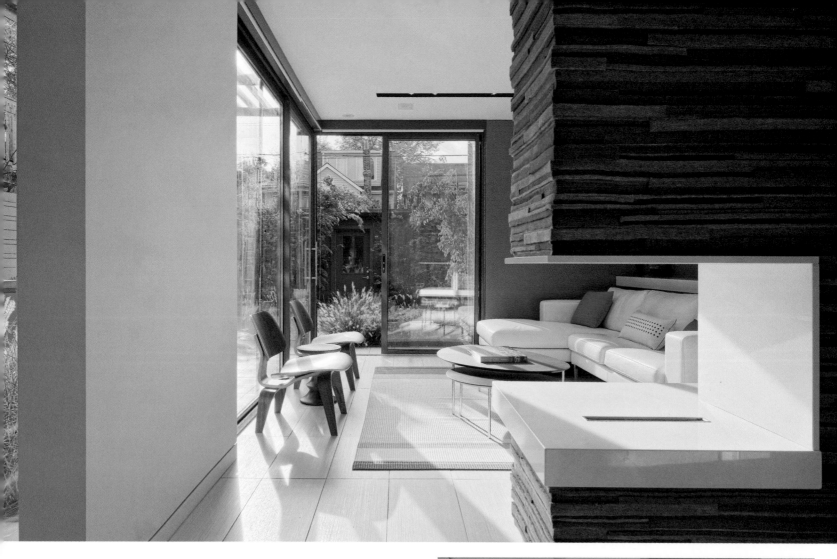

Interior sketch

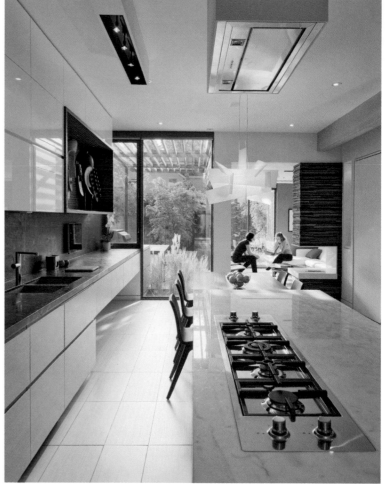

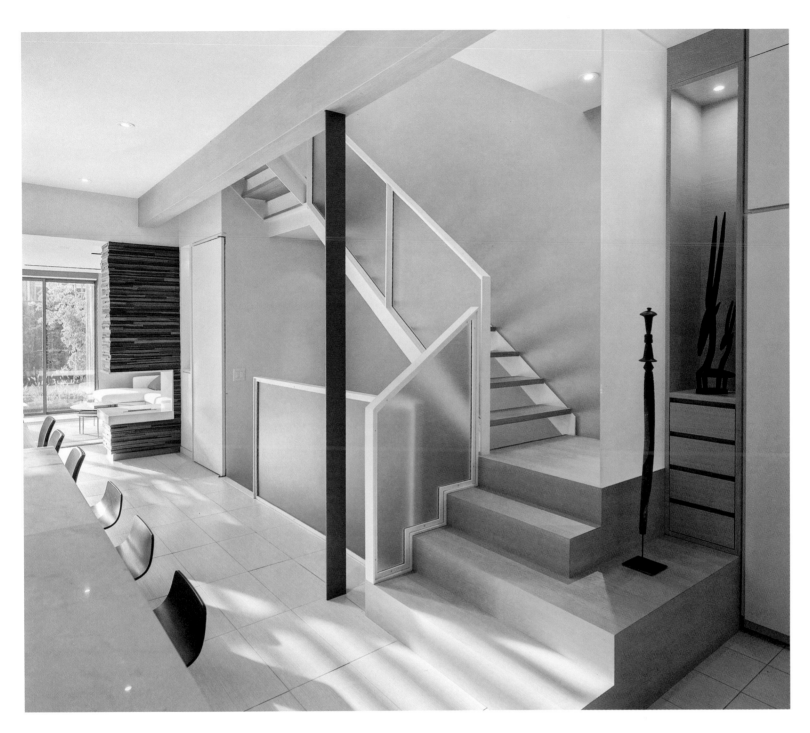

The open staircase and movable skylight provide natural light and also create natural ventilation in the home with a powerful chimney effect, making air-conditioning unnecessary.

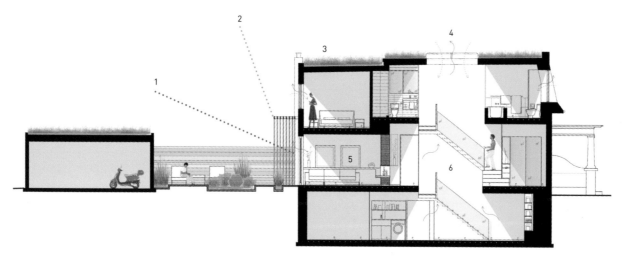

Longitudinal section

1. Winter sun
2. Summer sun
3. Green roof
4. Natural ventilation
5. Thermal mass flooring
6. Daylighting

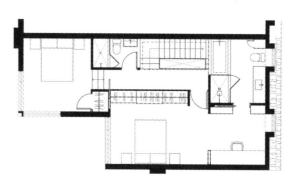

Second floor

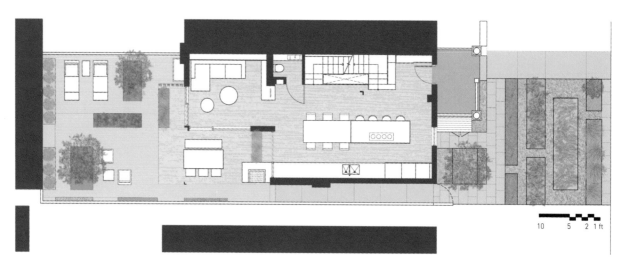

Ground floor

10 5 2 1 ft

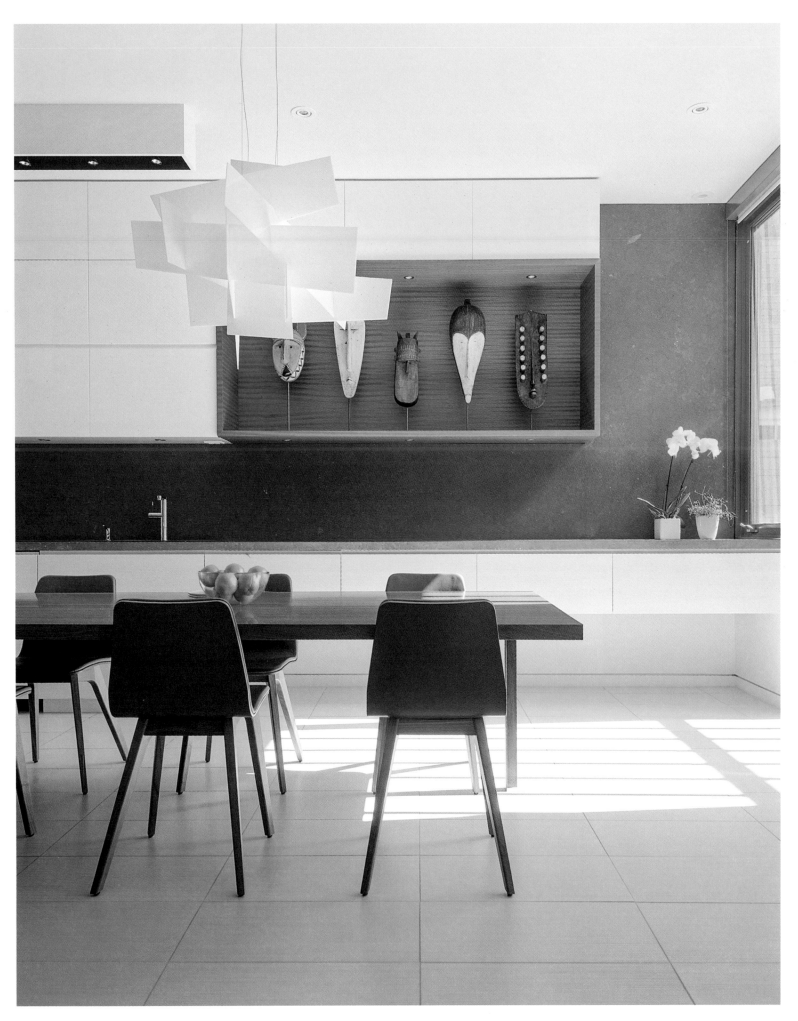

A21 HOUSE

a21studĩo

Location **Ho Chi Minh, Vietnam**
Surface area **430 square feet**
Photographs **© Hiroyuki Oki**

Rainwater collection and use

Natural daylight
Natural ventilation

Trees and plants integration

"Every morning, the first thing I would like to do is to begin a drawing with my mind free and content. I used to dream of a home office so as not to have to travel to work through the frequent traffic jams of a city as highly polluted as Ho Chi Minh."

With his limited budget, this unusually small and non-square plot located just ten minutes from downtown was the best option open to the owner for realizing his dream. The 430-square-foot plot, situated at the end of the street and surrounded by the high walls of neighboring homes, offered great challenges in designing a home office that was spacious enough for four employees and a couple with a child.

The true source of inspiration in the final design of this house is the capturing of nature, in which the sunlight, the wind, the rainwater, and the trees define the various human activities. Thus, the house is full of nature: a tree becomes the heart of the home, around which life is organized in a comfortable space where people can carry out their activities.

"Every morning, I sit next to the tree with a cup of coffee that mirrors the leaves that shine in the dawn sunlight, in harmony with the soft and gentle melody, thinking of the next drawings for my current projects."

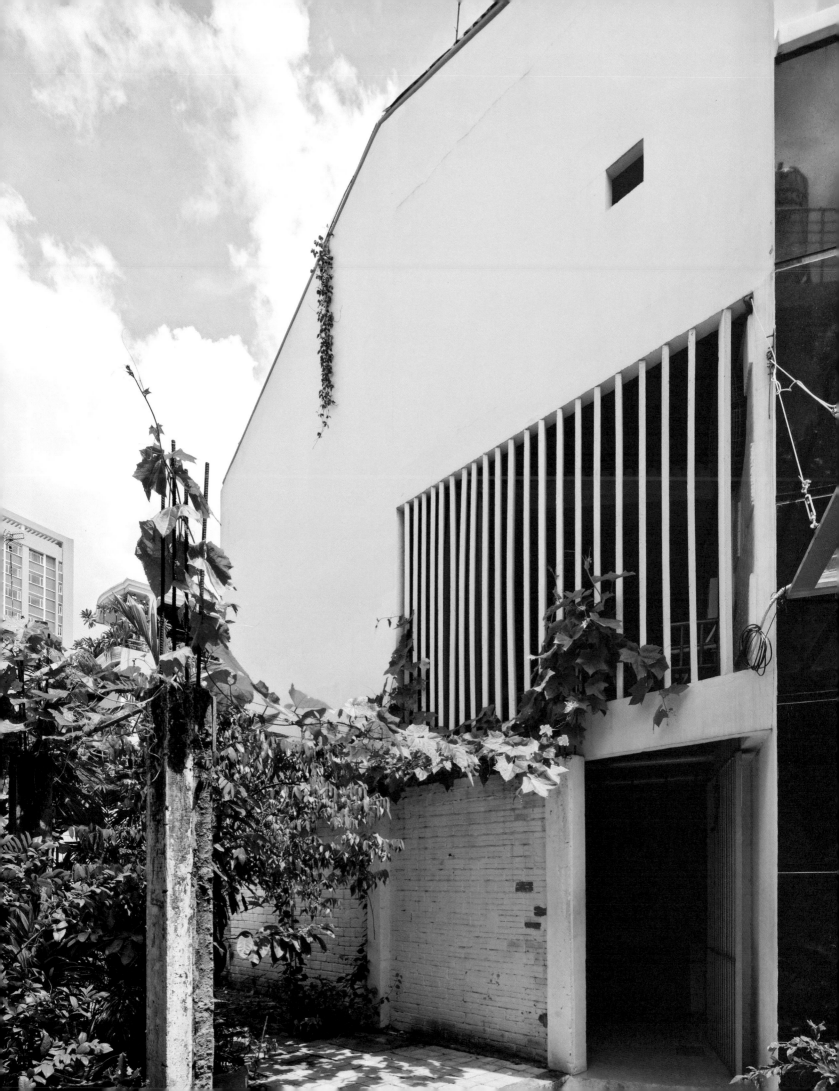

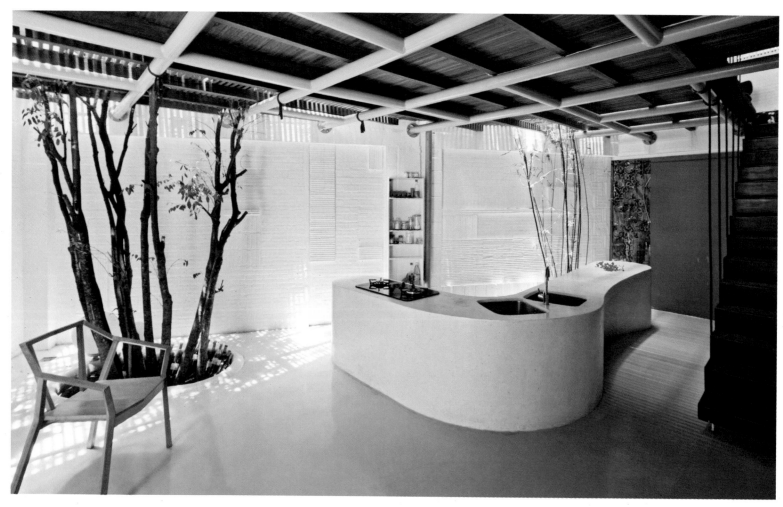

Site plan in perspective

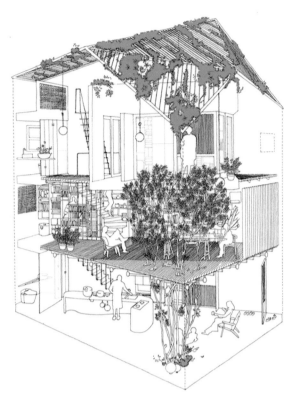

Axonometric view with plants

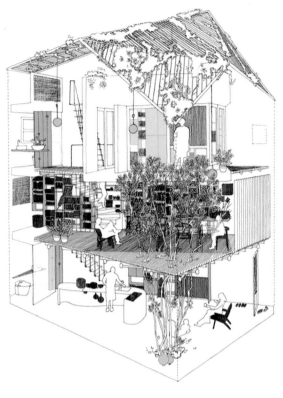

Axonometric view with furniture

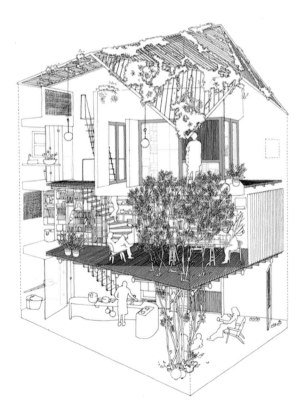

Axonometric view with wooden surfaces

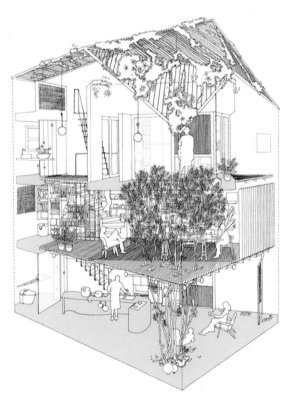

Axonometric view

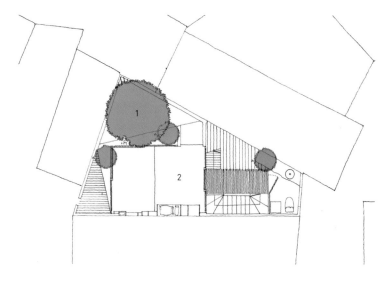

Third floor

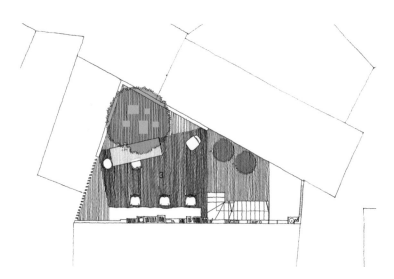

Second floor

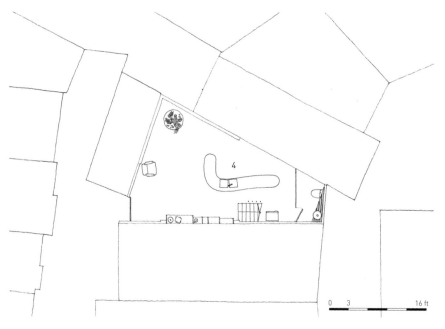

1. Void
2. Bedroom
3. Office
4. Kitchen

0 3 16 ft

First floor

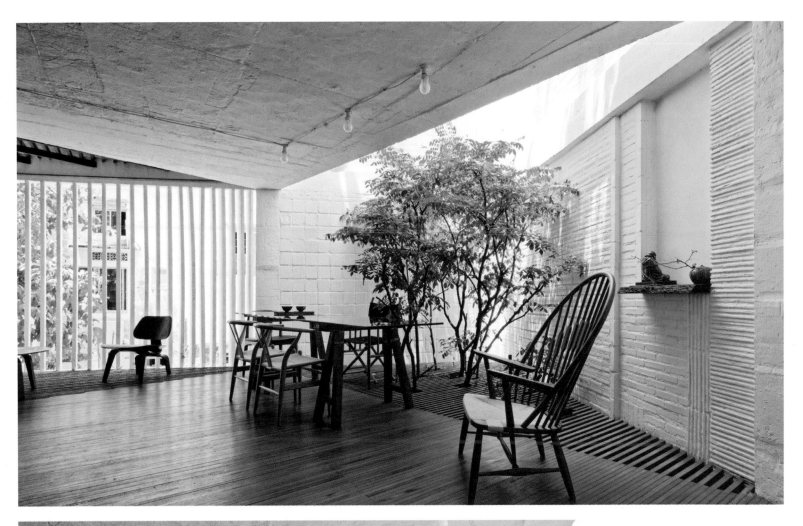

■ Including plants inside the home is a tribute to the auspicious times of yesteryear when nature surrounded humans, who in turn felt closer to changes in their environment.

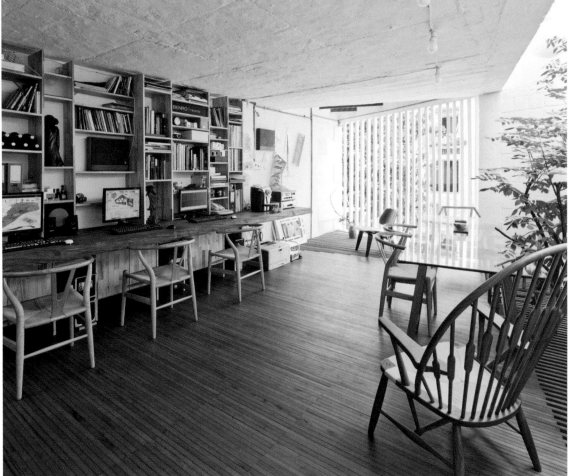

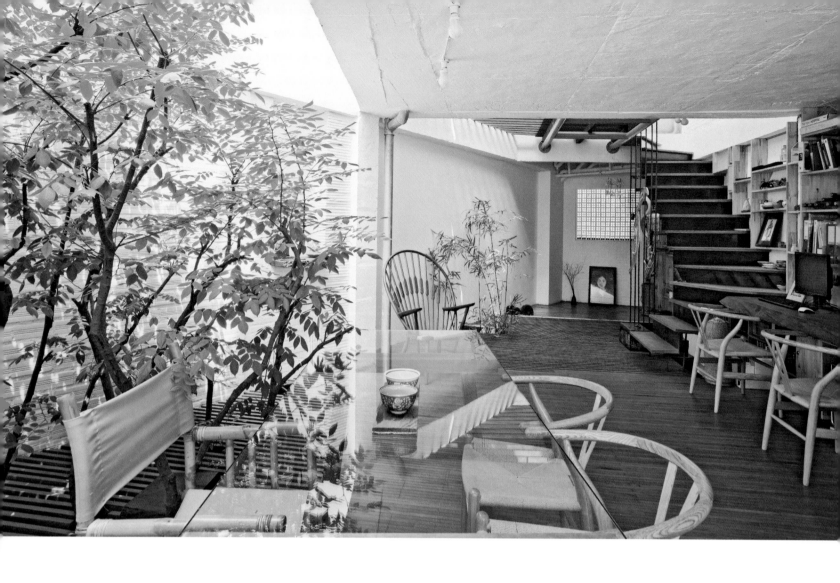

Longitudinal section

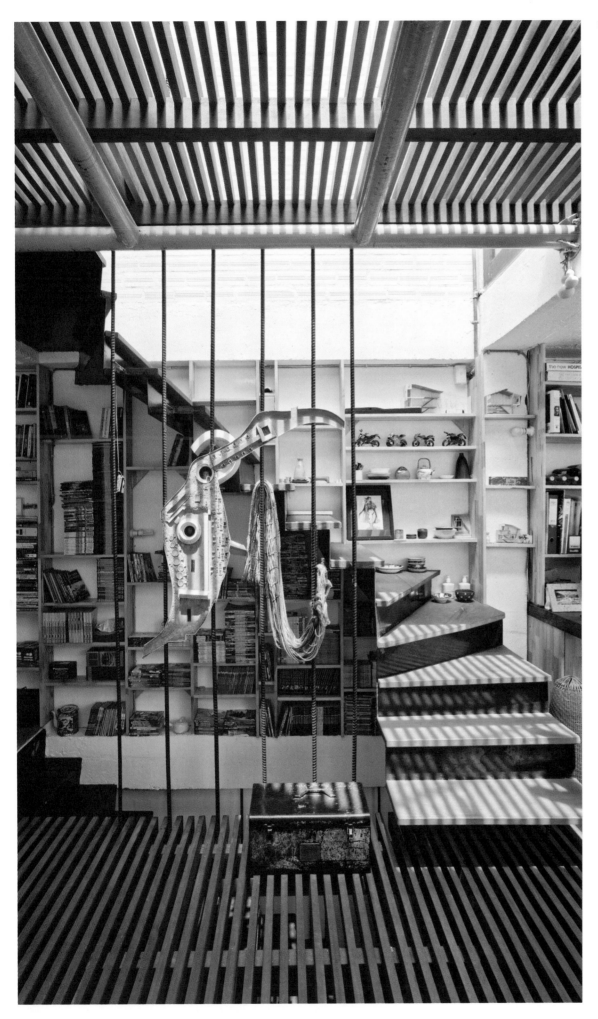

■ The lights run from the first-floor ceiling and are distributed across wooden tracks to illuminate every corner of the house.

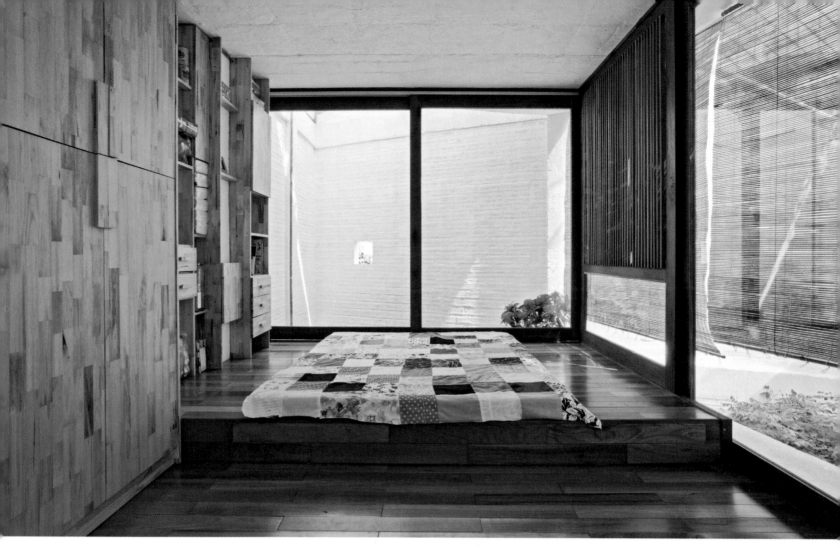

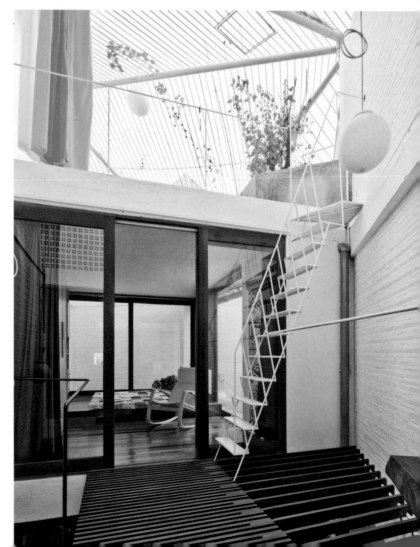

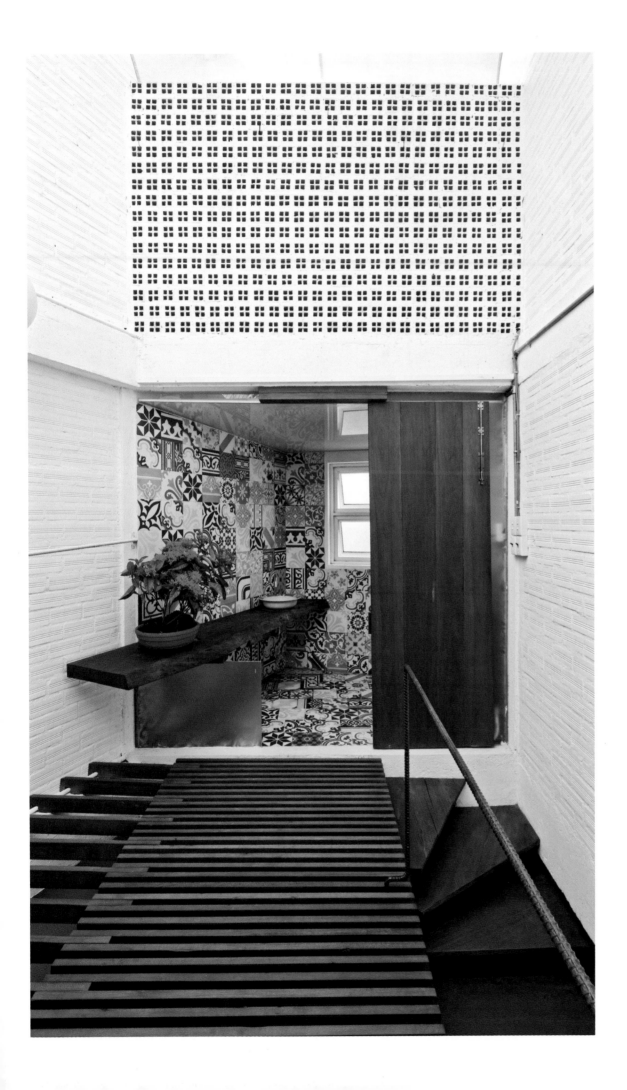

BRICK HOUSE

Leth & Gori

Location **Nyborg, Denmark**
Surface area **1,463 square feet**
Photographs **© Stamers Kontor**

 CO_2 low consumption

 One material construction: solid brick

 High insulation
Natural daylight

This cottage is part of the Mini-CO_2 Houses project initiated by the Realdania charity foundation, which sets out to develop affordable and sustainable housing with a small CO_2 footprint. To achieve this, the aim is to create houses that require no maintenance for fifty years and have a life span of at least one hundred and fifty years.

The house walls are built entirely of clay, to enable the house to breathe. The use of bricks creates a simple, solid, and homogeneous exterior wall that echoes traditional houses that have stood the test of time. By using a single building material, the number of joints between different materials is reduced, and the possibility of construction defects is minimized.

Leth & Gori's work rediscovers the knowledge and techniques used in traditional Danish brick houses. They focus on creating a contemporary home with a long life span, drawing on the best of historic building practices and meshing these with new knowledge and architectural techniques. The result is a home that exudes quality in its architecture and craftsmanship, with solid brick walls that render it strong and healthy, with low maintenance requirements and a pleasant indoor climate.

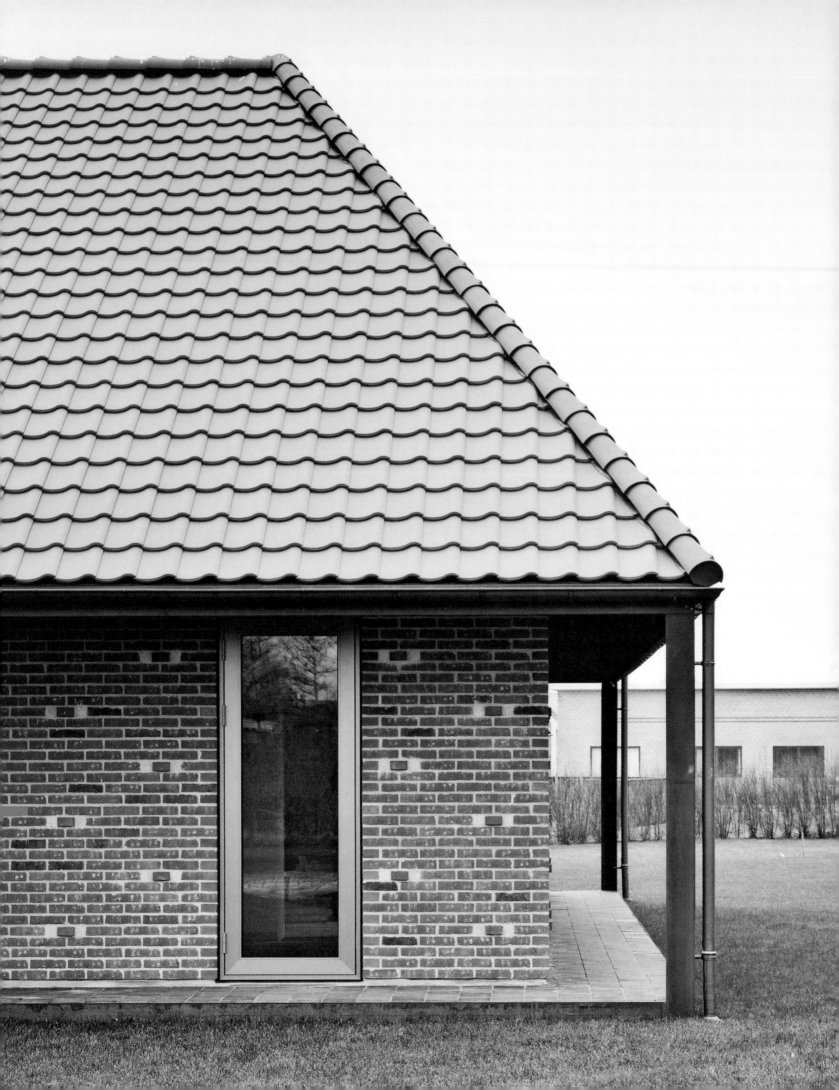

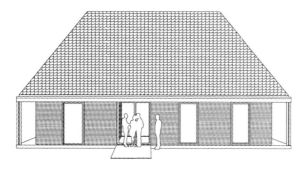

North elevation

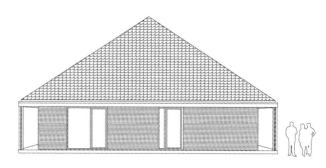

East elevation

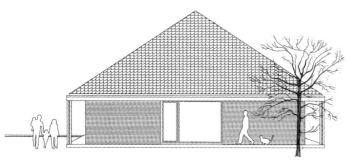

West elevation

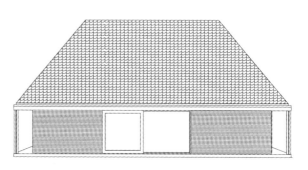

South elevation

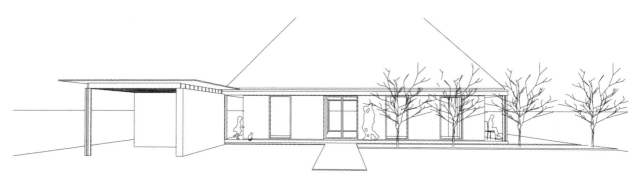

Street view

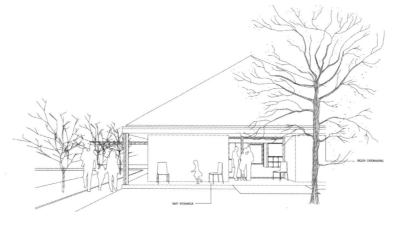

Veranda view

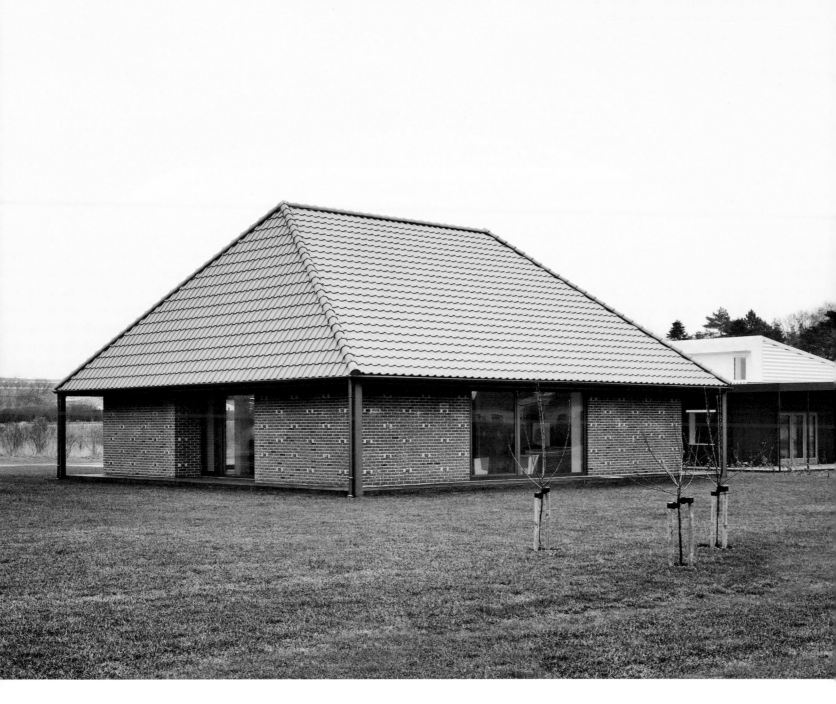

■ The brick walls provide a solid and healthy home with a long useful life, pleasant interior climate, and low maintenance.

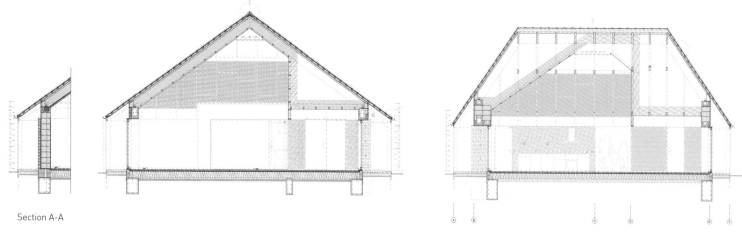

Section A-A

Section B-B

Detailed roof section

1. Recessed light ceiling
2. Plywood cladding with acoustically perforated boards
3. Visible collar tie roof construction
4. Exposed steel cord

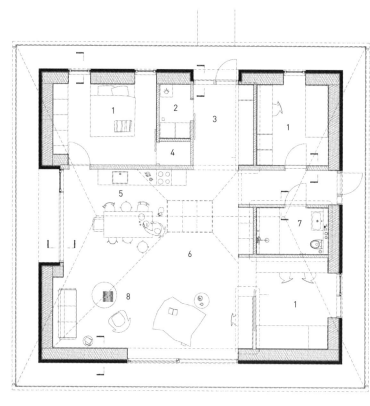

Floor plan

1. Bedrooms
2. Utility room
3. Entrance
4. Storeroom
5. Kitchen
6. Dining room
7. Living room
8. Bathroom

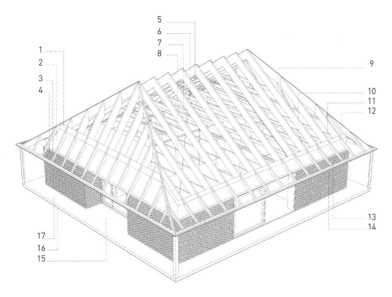

1. Homogeneous brick wall
2. Facade render colored
3. Corten steel 100 x 150 x 8 mm
4. Interlacing masonry
 Homogeneous brick wall
 108 mm bricks, standard format
 30 mm cavity filled with mortar
 425 mm clay blocks
 Gypsum plaster (finished
 wall surface)
5. Light ceiling
6. Interior plywood cladding
 Acoustically perforated boards
7. Collar beam
 Exposed
8. Steel cord
 Exposed

9. Hip Roof / 35° – 55°
 Interlocking roof tiles
 Underlayment: board sheating,
 tongue and groove
10. Paper wool insulation
11. Standard trusses
12. Hip rafter
13. Roof overhang
14. Eaves
 Copper downpipes
 Copper eaves flashing
15. Facade niche
16. Corten steel border
 15 mm corten steel
17. Veranda
 Clinker surface

Axonometric view

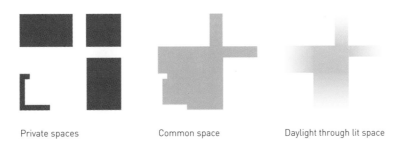

Private spaces

Common space

Daylight through lit space

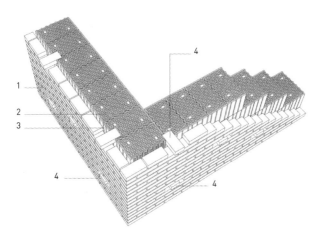

1. Interlacing masonry
 brick (108 x 228 x 55 mm)
2. Clay blocks
 248 x 425 x 249 mm
3. Cavity
 30 mm cavity filled with mortar
4. Interlocking brick

Wall construction detail

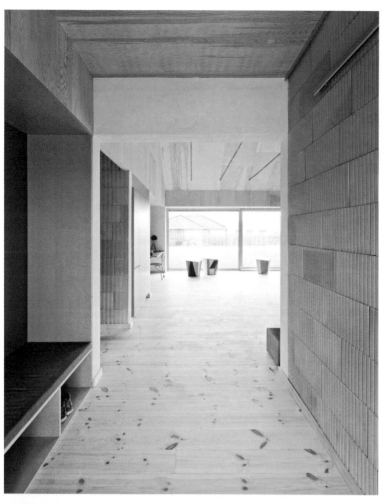

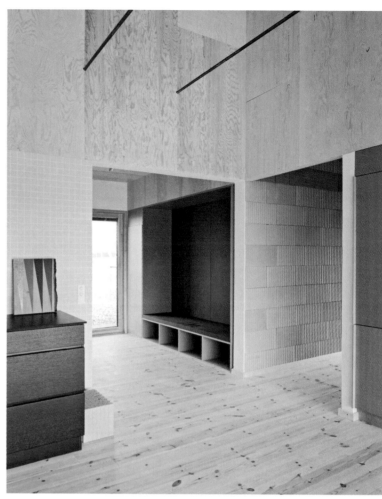

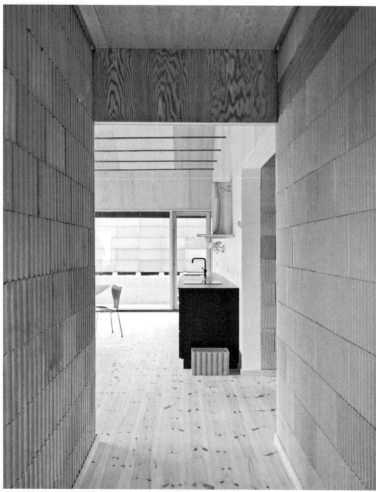

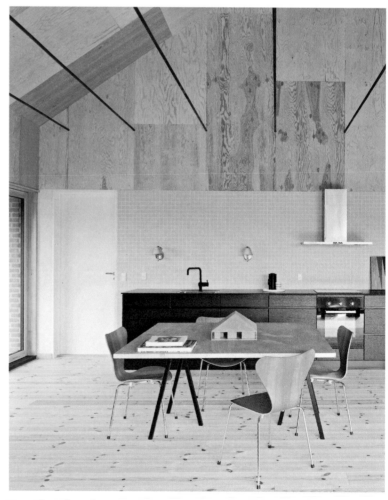

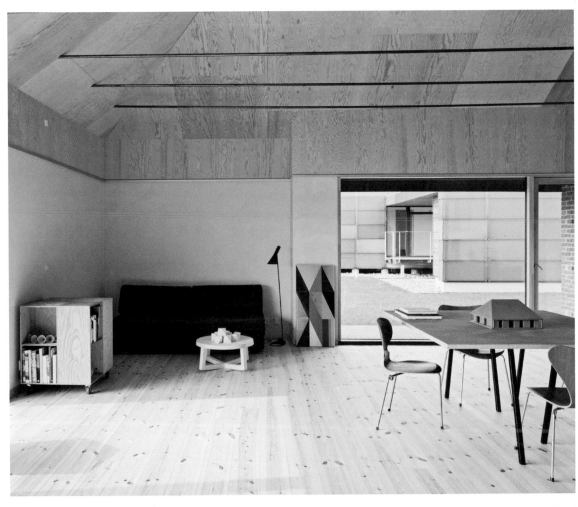

■ The interior is sophisticated yet
simple at the same time: all
bedrooms are organized around
a central space, and the exposed
bricks complement the wood floors
and surfaces.

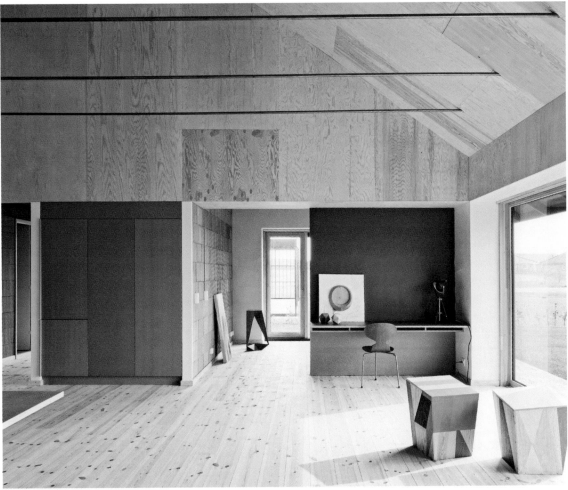

THE NEST

a21studĩo

Location **Binh Duong, Vietnam**
Surface area **430 square feet**
Photographs **© Hiroyuki Oki**

Visual integration

Natural daylight
Natural ventilation

Recycled materials
Low cost construction

Trees and plants integration

This home is located on the outskirts of Binh Duong, a newly developing urban area that is surrounded by houses in a variety of architectural styles. In this environment, a21studĩo and their client were keen that the new house should be "seen to be green" without compromising its comfort.

Due to the budgetary constraints of the project, the main frame of the house is formed from a light structure of sheet iron and steel in place of the usual bricks and mortar. Using this structure, as well as allowing the mortar to be lighter, it helps to cut construction times to less than the norm, enabling cost savings as a result.

With its columns and steel beams that connect to metal sheets, the framework of the house is covered or filled with plants, from a distance creating the impression of being a green box. Between the cold metal bars, nature defines itself.

Besides its low cost, the metal structure provides great spatial flexibility, which has captured the attention of Vietnamese society. By using abandoned items and having enough space to be able to live intelligently, it is possible to have a comfortable house that is committed to nature and flexible enough for any future requirements.

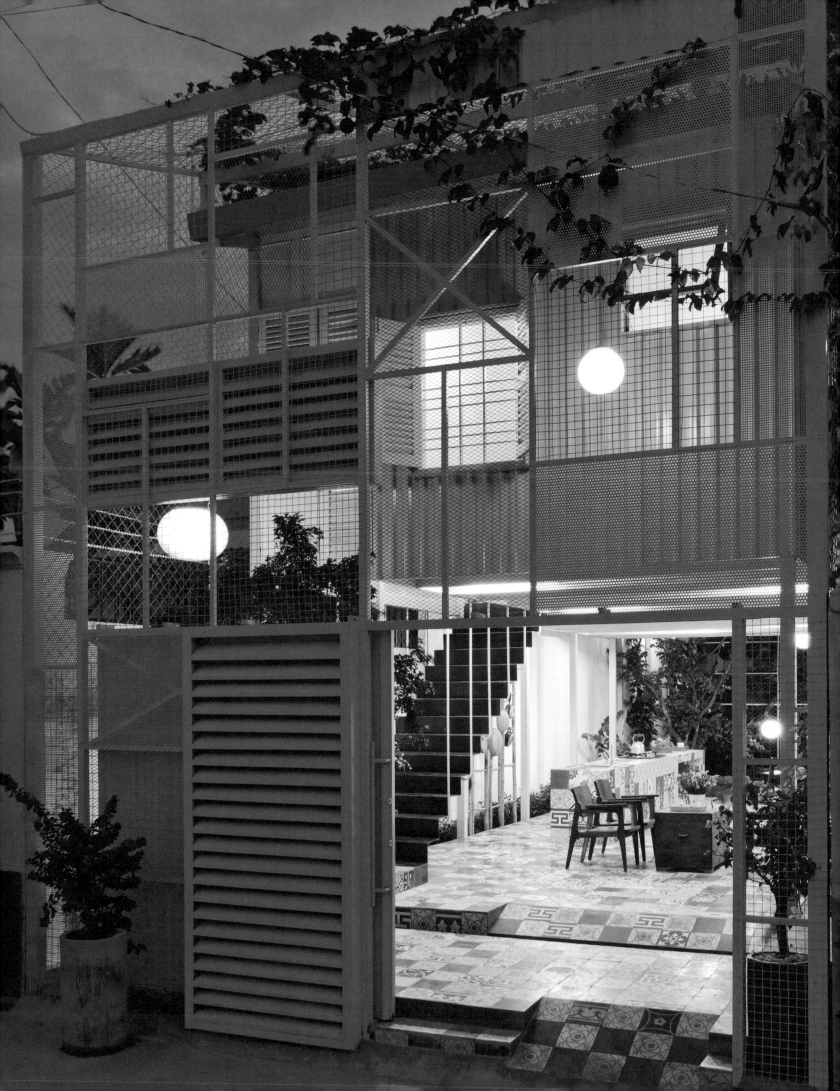

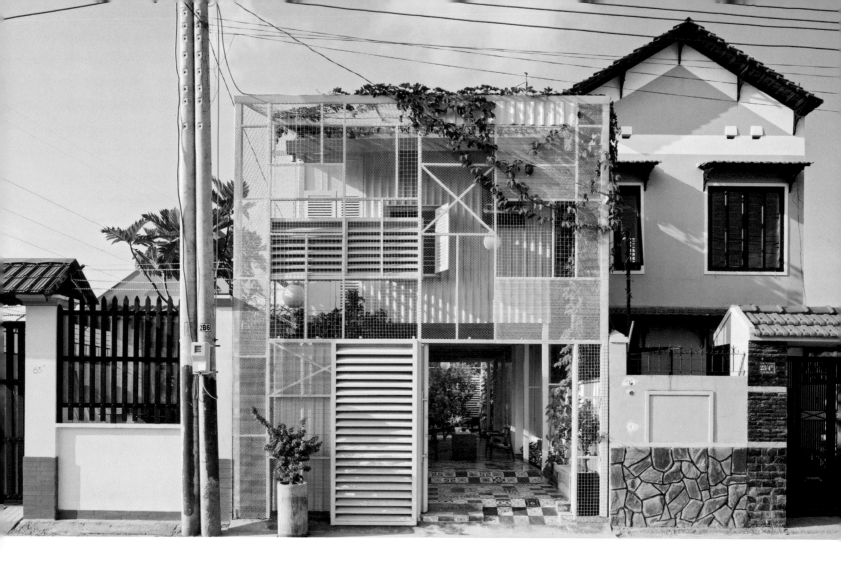

Concept of project development

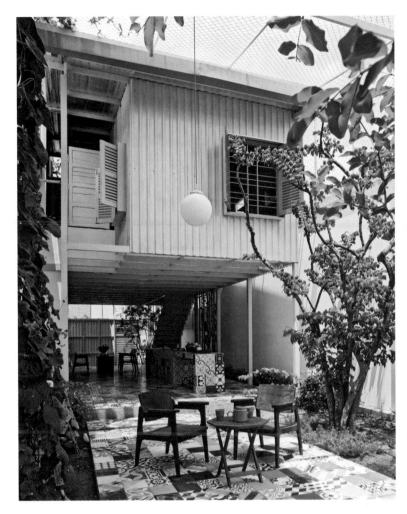
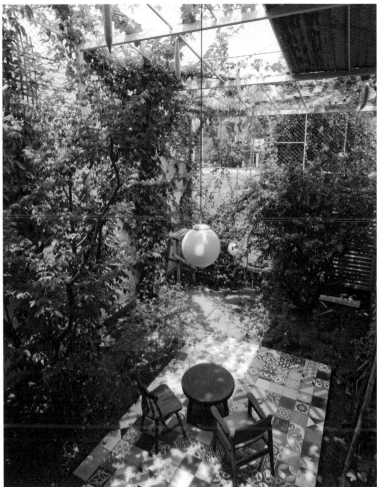

Concept of elevation

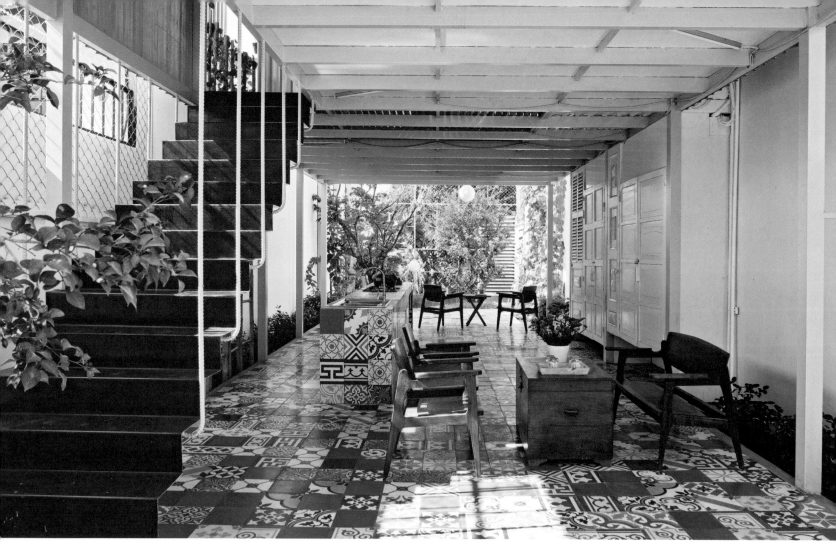

The kitchen and living room are open to nature, blurring the boundary between the home's interior and exterior.

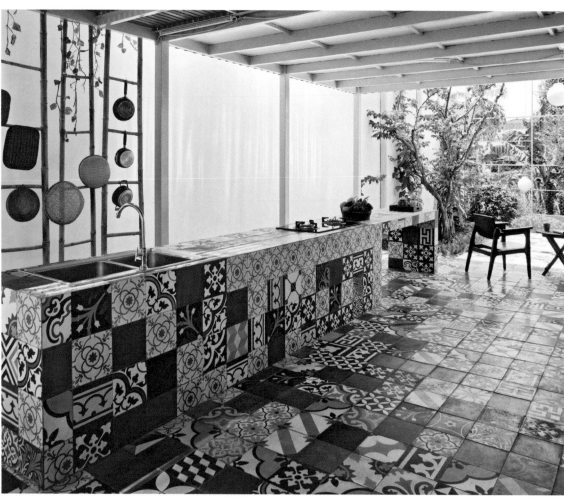

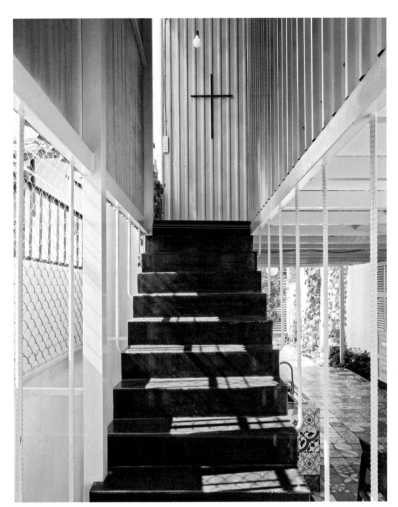

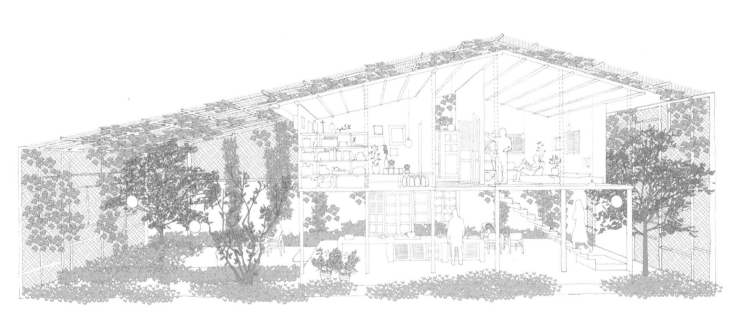

Longitudinal section

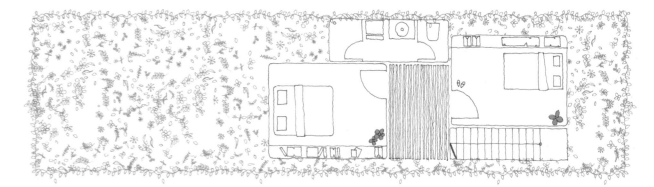

Floor plan

Diagrams

■ Abandoned furniture that is still in good condition is a clever solution for most rooms in the house and reduces the overall cost.

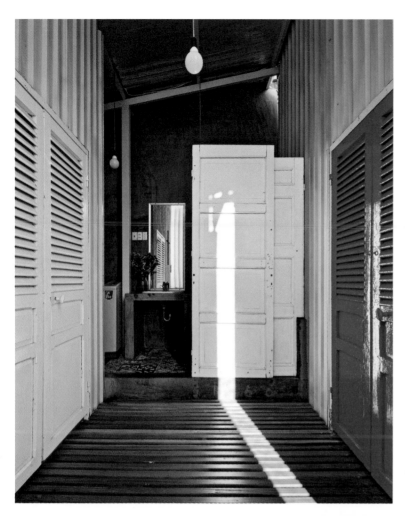

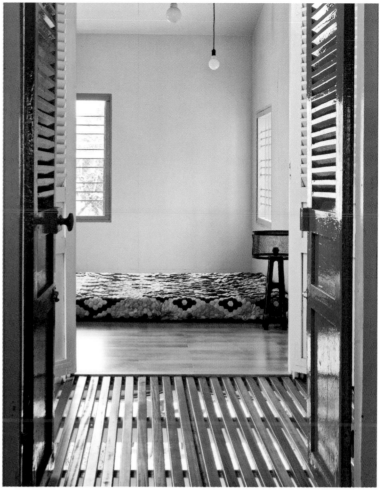

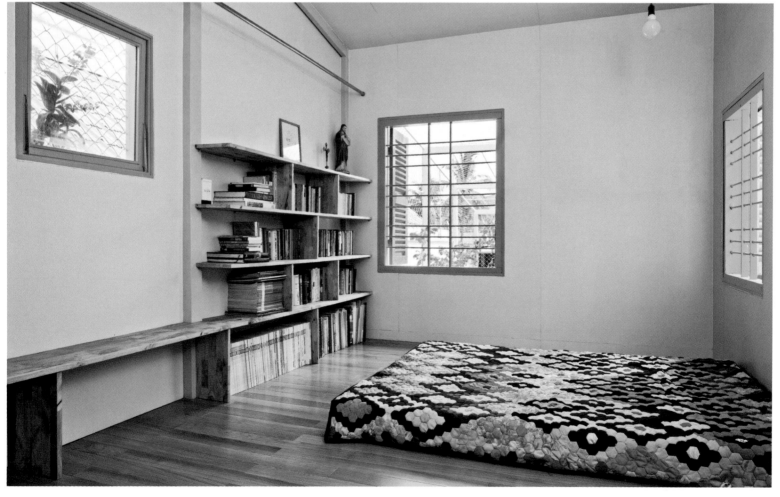

STAND 47
AT MONAGHAN FARM

Thomashoff + partner Architects

Location **Monaghan Farm, South Africa**
Surface area **4,025 square feet**
Photographs **© Karl Rogers**

 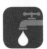 Landscape integration
Wind protection

 Prefabricated materials
Sustainable wood

Rainwater collection and use

Natural daylight

 Photovoltaic solar energy
High insulation

The aim of this collaborative project was to build an energy-efficient home in Monaghan Farm, which will act as a case study to demonstrate that housing in South Africa can be built successfully using predominantly energy-efficient materials while retaining the qualities of permanence and longevity that are associated with traditional houses.

The challenge of the project is to explore the process of designing and building housing that adheres to the concept of energy efficiency every step of the way. Thus, a simple layout is sought, while aiming to ensure the efficient use of resources both during the construction process and during the entire life cycle of the building. Furthermore, to maintain quality within the home, the project takes into account key factors such as comfort and familiarity as well as social status and aspiration, which are essential in this sector of the residential market.

The evolution of the project was documented in detail from the concept design phase until its full completion. All this information is available for carrying out a detailed case study of the project and evaluating its thermal performance.

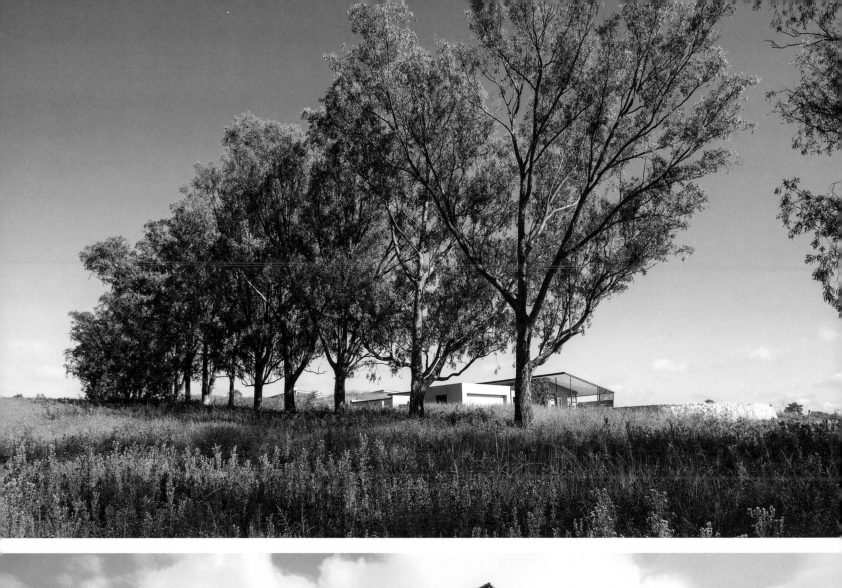

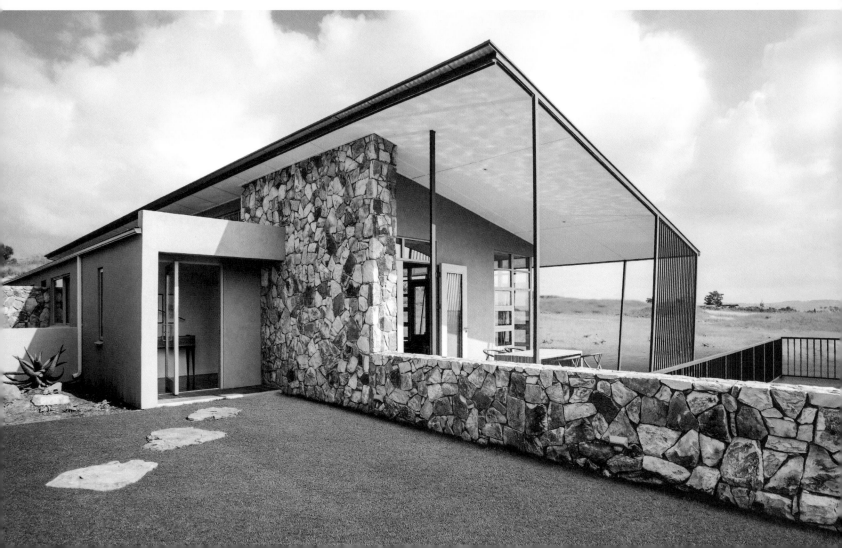

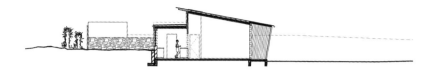

Section A-A

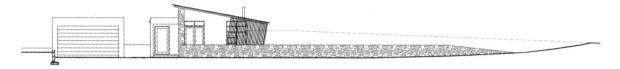

East elevation

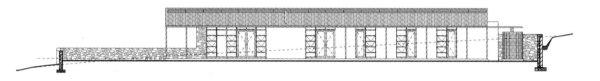

North elevation

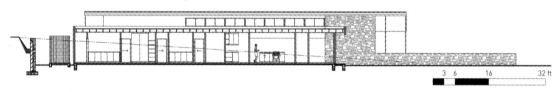

South elevation

3 6 16 32 ft

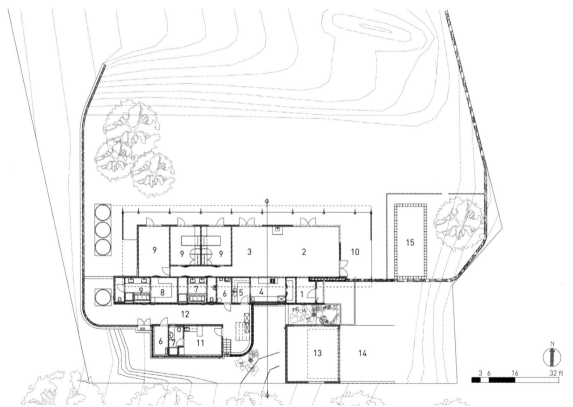

Floor plan

1. Foyer
2. Living room
3. Dining room
4. Kitchen
5. Scullery
6. Storeroom
7. Bathroom
8. Dressing room
9. Bedrooms
10. Veranda
11. Staff room
12. Yard
13. Garage
14. Driveway
15. Pool

N

3 6 16 32 ft

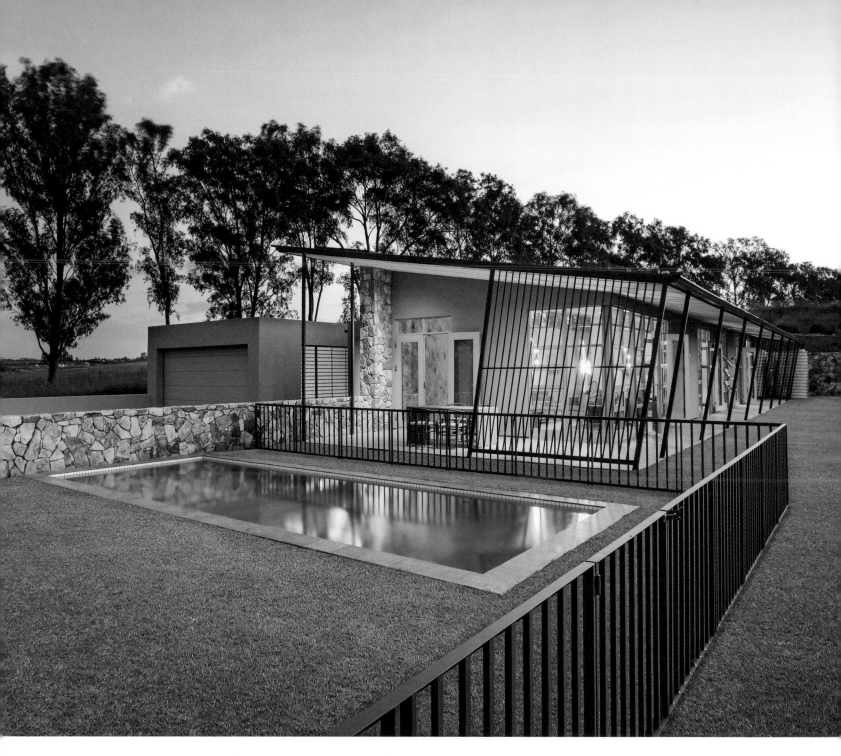

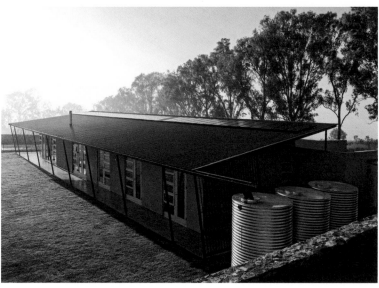

The sloped roof can collect up to 5,300 gallons of rainwater. The height and orientation selected were also adapted to the solar panel installation requirements.

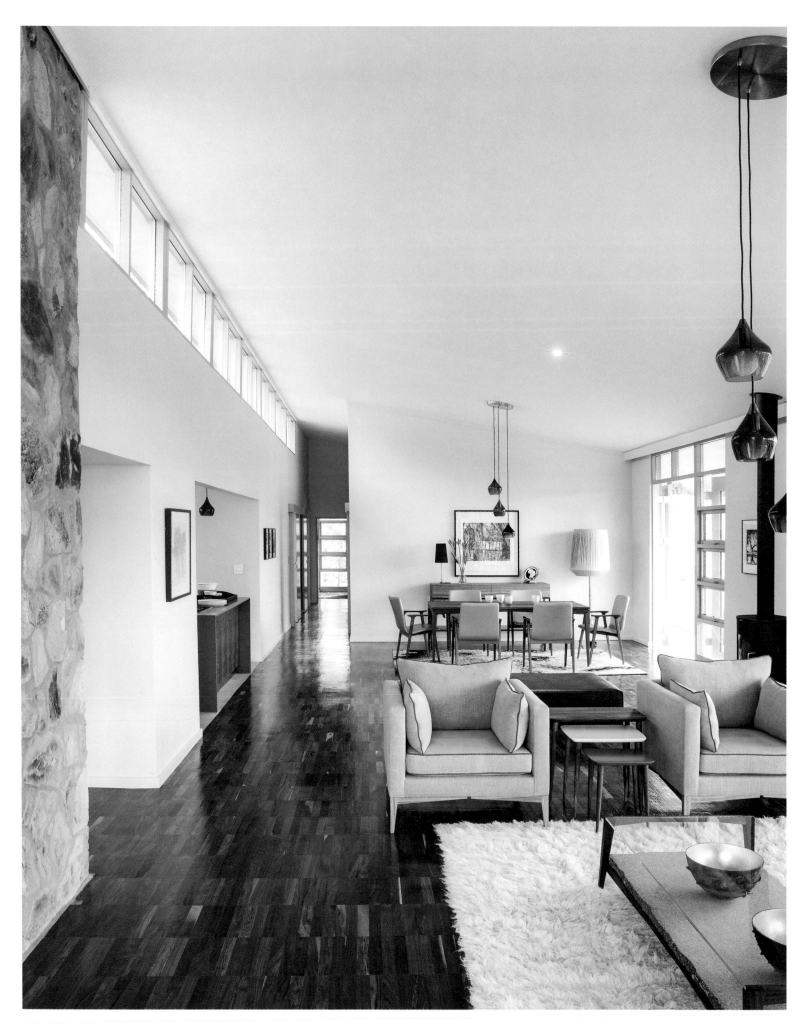

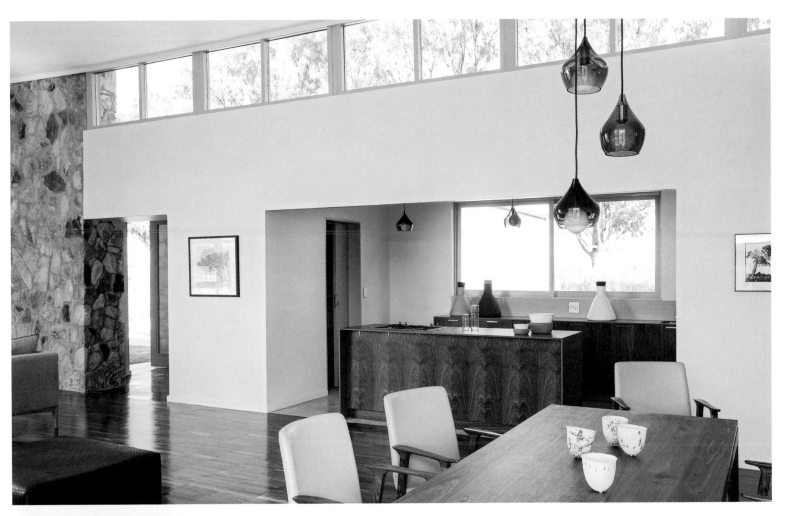

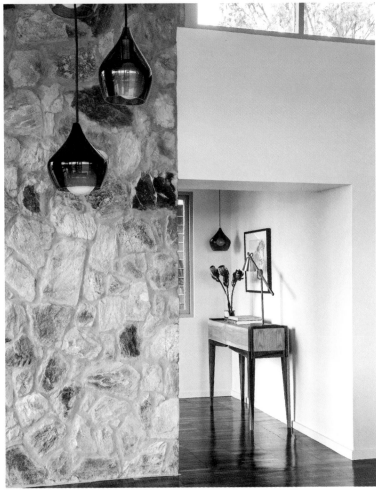

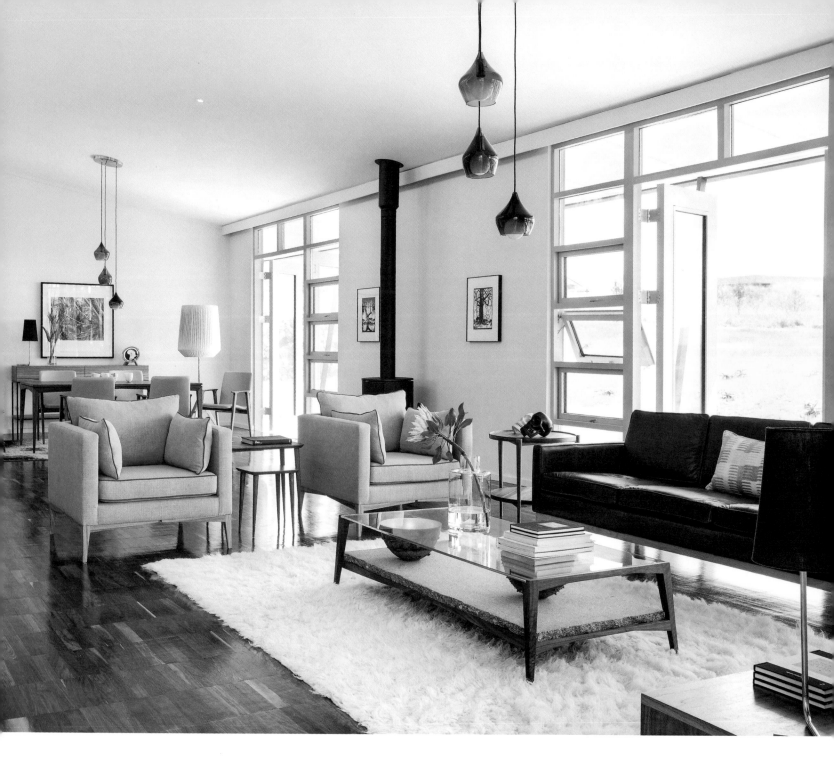

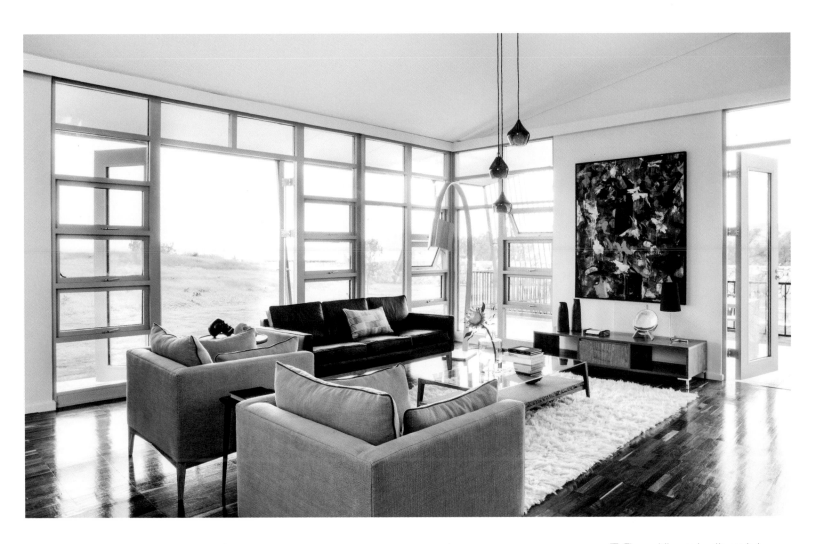

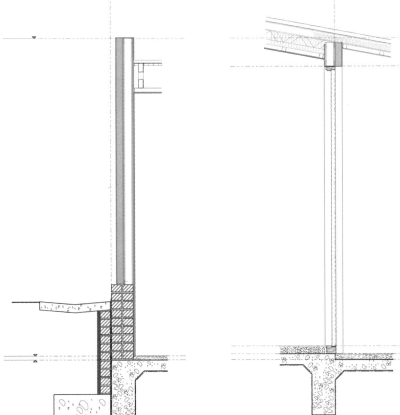

Detailed wall section

■ The multilayered walls made by Saint-Gobain offer thermal and acoustic insulation and greater fire resistance than traditional bricks and mortar, while also improving air quality.

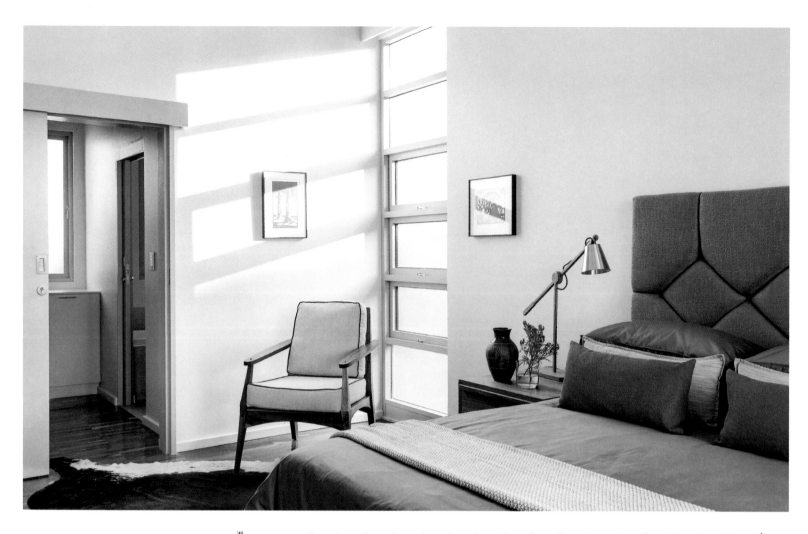

In order to facilitate the installation and allow for future changes, all electrical services are aligned and divided into areas throughout the center of the home's living room.

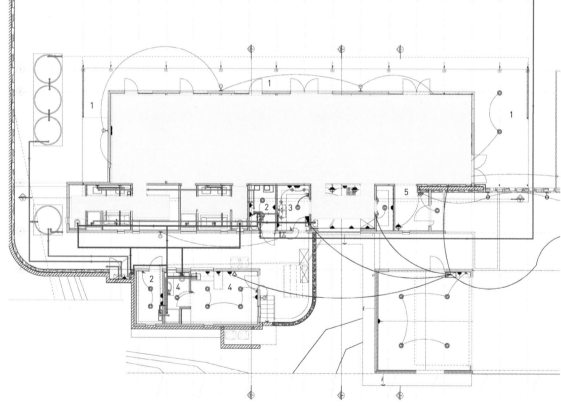

Electrical / water supply plan
1. Veranda
2. Storage area
3. Scullery
4. Bathroom
5. Foyer
6. Staff room

━━━━ Cold water supply (municipal)
━━━━ Hot water supply (municipal)
━━━━ Collected rainwater
━━━━ Rainwater / Municipal water (from changeover or diversion valve)

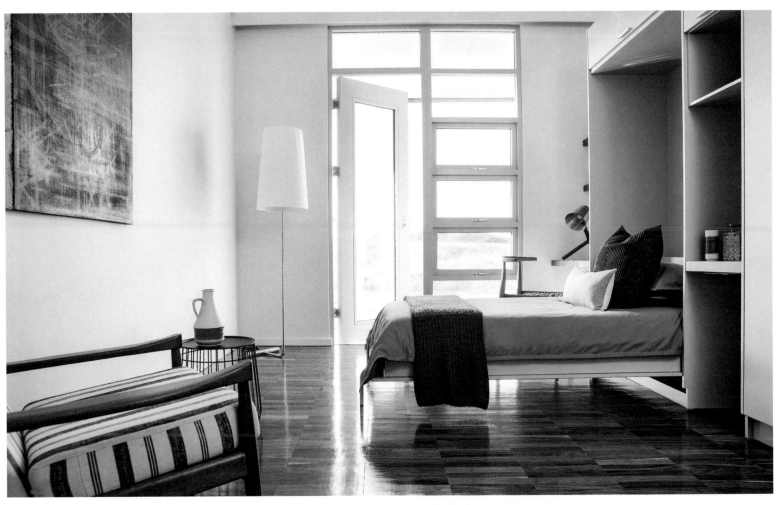

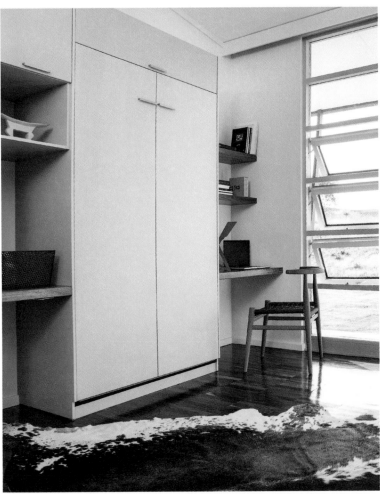

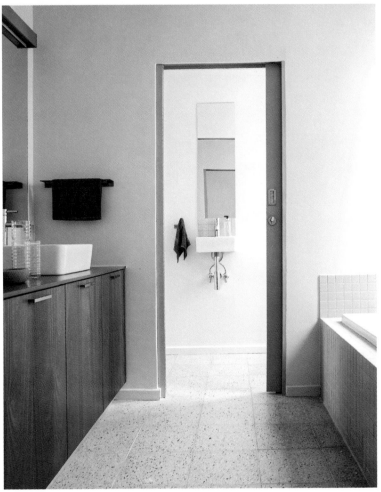

A SUSTAINABLE NEIGHBORHOOD

Atelier Tarabusi

Location **Nantes, France**
Surface area **44,541 square feet**
Photographs © **Sergio Grazia**

 Rainwater collection and use

 Mixed wood / concrete building system

 Passive solar
Gas condensing boiler
Independent wood boiler for multifamily dwellings

 Natural ventilation
High insulation
Double insulated glazing separated by argon

This housing complex in Nantes is energy-efficient and completely flexible, offering a sustainable solution that meets the needs of a wide variety of families.

Located in the Bottière Chênaie neighborhood, the project comprises two apartment blocks with thirty-six units and seven terraced blocks with twenty-six units, oriented to the east and west. The apartment blocks are designed in a more "classical" form and aim to attract those in search of a standard solution. Meanwhile, the terraces provide more flexible solutions: the residential complex meets the needs of many different types of families: young couples, first-time buyers, growing families, and singles.

The terraced units are conceived as small blocks in a compact form. Each block consists of two three-bedroom duplexes with private garden on the ground floor, and two smaller units with one and two bedrooms respectively, and direct access to a private terrace on the second floor. All the duplexes have a double-height living space, offering the residents the easy option of adding an extra bedroom: a real space in reserve, enabling a further 130-square-foot bedroom to be added to the home at low cost.

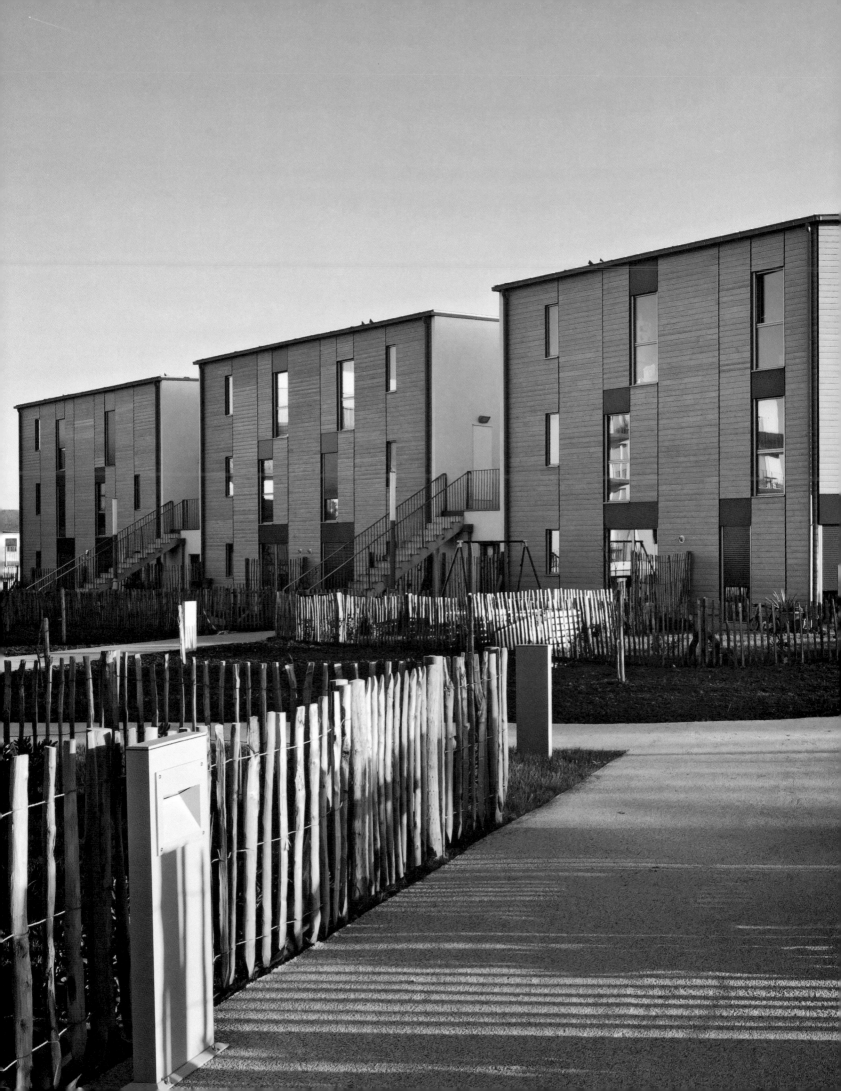

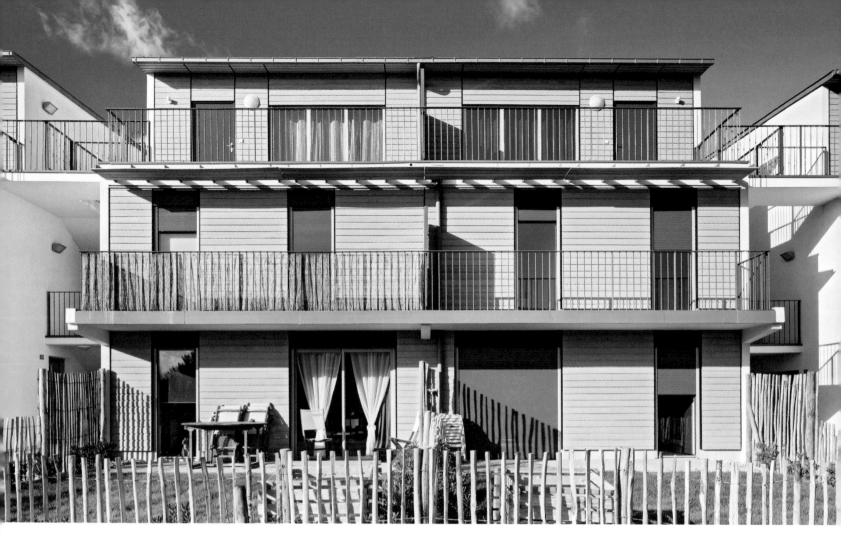

■ Rainwater is managed with a retention tank that filters into the groundwater and regulates the flow speed before exiting into the public drainage system.

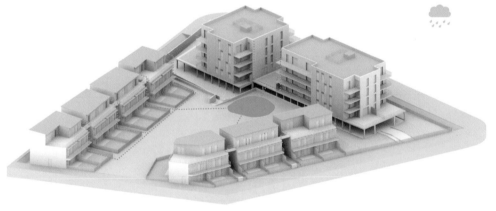

3-D view with the distribution of rainwater management system

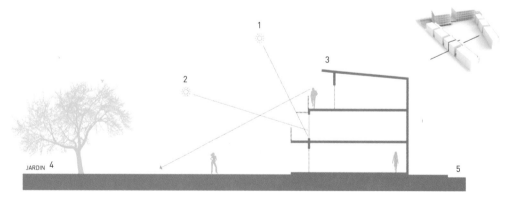

JARDIN 4 5

Section

1. Summer solstice 63º 4. Garden
2. Winter solstice: 16.5º 5. Street
3. Solar protection

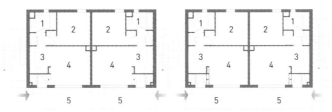

Second floor

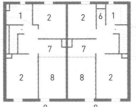
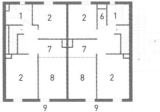

First floor

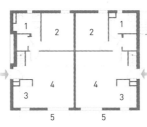
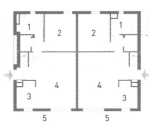

1. Bathroom
2. Bedroom
3. Kitchen
4. Living room
5. Terrace
6. Toilet
7. Mezzanine
8. Double volume
9. Balcony

Ground floor

Plans without additional room

Plans with additional room

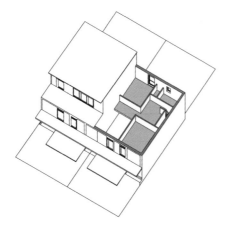
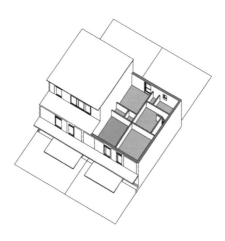

Axonometric view without additional room

Axonometric view with additional room

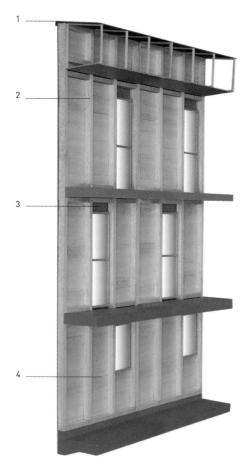

1. Zinc roof on wood framing
2. Vertical wood structure
3. Roller shutter box
4. Thermal insulation between wood frame

Detailed interior 3-D view of the facade

1. Composite panel like fundermax
2. Lacquered aluminum roller shutter
3. Pre-gray larch cladding
4. Lacquered aluminum carpentry
5. Hollow joint-vertical batten siding attachment

Detailed exterior 3-D view of the facade

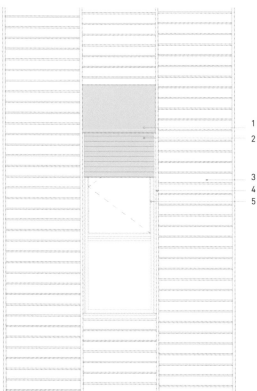

1. Composite panel like fundermax
2. Lacquered aluminum roller shutter
3. Pre-gray larch cladding
4. Hollow joint-vertical batten siding attachment
5. Lacquered aluminum carpentry

Exterior facade plan

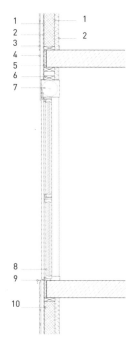

Outside
1. OSB panel
2. Rain screen
3. Pre-gray larch cladding
4. Composite panel like fundermax
5. Styrofoam insulation
6. Horizontal wood structure
7. Roller shutter box
8. Lacquered aluminum carpentry
9. Lacquered aluminum coping
10. Thermal insulation between wood frame

Inside
1. Vapor barrier
2. Plaster

Cross section of the facade

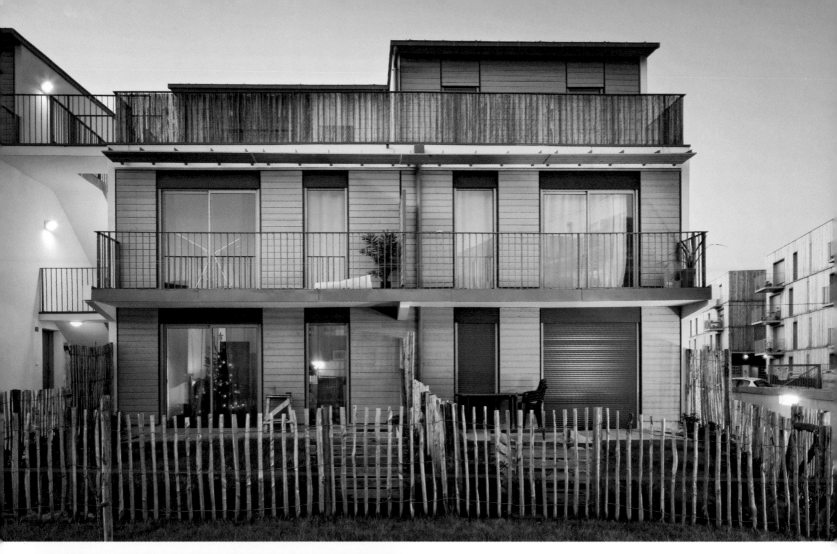

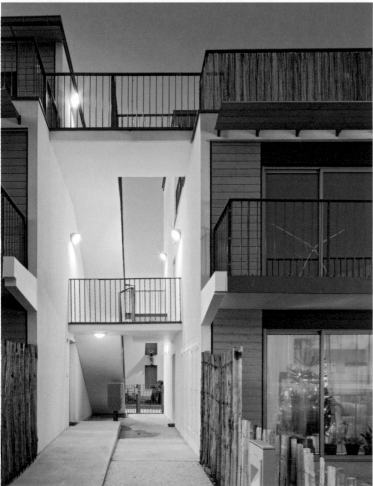

■ The combination of materials in the retention walls and facade takes advantage of the thermal properties of concrete and the technical, economic, and environmental advantages of wood.

■ Flexibility: the duplex is designed to respond to growing families by featuring extra tall ceilings as a space to add an additional bedroom.

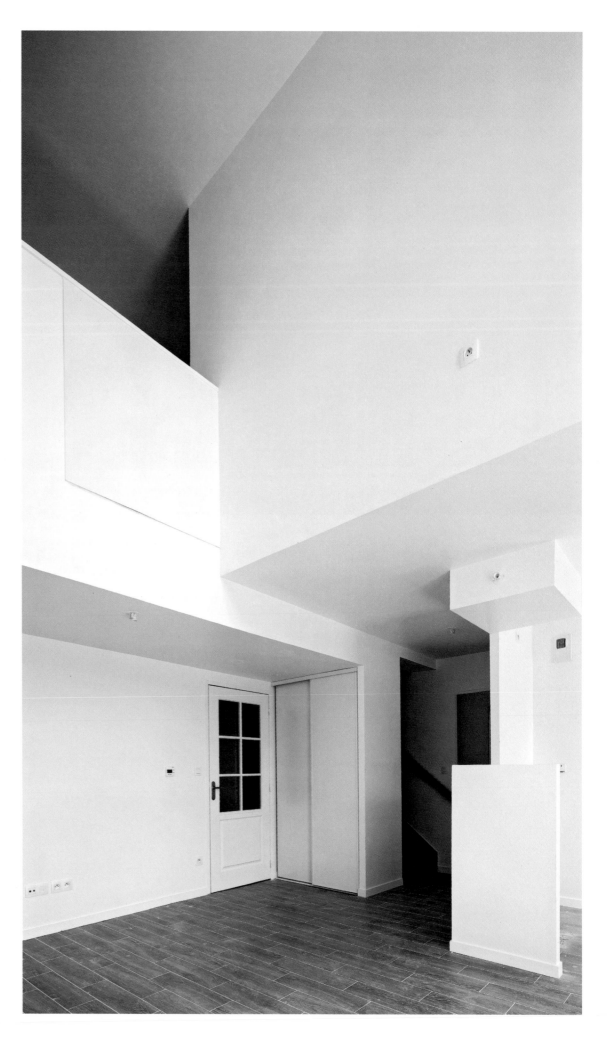

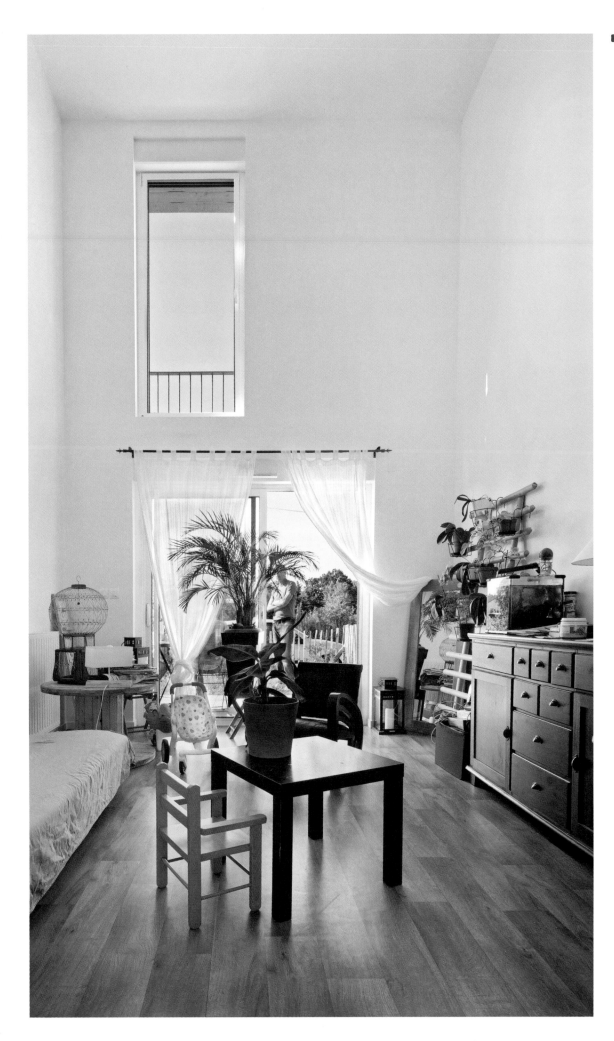

■ The home faces two directions, which facilitates natural interior ventilation and limits overheating during summer.

SINGLE-FAMILY HOME IN THE JIZERA MOUNTAINS

Pavel Horák | Prodesi

Location **Jizera Mountains, Czech Republic**
Surface area **1,539 square feet**
Photographs **© Lina Németh**

 Landscape integration

 Local materials
Wooden construction

The basic materials from which this house is constructed are traditionally used to build simple rectangular huts with gabled roofs, which are characteristic of the Jizera Mountains region in the Czech Republic. The design, with its wooden structure that rests cantilevered on a stone plinth as though moved from its original situation by a flood, is one of the wonders of the region.

The design adapts the house perfectly to the land it occupies. The west-facing plot offers a beautiful panoramic view of the valley. The terrain is quite rocky and has a prominent rock formation on the southwest flank, which is cleverly exploited by the Prodesi design to offer a beautiful view of the entire region.

The facade of the house is composed of long vertical interlocking larch planks whose characteristic tone was acquired naturally outdoors. The window frames, shadows, and metal roof are charcoal gray, a color that is consistent with the traditional wooden houses of the area, allowing the house to integrate fully with its environment.

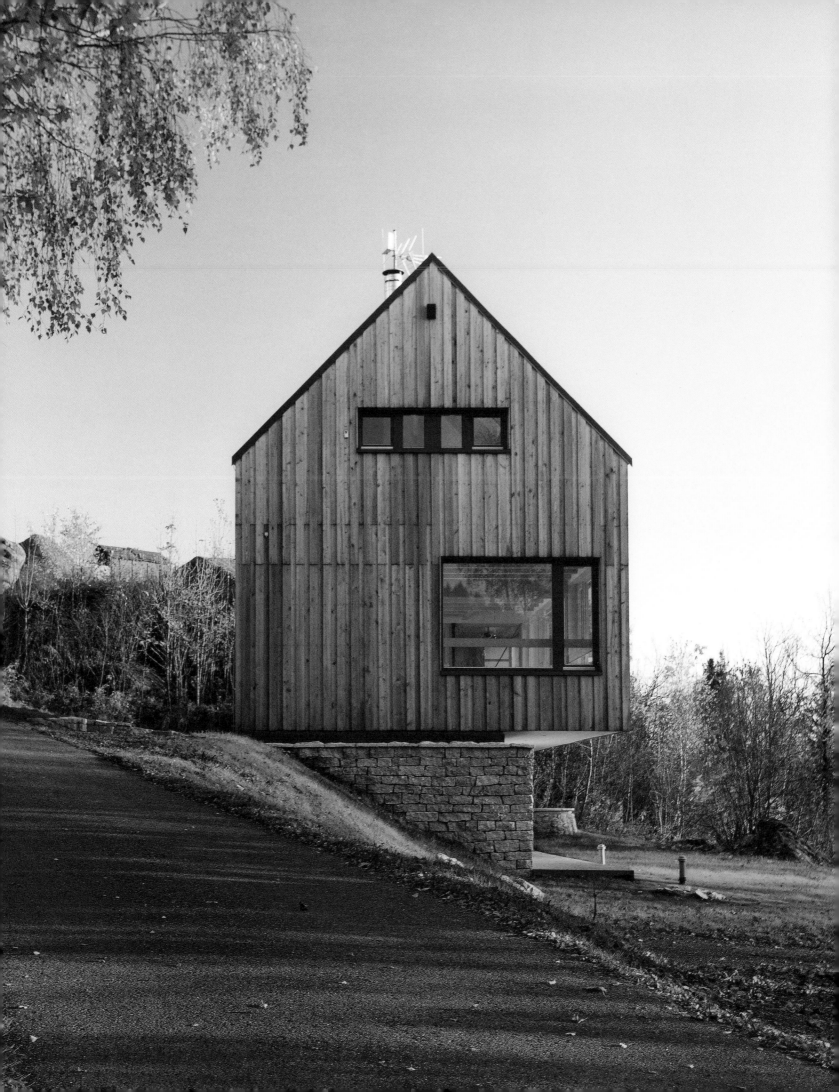

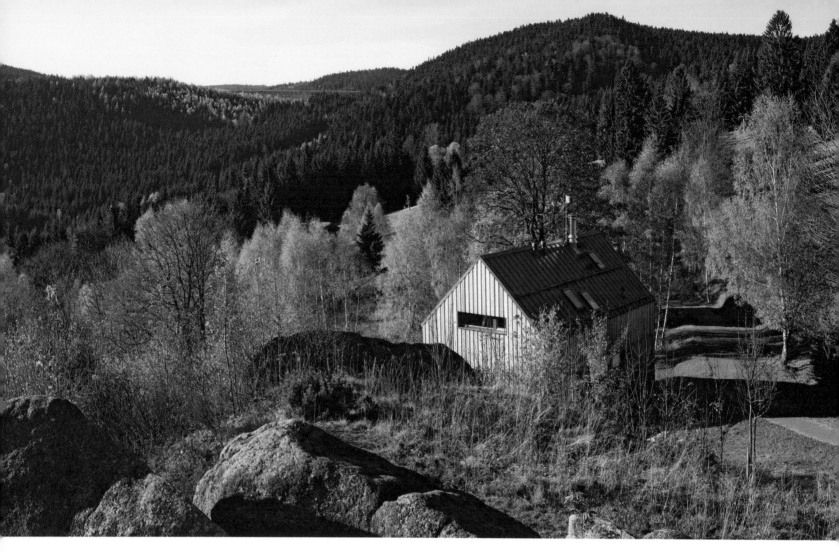

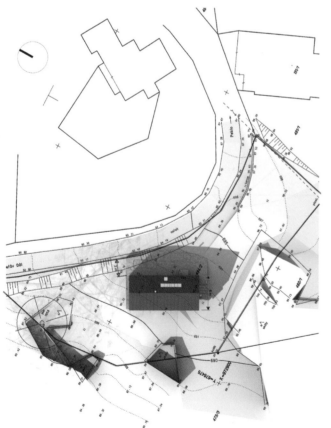

Site plan

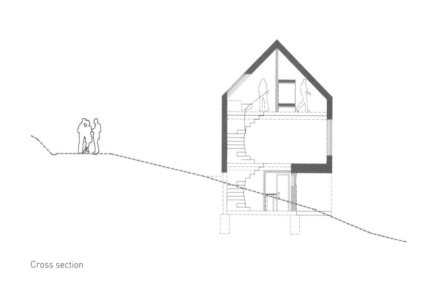

Cross section

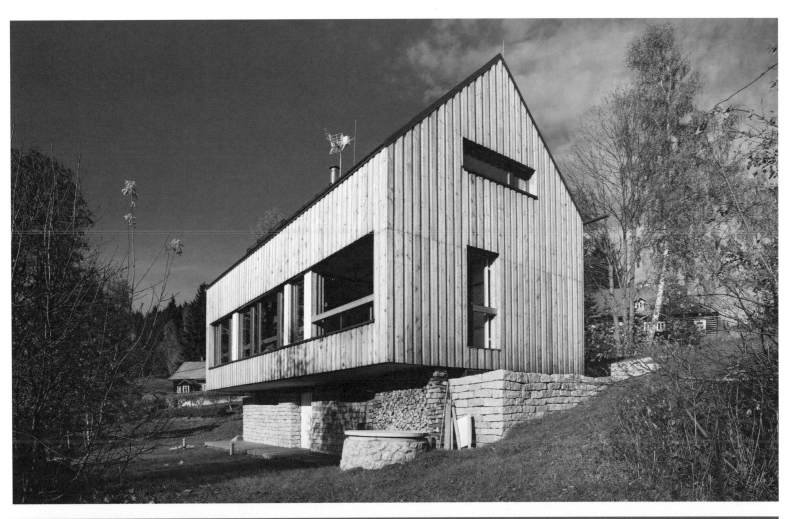

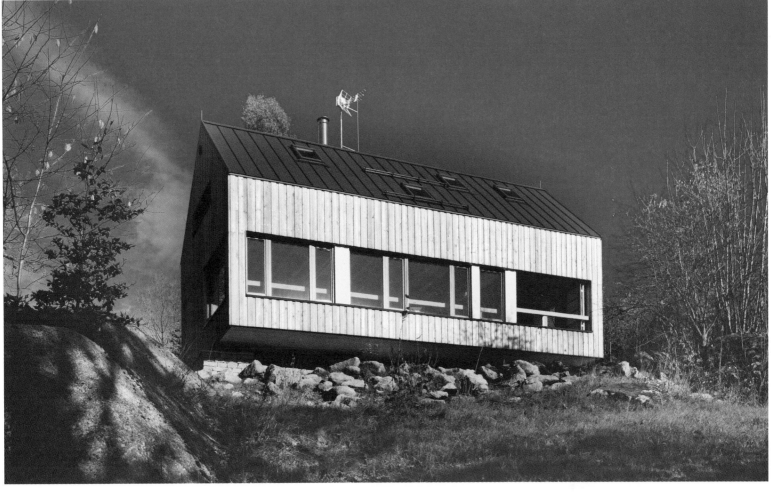

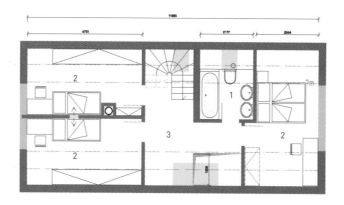

Attic floor

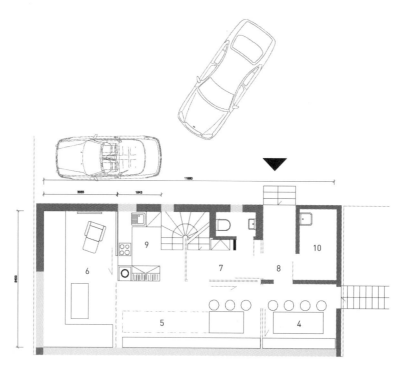

First floor

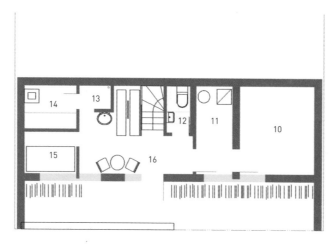

Basement

1. Bathroom	7. Vestibule	12. Toilet
2. Bedrooms	8. Entrance hall	13. Shower
3. Play space	9. Kitchen	14. Sauna
4. Terrace	10. Storage room	15. Pool
5. Living room	11. Utility room /	16. Hall
6. Covered terrace	Laundry room	

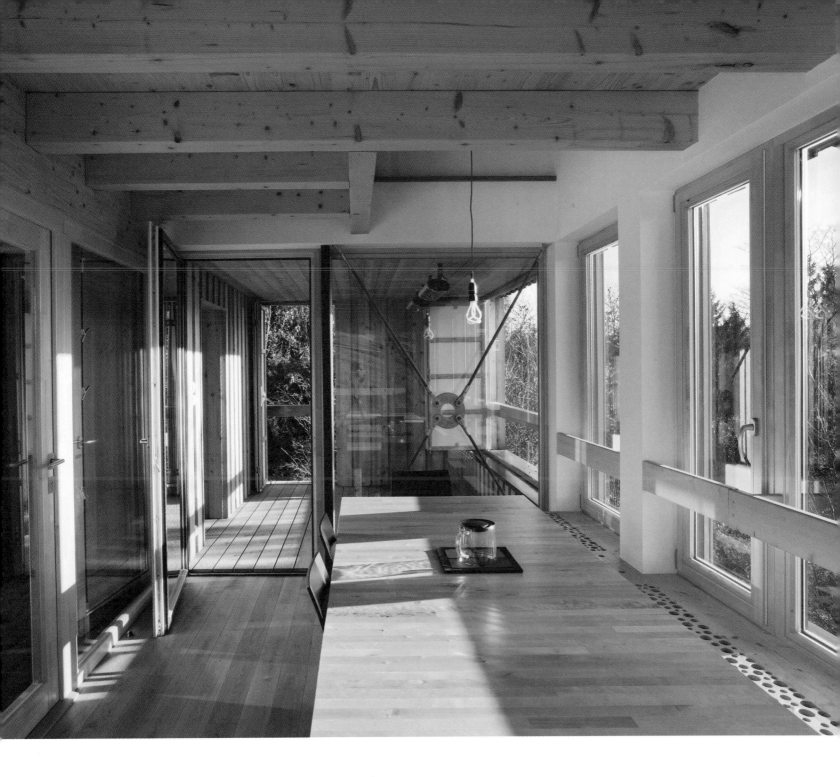

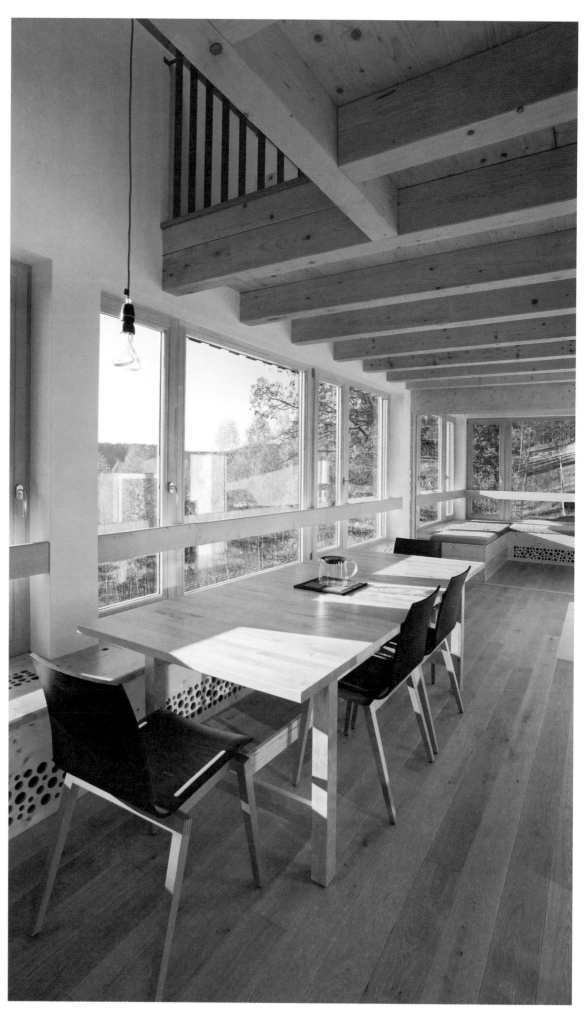

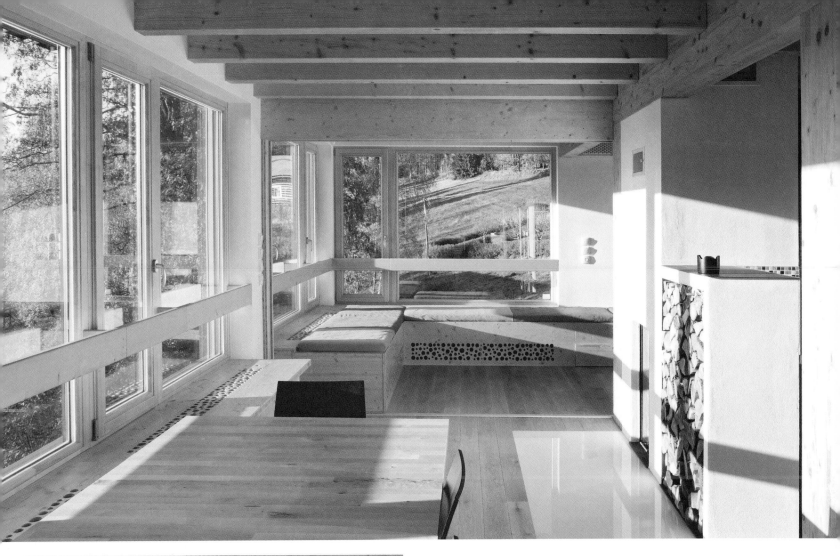

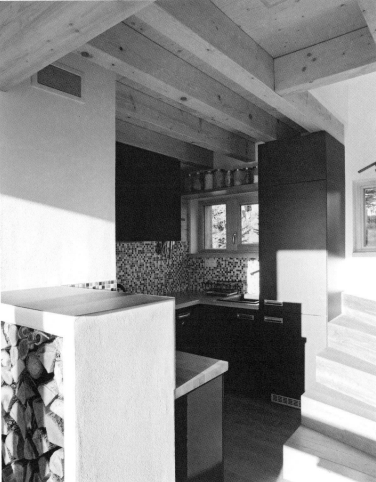

■ The wood widely used throughout the interior has varied shapes and finishes. The large, sliding doors are made of fir, while the main living room floor is polished oak.

ENCLOSED OPEN HOUSE

Wallflower Architecture + Design

Location **East Coast, Singapore**
Surface area **9,257 square feet**
Photographs **© Albert Lim**

Passive solar

Natural daylight
Natural ventilation

The owners wanted a spacious, contemporary home, as open as possible but without compromising on security and privacy. Surrounded by neighbors on all sides, the solution was to build a completely enclosed conjunction of buildings that would bring the outside spaces in, with pools and gardens that would normally be found outside the main body of the home.

The ground level does away with the walls that would have been necessary if the communal and private areas were to exist on the same floor. Thus, the view through the different areas of the ground floor extends for more than 130 feet, meaning that all the spaces are seen to be existing within the exterior structure.

The environmental transparencies at ground level and among the courtyards are also important in that they provide natural ventilation within the building: the temperature difference between courtyards, rooms, and the pool creates similar air flow to a sea breeze blowing onto the shore.

For the owners, the serenity created by having a space free of encumbrances, and the gentle breeze, the dappled sunlight, and the silence of the rippling water in a pond are priceless within such a dense and crowded urban landscape.

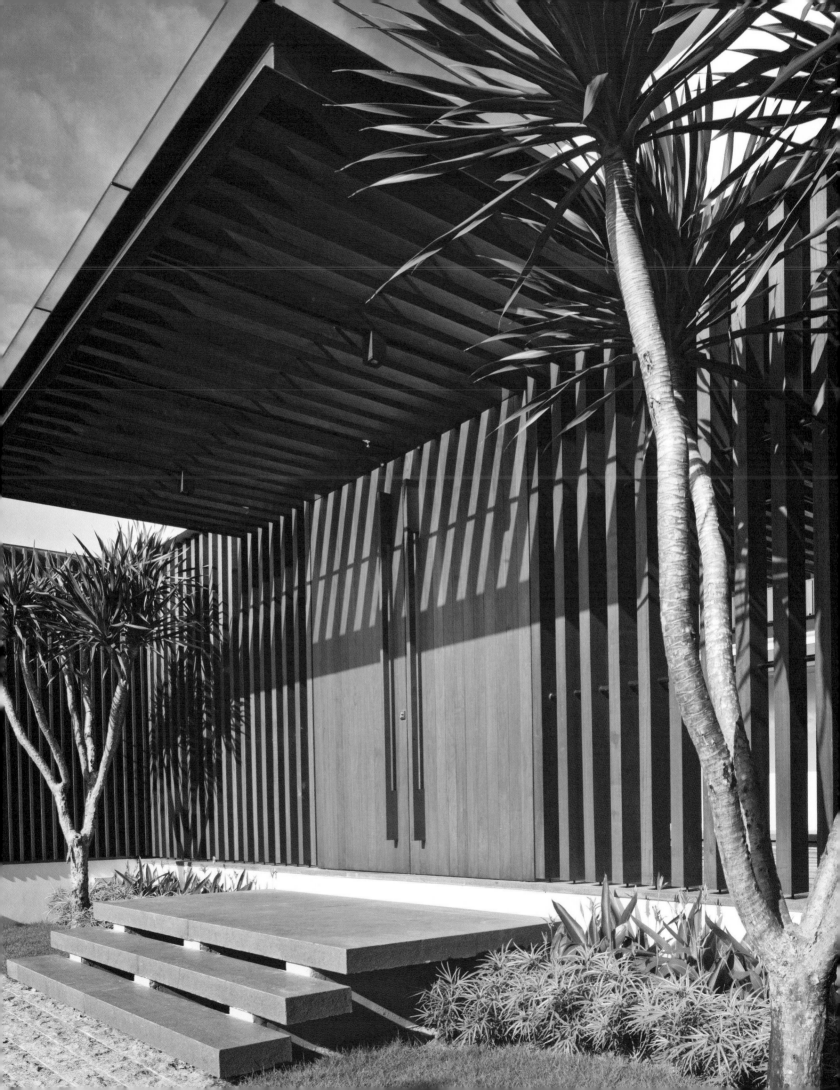

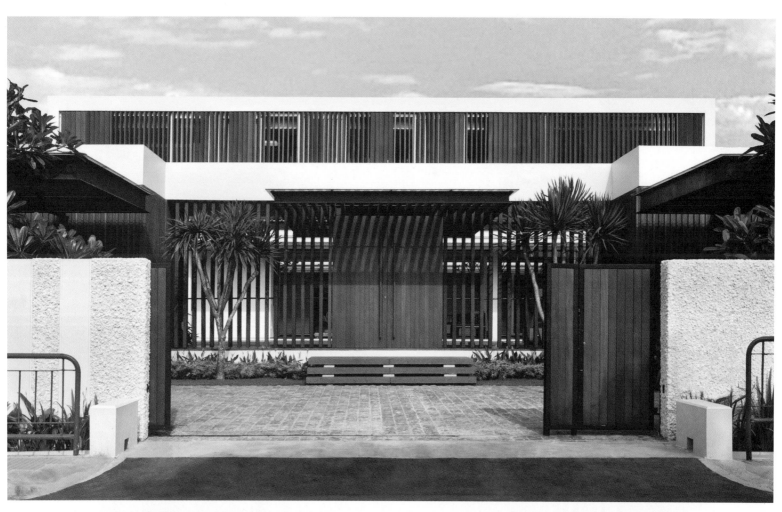

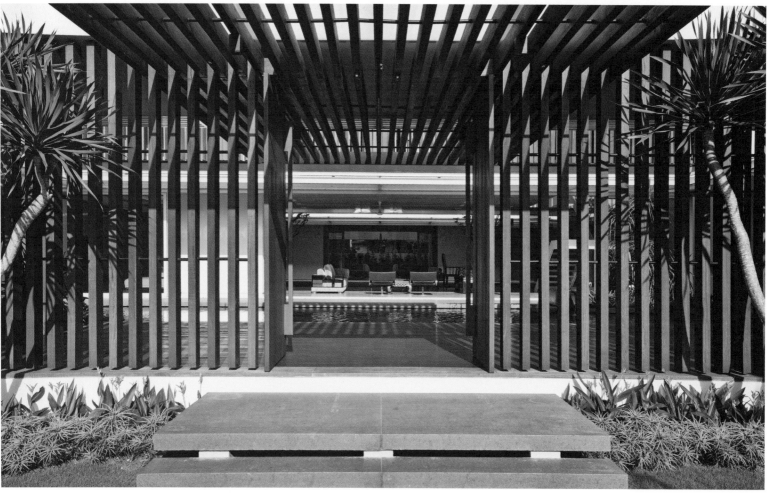

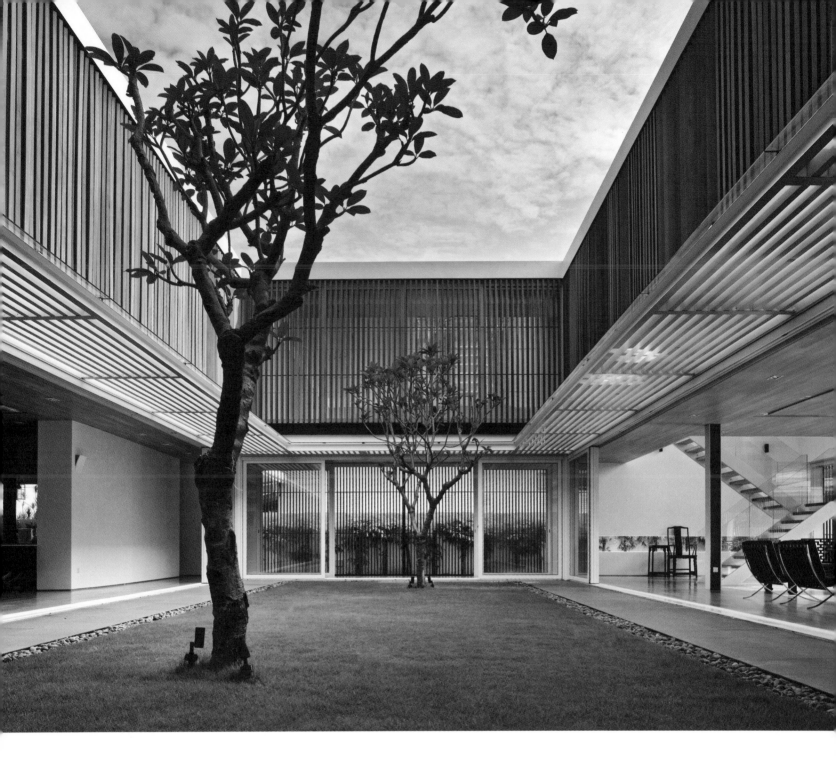

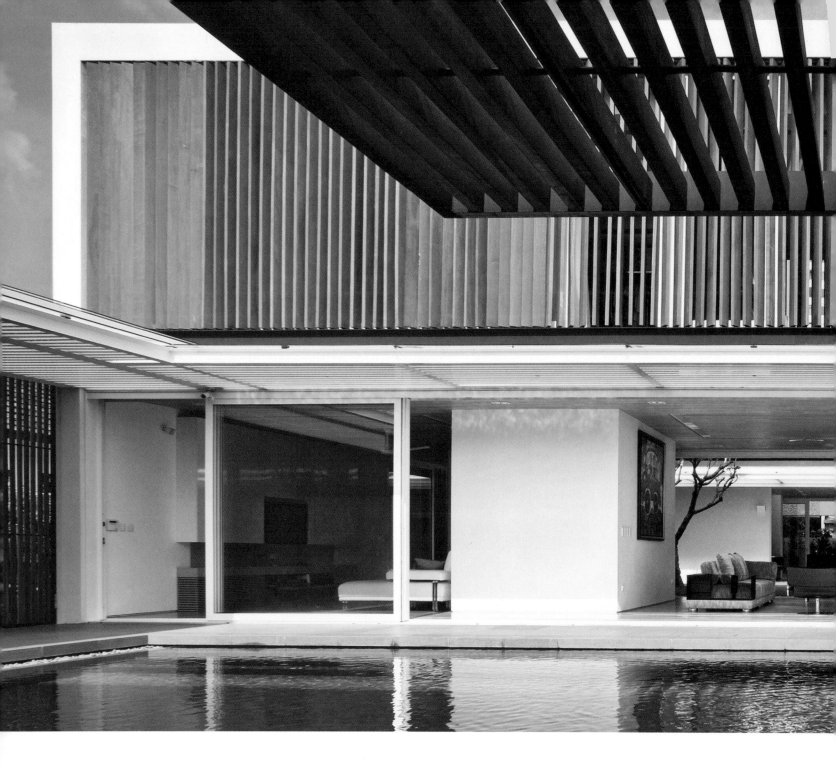

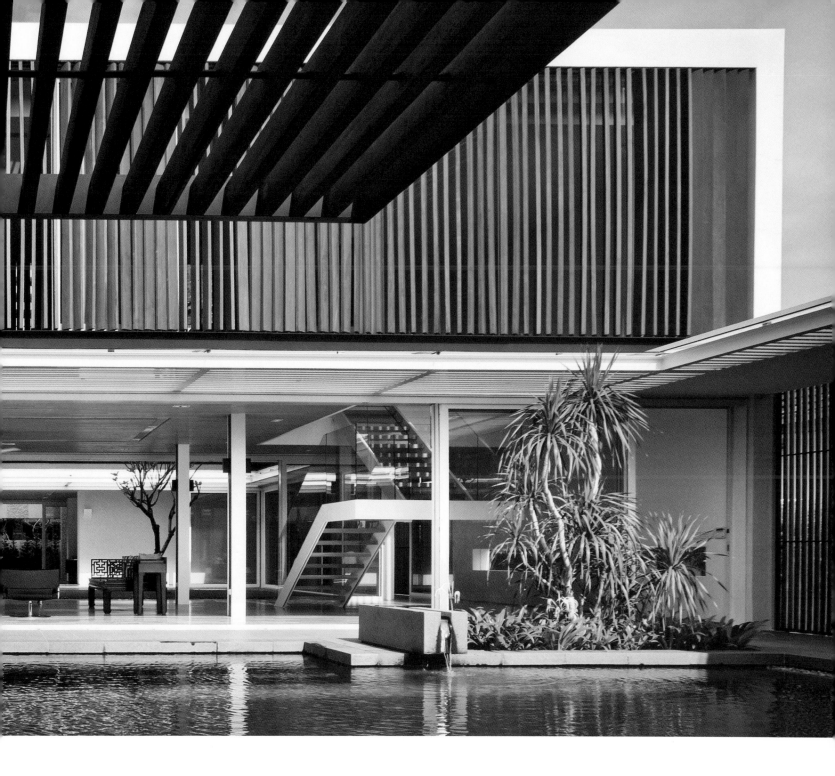

Front elevation

Side elevation

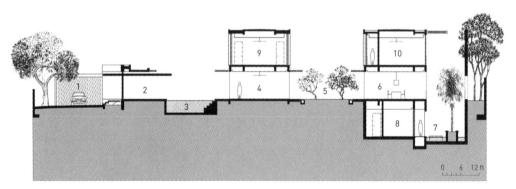

Longitudinal section

1. Carport
2. Foyer
3. Swimming pool
4. Living room
5. Courtyard
6. Dining room
7. Fish pond
8. Wine cellar
9. Master bedroom
10. Bedroom

0 6 12 ft

■ The adjacent and interconnected
spaces distribute the slightest of
breezes, promoting horizontal and
circular air movement. The patios
help to generate and maintain the
circulation.

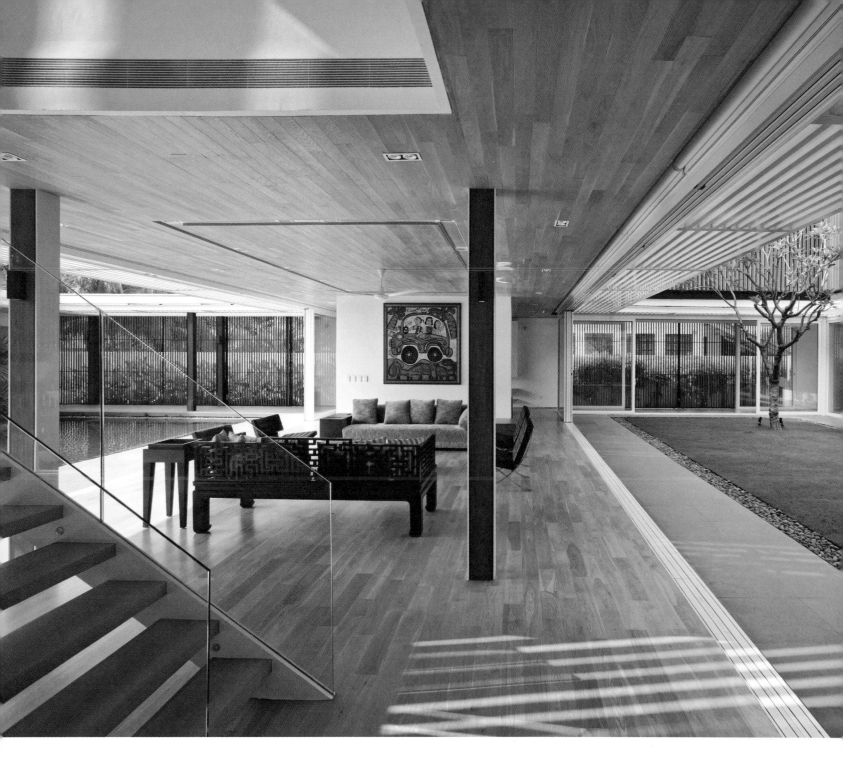

■ All patios have different material finishes that offer greater heat insulation and minimal maintenance (water, grass, and granite).

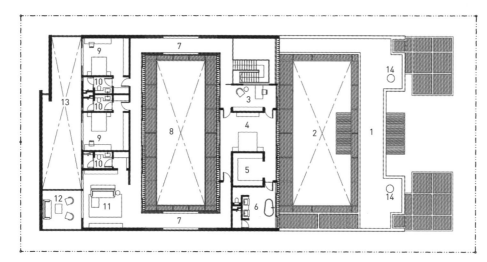

Second floor

1. Flat roof
2. Void to swimming pool
3. Study
4. Master bedroom
5. Wardrobe
6. Master bathroom
7. Corridor
8. Void to courtyard
9. Bedroom
10. Bathroom
11. Family room
12. Outdoor balcony
13. Void
14. Skylight

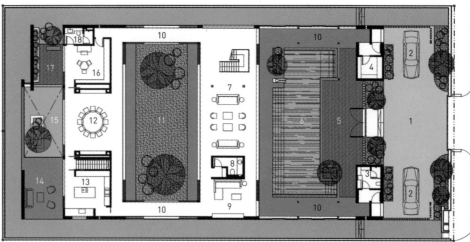

First floor

1. Driveway
2. Carport
3. Changing room
4. Storeroom
5. Foyer
6. Swimming pool
7. Living room
8. Powder room
9. TV area
10. Corridor
11. Courtyard
12. Dining room
13. Kitchen
14. Outdoor terrace
15. Void to basement
16. Study
17. Outdoor deck
18. Bathroom

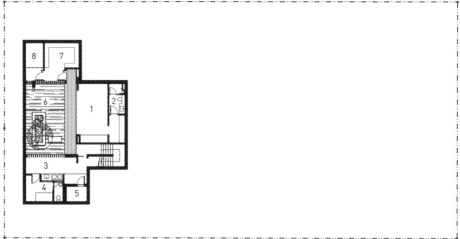

Basement

1. Wine cellar
2. Bathroom
3. Yard
4. Maid's room
5. Wine cellar
6. Fish pond
7. Storeroom
8. Ejector room

0 6 12 ft

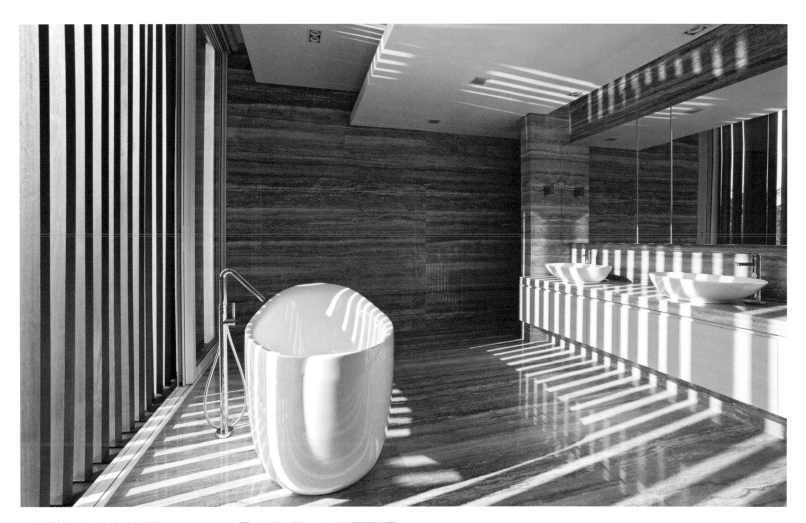

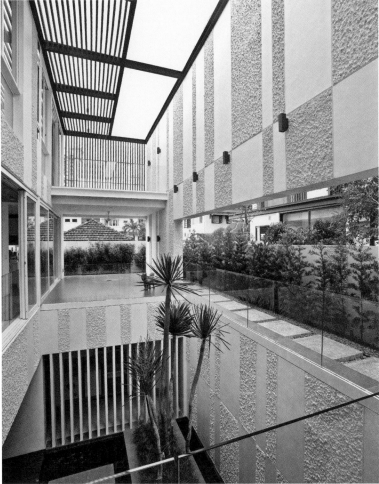

■ The floor-to-ceiling wood blinds on the second floor are manually adjustable, allowing you to filter the desired amount of breeze and sunlight.

ICE HOUSE

Erla Dögg Ingjaldsdóttir and Tryggvi Thorsteinsson | Minarc

Location **Reykjavik, Iceland**
Surface area **1,500 square feet**
Photographs © **Torfi Agnarsson**

 Landscape integration

 Passive solar

 Modular building system
(mnmMOD)
Local materials

 Cross-ventilation
Natural daylight

The large windows that occupy the entire facade are the most prominent feature of this beautiful house designed by Minarc. They completely bathe the living area and bedrooms in natural light, as well as frame the natural beauty of the surrounding Icelandic landscape: the connection between the house and the landscape that surrounds it is perfect.

The house's design ethos certainly embodies the great respect that Iceland has for the environment, for the preservation of its beautiful scenery and for its natural resources. By developing and using a new modular construction technique (mnmMOD), Minarc is able to cut costs and reduce waste, which is characteristic of prefabricated systems, retaining elegance and benefiting from the infinite possibilities of design personalization.

Thanks to the design freedom provided by the modular system, this home is formed from a series of linked cubes, which constitute the main living area and which project towards the horizon from a simple horizontal line. Maximum simplicity, maximum beauty.

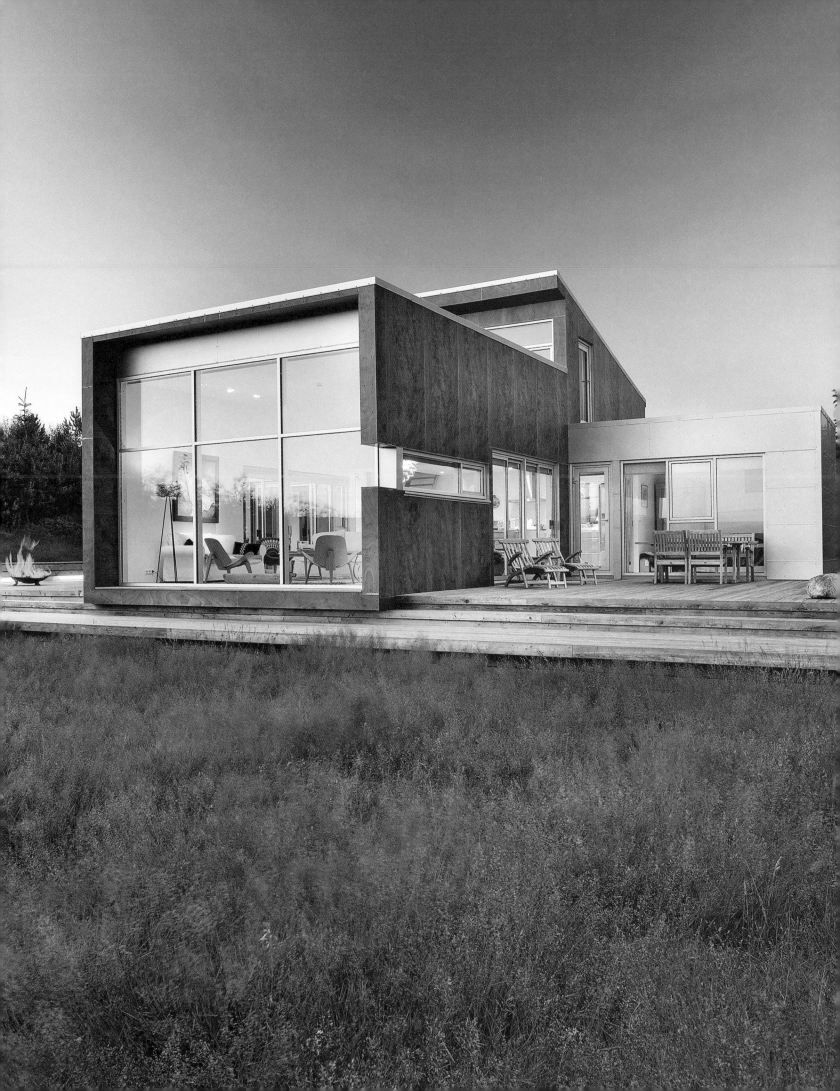

Elevation

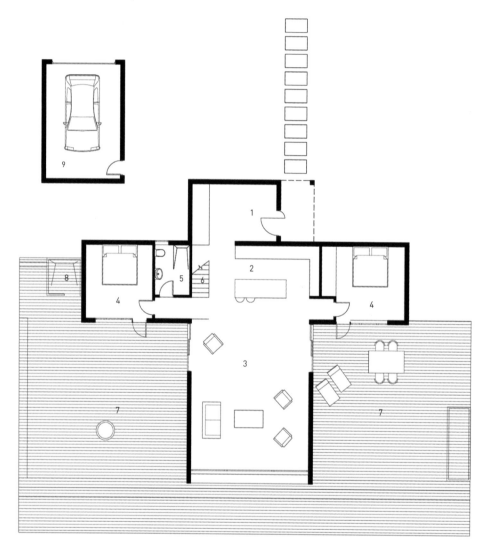

1. Entrance
2. Kitchen
3. Living area
4. Bedrooms
5. Bathroom
6. Stairs
7. Outdoor decks
8. Outdoor shower
9. Parking
10. Loft
11. Roof garden

First floor

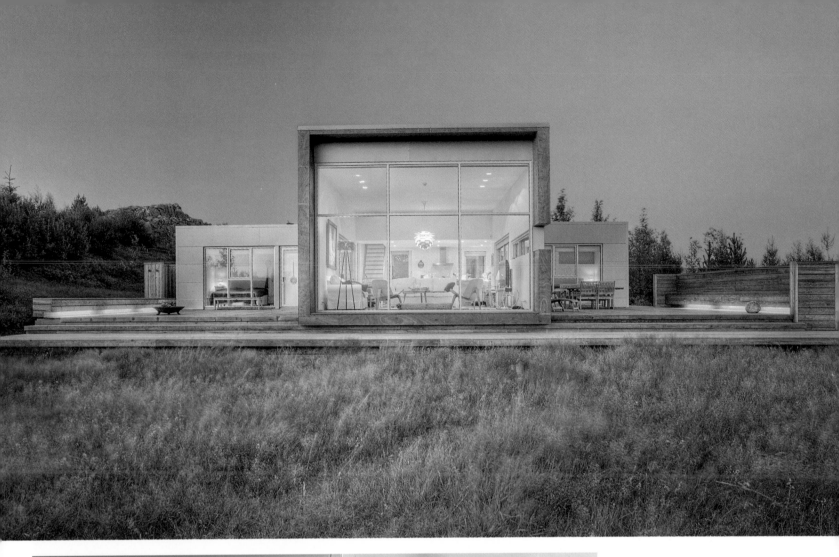

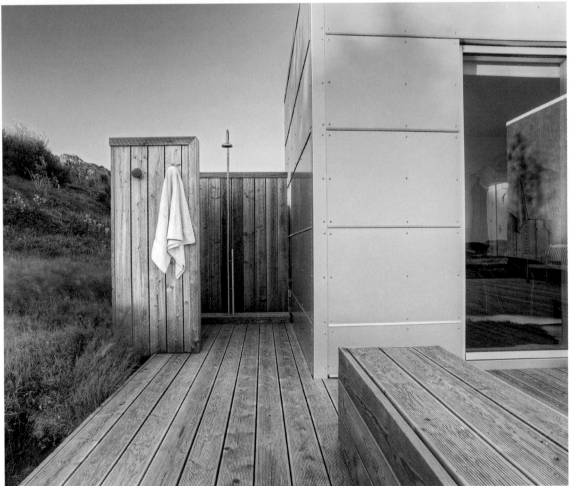

■ The outdoor shower brings one
closer to nature and the elements.

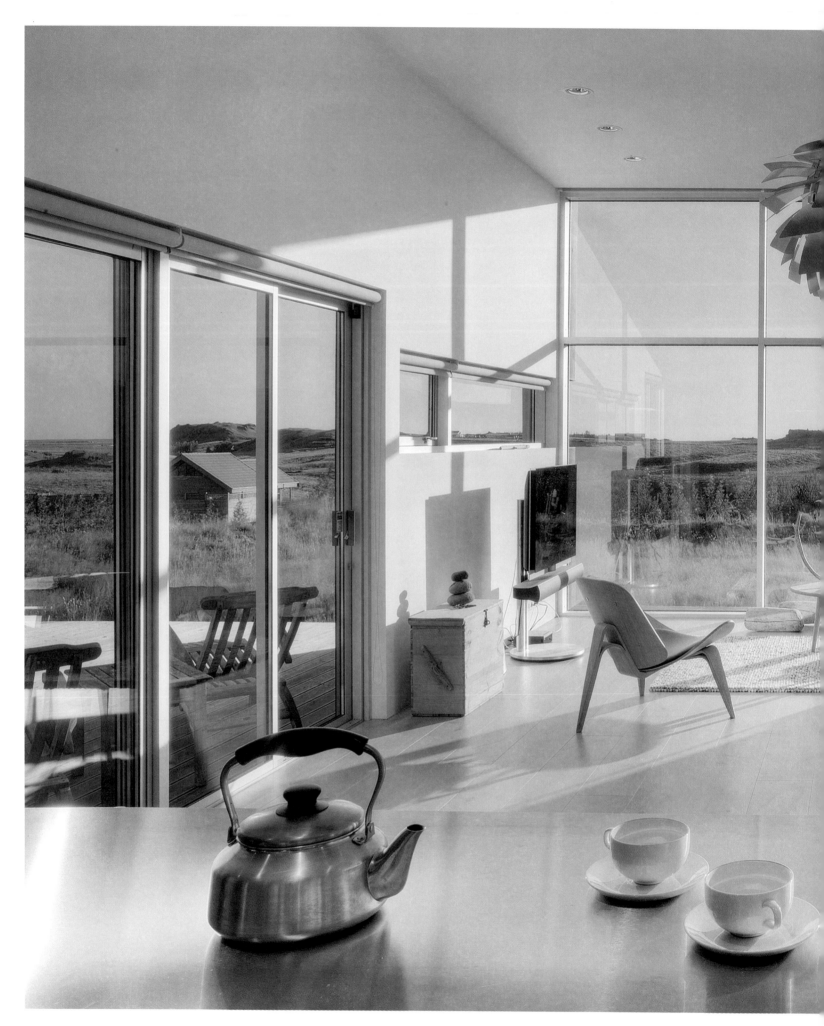

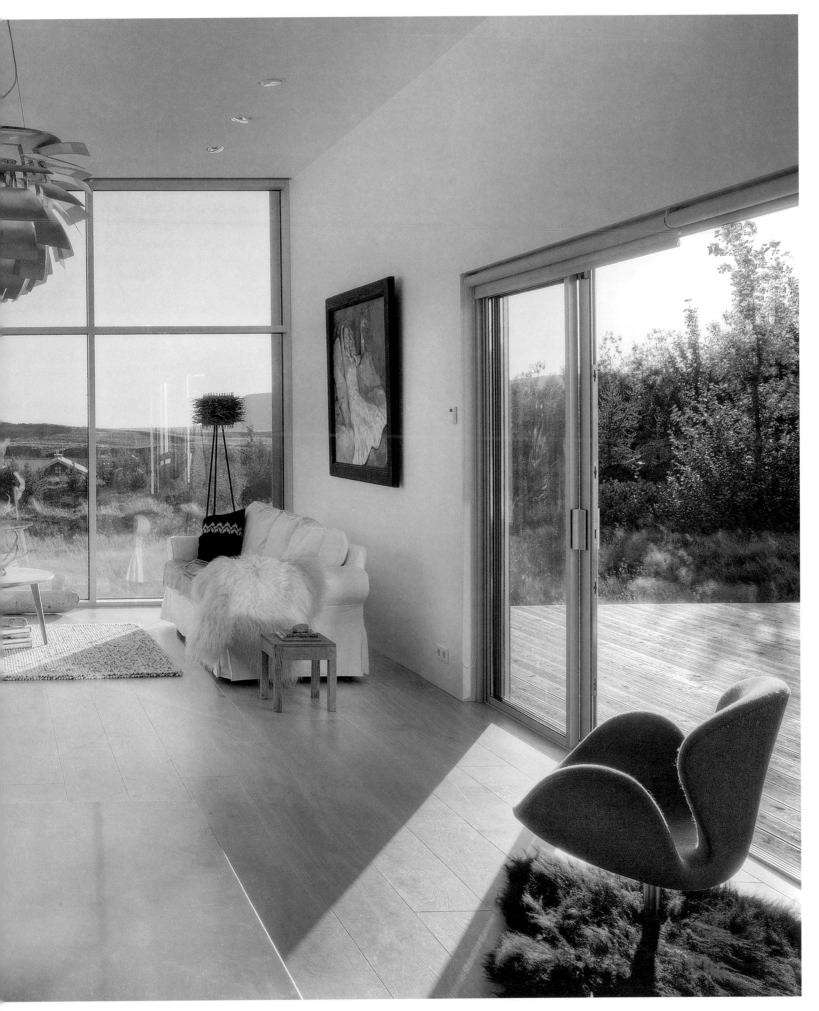

ZEB PILOT HOUSE

Snøhetta

Location **Kingston, Tasmania, Australia**
Surface area **2,368 square feet**
Photographs © **Bruce Damonte** © **Snøhetta** © **EVE**

 Landscape integration

 Sustainable wood
Prefabricated materials
Local materials

 Solar hot-water system
Rainwater collection and use

 Natural daylight
Natural ventilation

 Photovoltaic solar energy
CO_2 low consumption
Geothermal energy
Passive solar / High insulation

ZEB Pilot House is a cooperation between Snøhetta; SINTEF, the largest independent research organization in Scandinavia; the partner of ZEB; Brødrene Dahl, and Optimera. Although the project focuses on the design of a detached house, it has become a demonstration platform to facilitate learning about the methodology of construction using integrated sustainable solutions.

The design of an ambitious environmental project such as this is driven by knowledge of new technologies, local energy sources, materials and construction techniques, and other local resources, as well as the intelligent placement and orientation of the house to make optimal use of energy resources. Clearly, high environmental ambitions create new parameters in the design process.

In parallel, the project retains the comfortable qualities that are vital in any home. The need to achieve comfort and a sense of well-being dominates the design process to the same extent as its energy demands. To this end, the project boasts a variety of spaces that can be enjoyed throughout the year and includes fruit trees and vegetable gardens outside to accommodate small-scale food production.

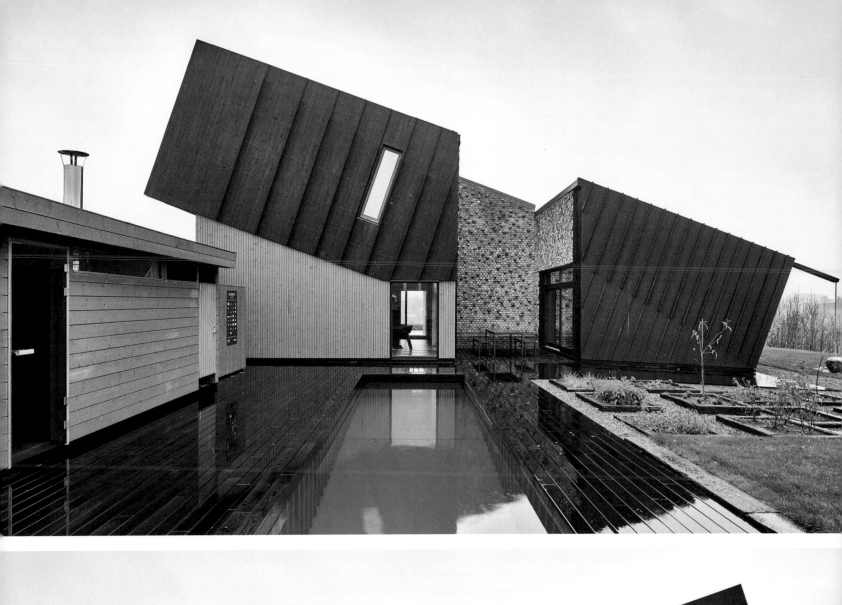

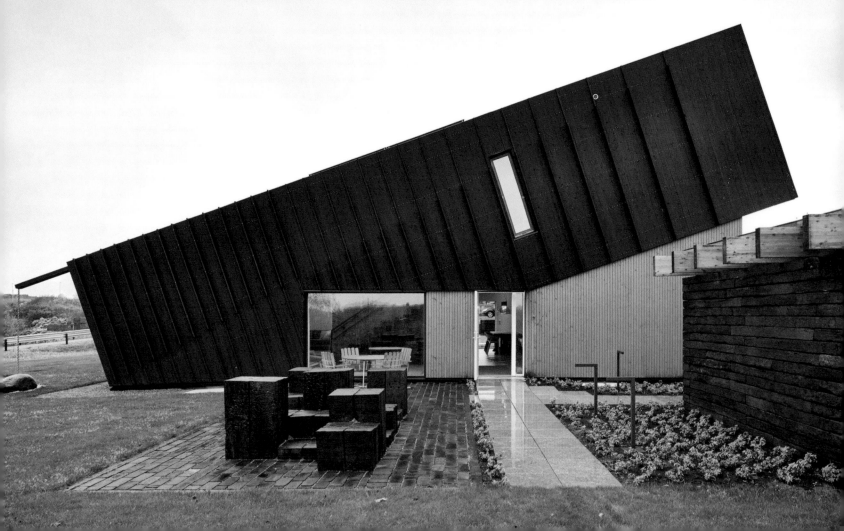

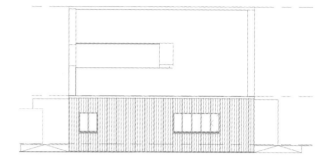

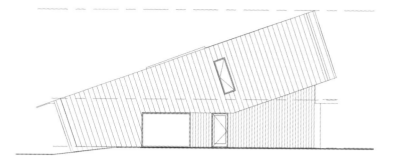

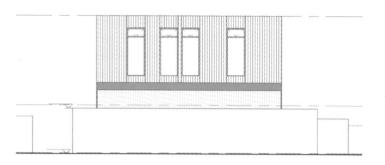

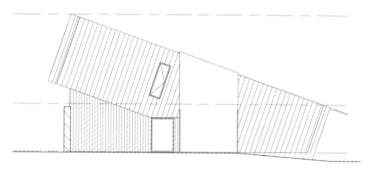

Elevations

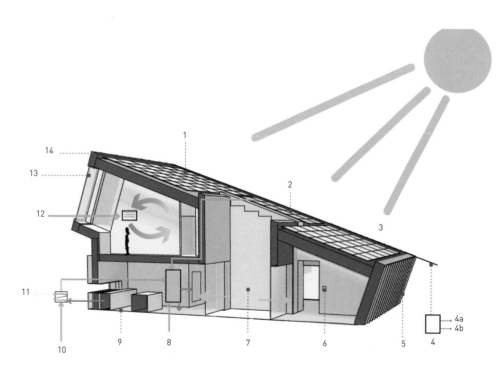

1. Solar cells (photovoltaic panels)
 1,600 ft² - 19200 kWh/year
2. Solar collectors
 170 ft² - 4000 kWh/year
3. Roof slope 19
4. Rainwater collection
 4a. Toilet
 4b. Garden
5. Passive exterior sun shading
6. Light and air are automatically
 controlled based on use and need.
7. Thermal mass stabilizes the
 temperature.
8. The boiler gets heated water from
 the solar collectors, an energy well,
 the air system, and the water heat
 recovery systems.
9. Radiant floor heating heats the house.
10. Gray water heat recovery, drain water
 heat recovery.
11. One radiator on each floor can heat
 the whole house.
12. Excess heat from the indoor air is
 used to heat the incoming air and
 tap water.
13. Windows with a good U-value
14. Efficient insulation

Diagram of low energy consumption and bioclimatic strategies

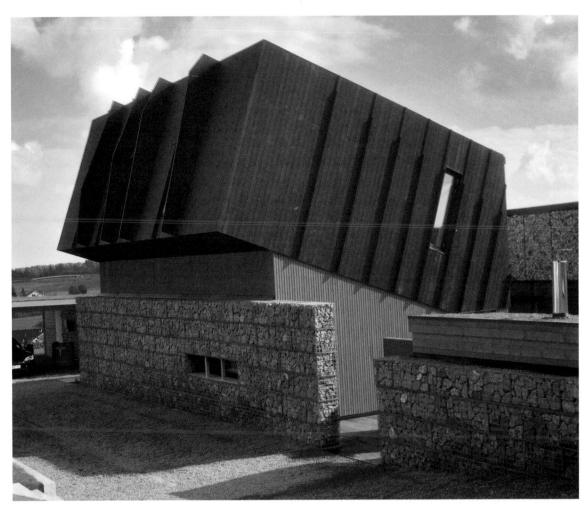

■ The sloped roof is festooned with solar panels, which, along with geothermal energy, cover the house's energy needs and generate more than enough energy to supply an electric car all year long.

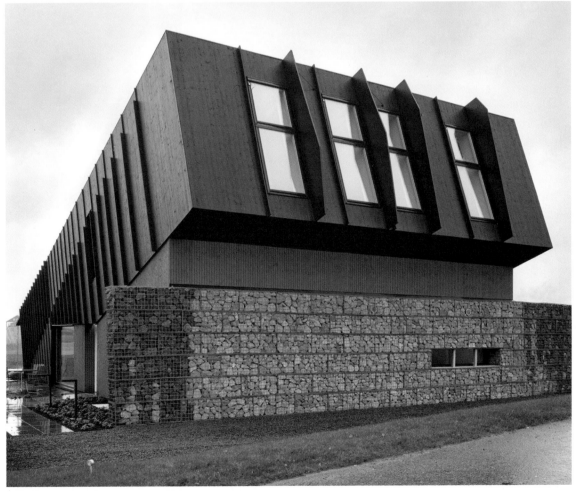

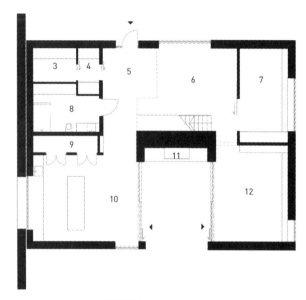

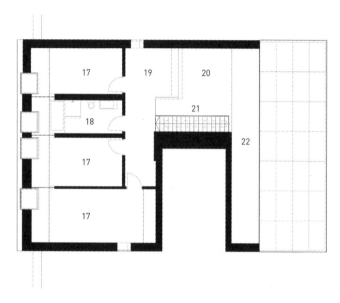

First floor

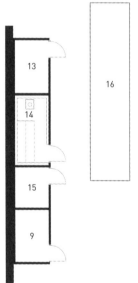

Ground floor

1. Inverters and battery bank
2. Carport / Cyclepart
3. Storeroom
4. Cloak room
5. Entrance
6. Multimedia room
7. Guest room / Office
8. Bathroom / Washroom

9. Technical room
10. Kitchen / Dining room
11. Fireplace
12. Living room
13. Garden storage
14. Sauna
15. Outside shower
16. Swimmimg pool

17. Bedrooms
18. Bathroom
19. Mezzanine
20. Void
21. Skylight
22. Cut volume

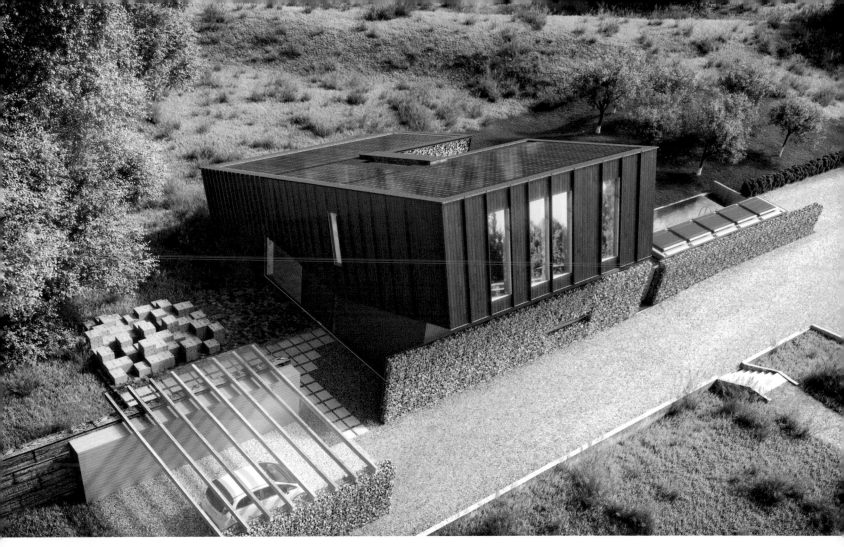

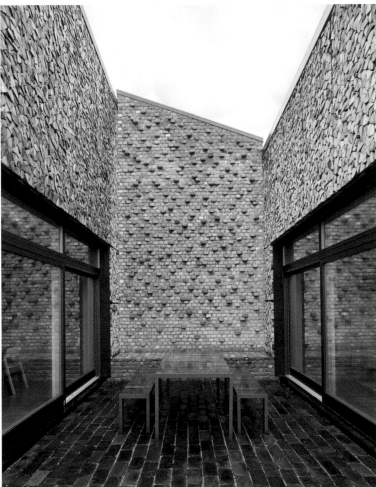

■ From early spring until late autumn, an open-air atrium with outdoor furniture invites life outside the home into a beautiful space with walls made of recycled wood and stacked bricks.

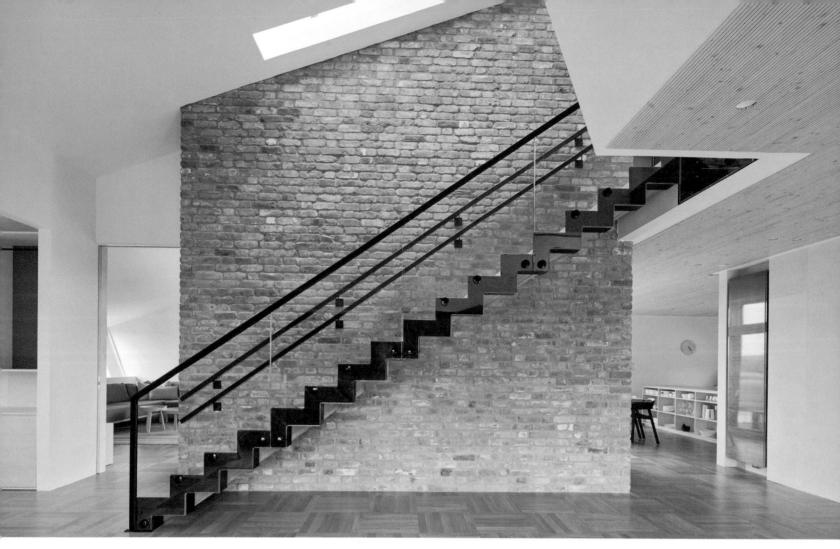

■ The materials used inside were selected for their capacity to contribute to a pleasant interior climate and air quality but without forgetting about aesthetics.

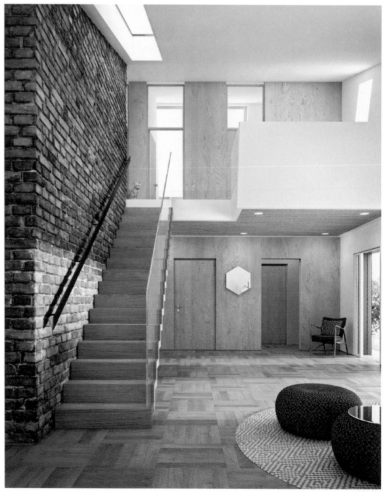

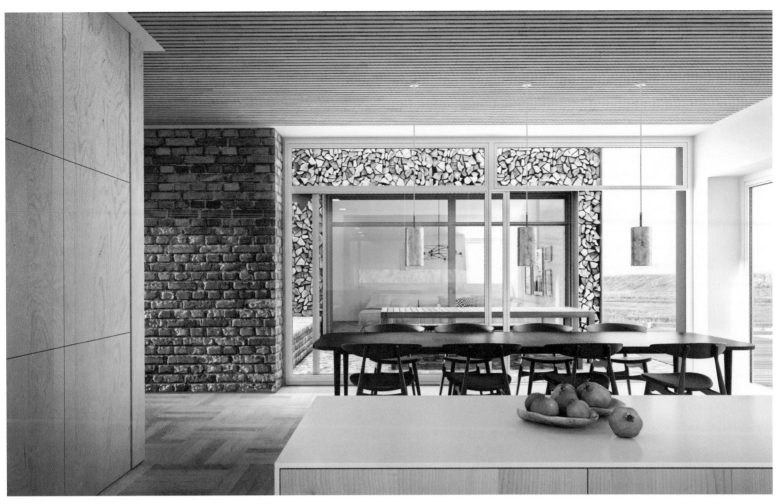

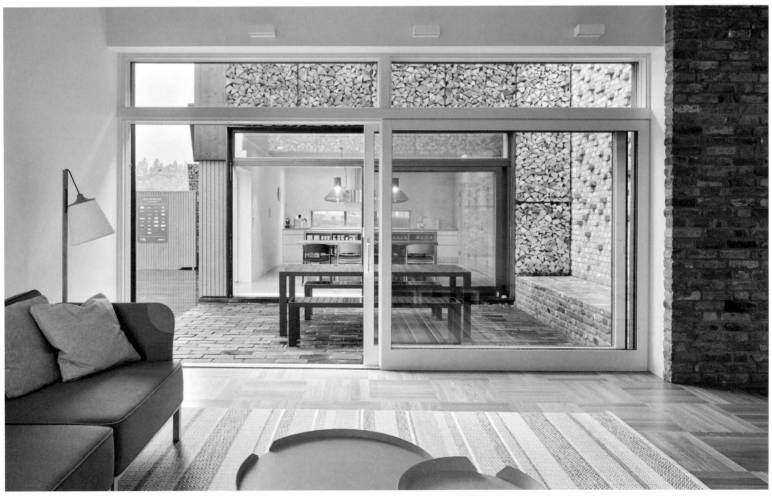

WATER-COOLED HOUSE

Wallflower Architecture + Design

Location **Bukit Timah, Singapore**
Surface area **6,264 square feet**
Photographs **© Albert Lim**

Landscape integration

Natural ventilation
Passive cooling: pool as a cooling pond
Natural daylight
High insulation by the pond

This concept reverses the layout and stylized norms of the local residential style. Hidden from the road, the enclave in which the house sits is surrounded by a thick green screen of mature trees with a characteristic breeze that blows across the site. The owner wanted a contemporary home in which a constant cool temperature was paramount — a way of enjoying the contrast with the lush tropical environment.

In order to fully appreciate the varied natural environment, and to maximize the visual depth and distance, a light, transparent structure houses the main living room and study as a separate unit on the second floor. A dark reflecting pool surrounds this shape and increases the feeling of serene seclusion and privacy. The pool is also designed to provide heat insulation to the dining room, bedrooms, and the other family living spaces located beneath the solar heated area.

On the lower level, water also plays a prominent role in the project. The living and service areas align perfectly with a long strip of light and air, which run parallel to a long continuous koi pond, which in turn contributes to the micro cooling of this part of the house.

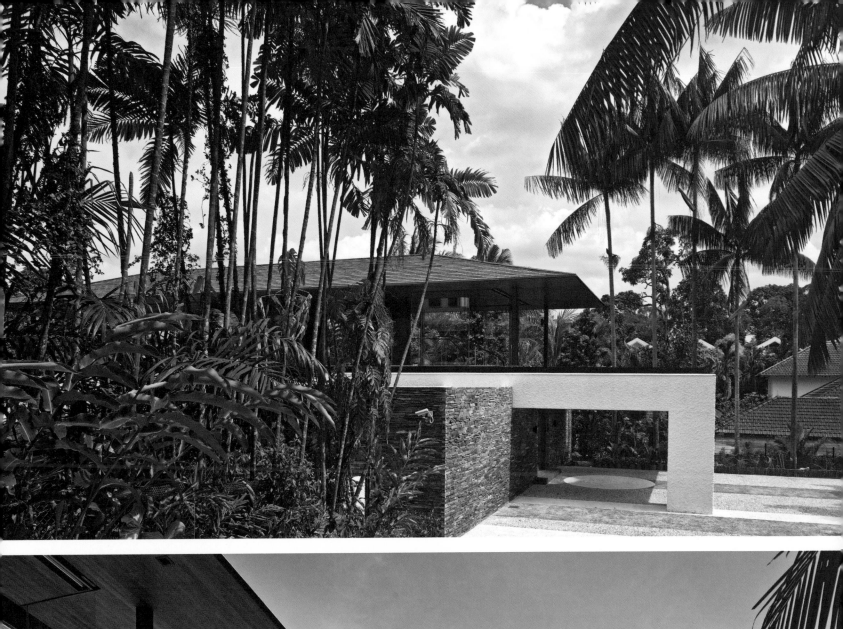

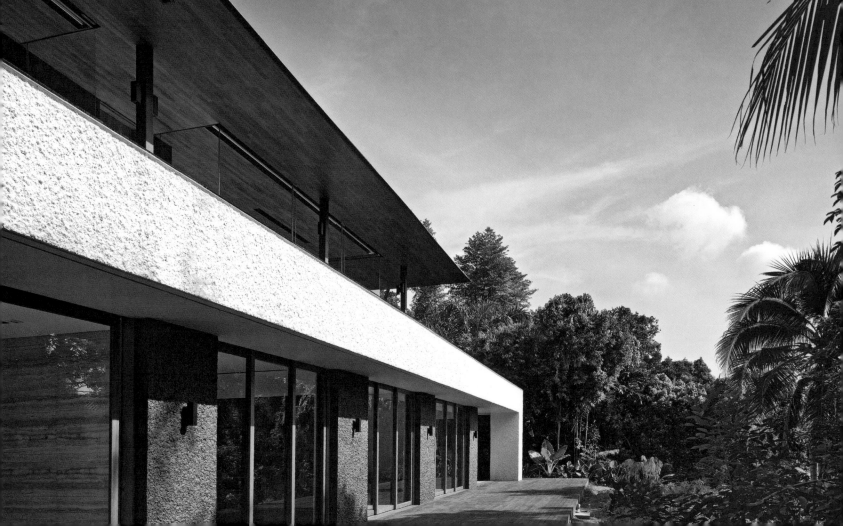

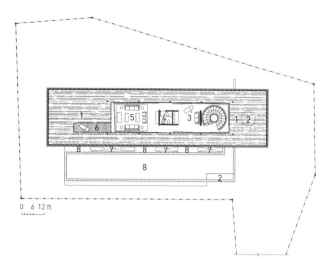

Second floor

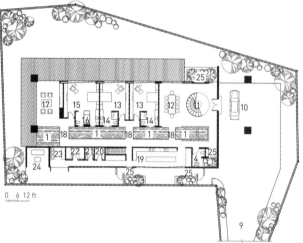

First floor

1. Pond
2. Skylight
3. Hall
4. Powder room
5. Living room
6. Outdoor deck
7. Void
8. Flat roof
9. Driveway
10. Carport
11. Spiral stairs
12. Dining room
13. Bedroom

14. Bathrooms
15. Master bedroom
16. Master bathroom
17. Family room
18. Passageway
19. Kitchen
20. Store room
21. Maid's bathroom
22. Maid's bedroom
23. Yard
24. Air condenser
25. Planter

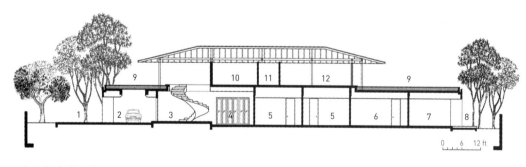

Longitudinal section

1. Driveway
2. Carport
3. Spiral stairs
4. Dining room
5. Bedrooms
6. Master bedroom
7. Family room
8. Outdoor deck
9. Pond
10. Hall
11. Powder room
12. Living room

Elevation

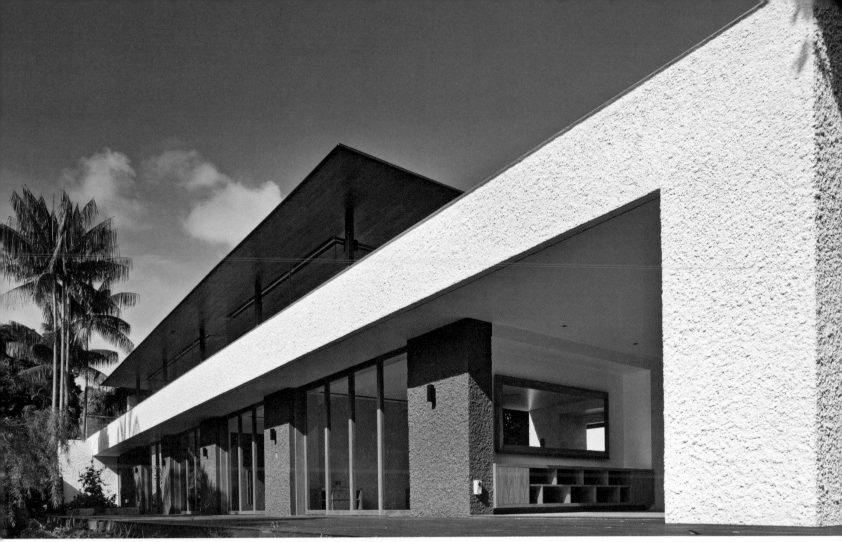

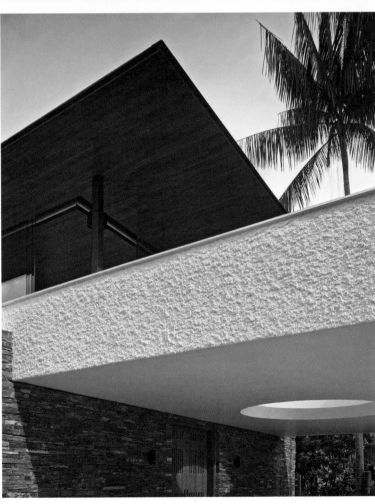

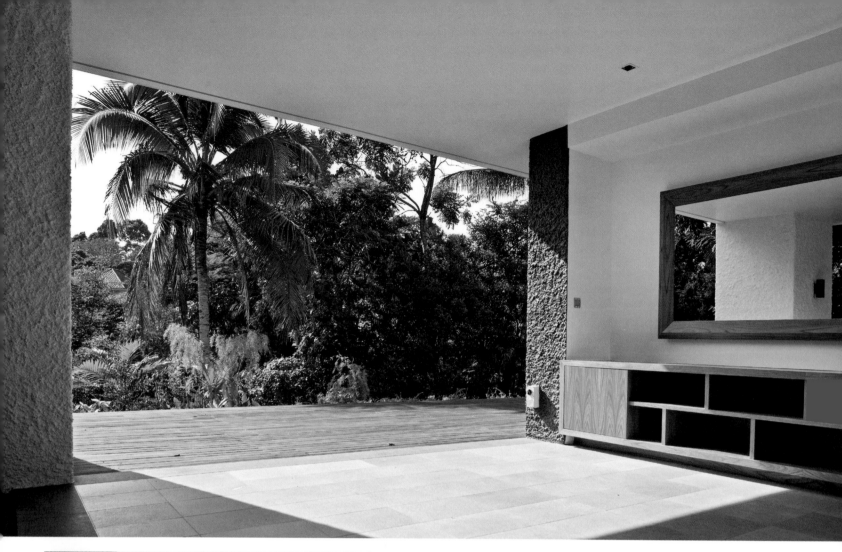

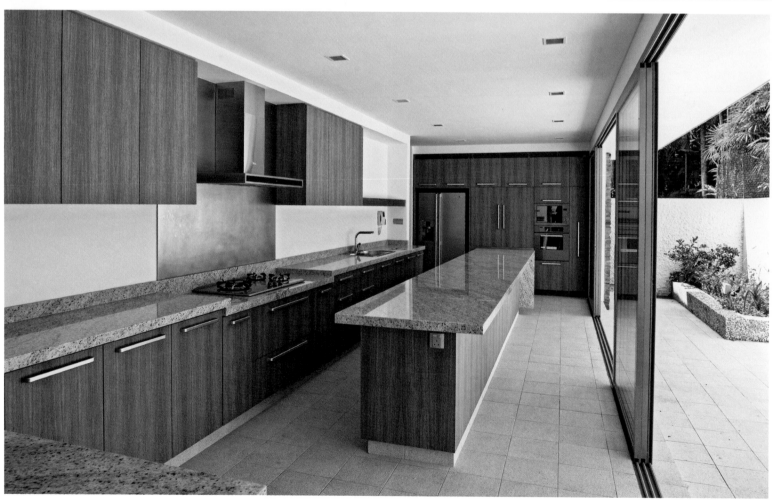

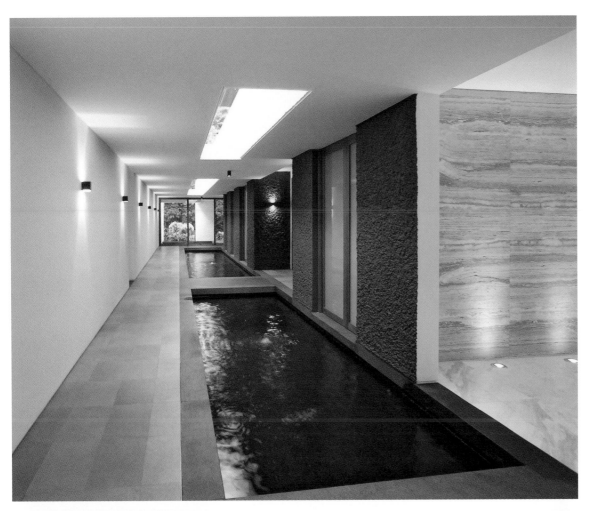

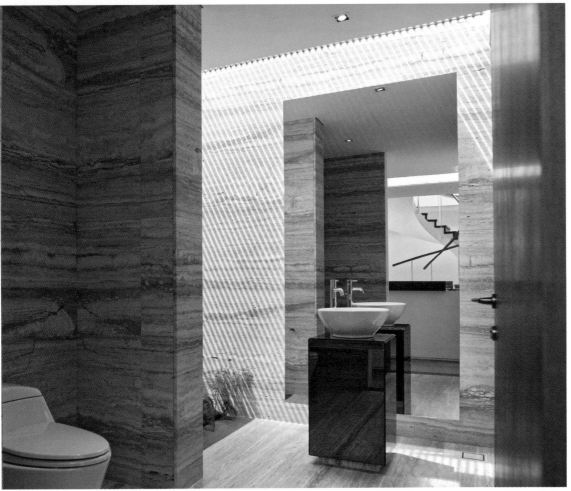

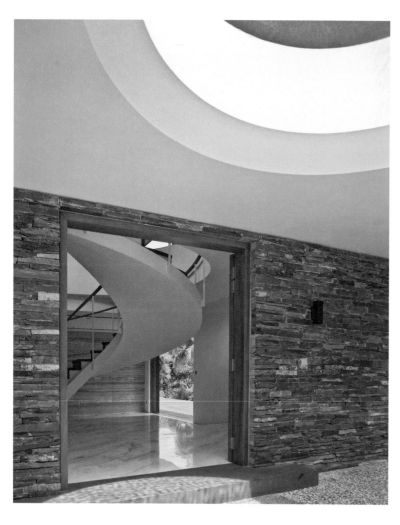

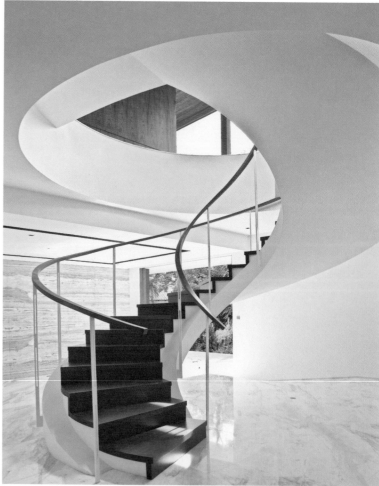

The main entryway features an oculus above the upper pool, where sunlight is filtered and cooled in the water. Needless to say, water is the protagonist in this home.

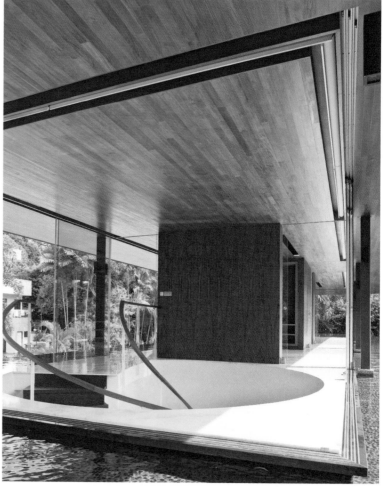

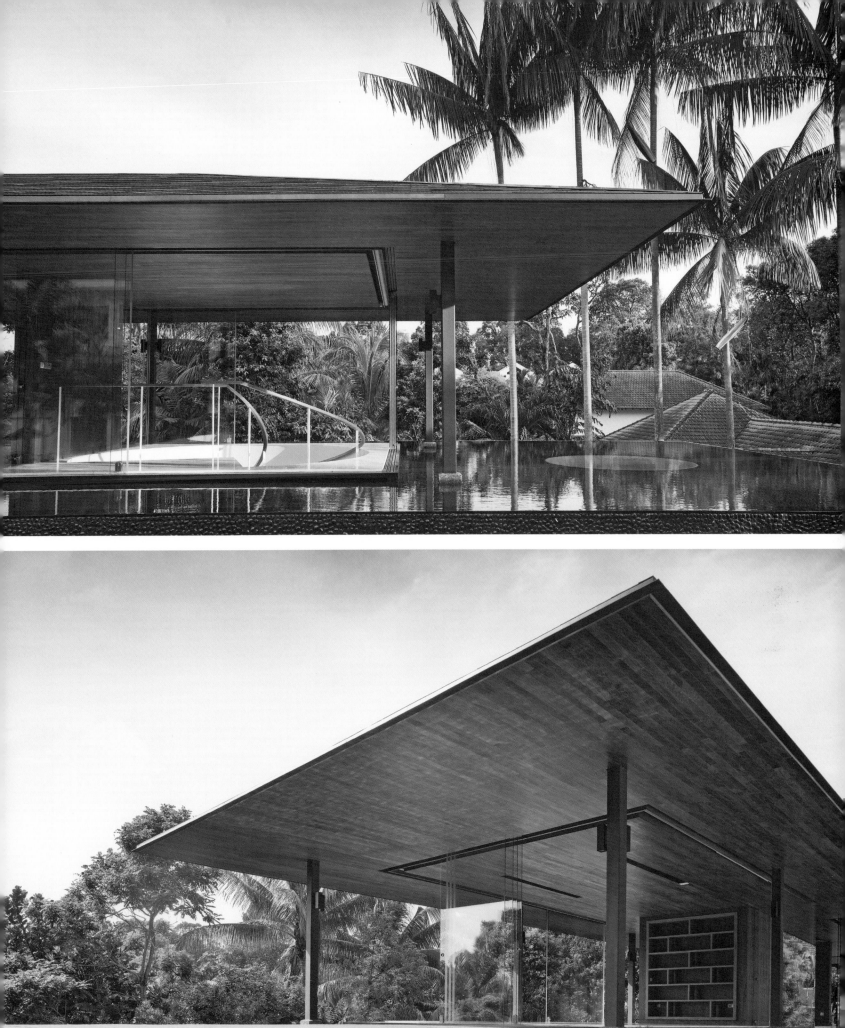

Glossary

Air-conditioning systems: the simultaneous control of temperature, humidity, and movement and quality of air inside a space.

Cross-ventilation: natural ventilation with an entrance and an exit for air has to be present, and where the pressure of the air entering the space must be different to the pressure of the air leaving.

Domotics: All systems capable of automating a home, providing energy management services, security, welfare, and communication, and can be integrated through outdoor and indoor communication networks, wired or wireless or whose control has certain ubiquity, from within or outside the home. It could be defined as the integration of technology in the intelligent design of a building.

Geothermal energy: energy that can be obtained using the heat inside the earth.

Gray water recycling: recovery systems for the wastewater generated from plates and washbasins, showers and baths, because it is nearly as clean as potable water. Gray water often also includes wastewater from washing machines and sometimes includes discharge from dishwashers and kitchen sinks. The gray water can be recycled onsite for uses such as toilet flushing, landscape irrigation, and constructed wetlands.

Green roof: roof that is partially or completely covered with vegetation and a growing medium, planted over a waterproofing membrane. Green roofs absorb rainwater, provide insulation, create a habitat for wildlife, increase benevolence, and decrease stress of the people around the roof by providing a more aesthetically pleasing landscape, and help to lower urban air temperatures and mitigate the heat island effect.

Indoor air quality (IAQ): air quality within and around buildings and structures, especially as it relates to the health and comfort of building occupants.

KNX (standard): standardized (EN 50090, ISO/IEC 14543), OSI-based network communications protocol for intelligent buildings.

Landscape integration: integration of the building in the land, respecting the environmental, geological, and morphological characteristics.

Local materials: materials produced locally that reduce the fuel need for their transport.

Natural daylight: calculated placement of windows or other openings and reflective surfaces so that during the day natural light provides effective internal lighting.

Natural ventilation: process of supplying and removing air through an indoor space without using mechanical systems.

Passive solar: design strategies of buildings where windows, walls, and floors are specially placed to collect, store, and distribute solar energy in the form of heat in the winter and reject solar heat in the summer. Passive solar design, unlike active solar heating systems, it does not involve the use of mechanical and electrical devices.

Passivhaus (Passive house): rigorous and voluntary standard for energy efficiency in a building, reducing its ecological footprint. It results in ultra-low energy buildings that require little energy for space heating or cooling.

Photovoltaic solar energy: method of converting solar energy into direct-current electricity using semiconducting materials that exhibit the photovoltaic effect. A photovoltaic system employs solar panels composed of a number of solar cells to supply usable solar power.

Radiant floor: a type of radiant heating system where the building floor contains channels or tubes through which hot air or water are circulated. Radiant floor heating eliminates the draft and dust problems associated with forced-air heating systems.

Rainwater collection: accumulation and deposition of rainwater for reuse onsite, rather than allowing it to run off. Its uses include water for gardening, livestock, irrigation, domestic use with proper treatment, and for indoor home heating, etc.

Recyclable materials: materials used in the building construction that can be recovered and reused after the finish of the effective life of the building.

Recycled materials: new materials obtained from the processing of waste materials. These materials can be used in sustainable buildings to prevent waste of potentially useful materials, reduce the consumption of fresh raw materials, reduce energy usage, reduce air pollution and water pollution by reducing the need for "conventional" waste disposal, and lower greenhouse gas.

Solar (thermal) chimney: a way of improving the natural ventilation of buildings by using convection of air heated by passive solar energy.

Straw-bale construction: building method that uses bales of straw (commonly wheat, rice, rye, and oats) as structural elements, building insulation, or both.

Sustainable wood: wood that comes from responsibly managed forests.

Thermal comfort: satisfaction of a person with a specific thermal environment.

Thermal inertia: capacity of a material to store received thermal energy and release it progressively.

Thermal insulation: capacity of materials to resist the passing of heat through conduction. All materials offer resistance, to a greater or lesser degree, to heat passing through them.

Visual integration: integration of the building in the aesthetic and visual characteristics of their immediate environment, whether urban or rural.

Directory

a21studĩo
2/10 Nguyễn Huy Lượng, ward 14,
Bình Thạnh district,
Ho Chi Minh city, Vietnam
Tel.: +84 8 38411603
arch21studio@gmail.com
www.a21studio.com.vn

Andrea Oliva Architetto l Studio Cittaarchitettura
Via L. Ariosto, 17
Reggio Emilia, 42121, Italy
Tel. / Fax: +39 0522 1713846
info@cittaarchitettura.it
www.cittaarchitettura.it

Arkin Tilt Architects
1101 8th Street,
Berkeley, California 94710, USA
Tel.: +1 510 528 98 30
info@arkintilt.com
www.arkintilt.com

Atelier Tarabusi
27 Rue David d'Angers
75019, Paris, France
Tel. / Fax: +33 1 42 41 47 59
atelier@tarabusi.net
www.tarabusi.net

Biro Gašperič
Ljubljana, Slovenia
Tel.: +386 41 758 583
matej@birogasperic.com
www.birogasperic.com

Dorrington Atcheson Architects
68 France St S, Eden Terrace,
Auckland 1010, New Zealand
Tel.: +64 9 361 6688
Fax: +64 9 280 5008
info@daa.co.nz
www.daa.co.nz

Dubbeldam Design Architects
401 Richmond Street West, #258
Toronto, Ontario M5V 3A8,
Canada
Tel.: +1 416 913 6757
design@dubbeldam.ca
www.dubbeldam.ca

iredale pedersen hook
Suites 5 & 6, Murray Mews
329-331 Murray Street
Perth, Australia 6000
Tel.: +61 8 9322 9750
Fax: +61 8 9322 9752
email@iredalepedersenhook.com
www.iredalepedersenhook.com

Kennedy & Violich Architecture, Ltd.
10 Farnham Street
Boston, Massachusetts 02119, USA
Tel.: +1 617 442 0800
Fax: +1 617 442 0808
info@kvarch.net
www.kvarch.net

Leth & Gori
Absalonsgade 21B ST TH
1658 Copenhagen V, Denmark
Tel.: +45 25636999
info@lethgori.dk
www.lethgori.dk

MVRDV
Dunantstraat, 10,
3024, BC Rotterdam
The Netherlands
Tel.: +31 10 477 2860
Fax: +31 10 477 3627
office@mvrdv.com
www.mvrdv.nl

Paravant Architects
6017 West Washington Boulevard,
Culver City, California 90232, USA
Tel.: +1 213 787 6330
Fax: +1 310 313 0929
info@paravantarchitects.com
www.paravantarchitects.com

Prodesi
Husitská 36, 130 00 Praha 3,
Czech Republic
Tel.: +420 2-83 853 424
prodesi@prodesi.cz
www.prodesi.cz

Snøhetta
Akershusstranda 21
N-0150, Oslo, Norway
Tel.: +47 2-4 1560 60
contact@snohetta.com
www.snohetta.com

Studio mk27
Al. Tietê, 505 Jardins
01417-020, São Paulo, Brazil
Tel.: +55 11 3081 3522
info@studiomk27.com.br
www.studiomk27.com.br

Thomashoff + partner Architects
244 Hans Pirow Street,
Muckleneuk, Pretoria, South Africa
Tel.: +27 12 341 4508
Fax: +27 12 341 4508
info@thomashoffstudio.co.za
www.thomashoffstudio.co.za

Wallflower Architecture + Design
7500A, Beach Rd #15-303,
The Plaza, Singapore 199591
Tel.: +65 6-297 6883
admin@wallflower.com.sg
www.wallflower.com.sg

Welldom
Cà Spineda
Via Aglaia Anassilide, 41 int. 1,
31044 Biadene - Montebelluna, Italy
Tel.: +39 0423 605551
Fax: +39 0423 1996701
info@welldom.it
www.welldom.it